the
eclectic eye

Josef Albers Lita Albuquerque Peter Alexander David Amico Doug Argue Arman Robert Arneson

Los Carpinteros John Chamberlain Les Christensen Christo Chema Cobo Bruce Conner

Barry Flanagan Sam Francis Viola Frey Katharina Fritsch Torben Giehler Gilbert & George

Tim Hawkinson David Hockney Hans Hofmann Jenny Holzer Robert Irwin Vincent James Jasper Johns

Louise Lawler Sol LeWitt Roy Lichtenstein Los Carpinteros John McCracken John McLaughlin

Barnett Newman Isamu Noguchi Kenneth Noland John Okulick Claes Oldenburg Nam June Paik

Ed Ruscha George Segal Al Souza Frank Stella Christopher Taggart Tony Tasset

the
eclectic eye

selections from the
Frederick R. Weisman Art Foundation

Charles Arnoldi Richard Artschwager John Baldessari William Baziotes Larry Bell Tony Berlant

Joseph Cornell Mary Corse Ronald Davis Willem de Kooning Lesley Dill Jim Dine Charles Fine

Jack Goldstein Joe Goode Arshile Gorky Paolo Grassino Red Grooms Duane Hanson Keith Haring

Donald Judd Anish Kapoor Craig Kauffman Ellsworth Kelly Edward & Nancy Reddin Kienholz

Arnold Mesches Henry Moore Joel Morrison Ed Moses Robert Motherwell Matt Mullican

Michelangelo Pistoletto Sigmar Polke José Luis Quiñones Larry Rivers James Rosenquist

Robert Therrien Alison Van Pelt Andy Warhol Marijke van Warmerdam Tom Wesselmann Tom Wudl

Frederick R. Weisman Philanthropic Foundation
Los Angeles

The Eclectic Eye: Selections from the Frederick R. Weisman Art Foundation is a catalogue organized by Billie Milam Weisman, Director, Frederick R. Weisman Art Foundation, to highlight selections from the Foundation's lending collection.

This catalogue has been made possible through the support of the Frederick R. Weisman Philanthropic Foundation.

Published by the
Frederick R. Weisman Philanthropic Foundation
275 N. Carolwood Drive
Los Angeles, California 90077

ISBN 0-9740908-0-8

Project coordinator: Billie Milam Weisman
Project liaison: Julianne Nelson
Editors: Karen Jacobson and Alison Pearlman
Design: Billie Milam Weisman with Mark Ong, Side By Side Studios

Printed in China by C & C Printing

Cover: Ed Ruscha: *Please...*, 1985;
Oil on canvas; 59¼ x 149⅝ in.

Library of Congress Cataloging-in-Publication Data

The eclectic eye : selections from the Frederick R. Weisman Art Foundation.—1st ed.
 p. cm.
 ISBN 0-9740908-0-8 (pbk. : alk. paper)
 1. Art, Modern—20th century—Catalogs. 2. Weisman, Frederick R., 1912-1994—Art collections—Catalogs. 3. Art—Private collections—California—Los Angeles—Catalogs. 4. Art—California—Los Angeles—Catalogs. 5. Frederick R. Weisman Foundation—Catalogs. I. Frederick R. Weisman Foundation.
 N6487.L67F744 2004
 708.194'94—dc22
 2004004917

Contents

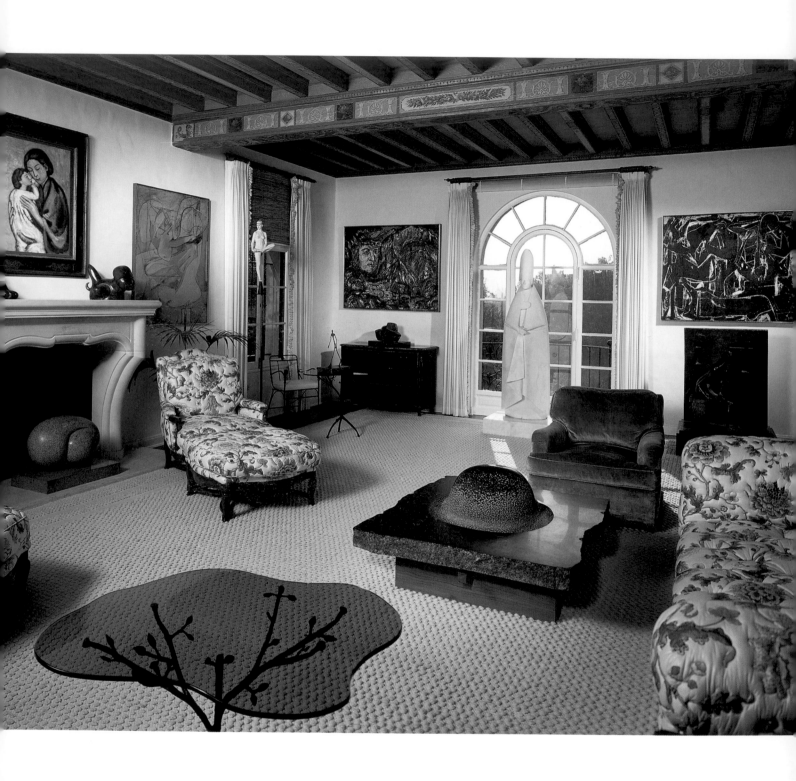

Foreword

Frederick R. Weisman was an adventurous collector who relied on his own judgment rather than the expert opinions and critical tendencies of the time. When I began to work with Fred in the mid-1980s, he was an intuitive collector who acquired what he liked—in abundance and without hesitation. From him I learned to trust my intuition in forming my own taste in art. He often said, gesturing to his heart, "If it hits me here, I will add it to the collection." Fred had equal enthusiasm for all the art in the collection, and when asked if he had a favorite work, he would invariably reply, "Do you have children. . .?" In other words, he loved them all, but each in a different way.

From the beginning, Fred wished to keep the entire collection on display at his Los Angeles estate, and felt that there was always room for more art—even if it meant shuttering windows and sealing doors or hanging works on the ceiling. Given this proliferation of art—together with his desire to give back through philanthropy—it was a natural decision for him to initiate an active exhibition program throughout the United States, Asia and Europe.

The Eclectic Eye: Selections from the Frederick R. Weisman Art Foundation honors his legacy by showcasing the diversity of the art in the lending collection of the Foundation. This publication documents the range of works available for loan and highlights key works in essays based on in-depth research and artist interviews. In 2004 a selection of works featured in *The Eclectic Eye* will travel to several venues, including the New Orleans Museum of Art, where a wing devoted to work by contemporary Louisiana artists is named for Frederick R. Weisman, and the Frederick R. Weisman Museum of Art at Pepperdine University.

The Eclectic Eye illustrates a range of works by American and European artists. Fred collected a majority of the featured works, including those by Willem de Kooning, Arshile Gorky, Roy Lichtenstein, Frank Stella, and Andy Warhol. Since his death in 1994, the Foundation has sought to extend his legacy and strengthen the scope of the collection by acquiring new works—including those by Anish Kapoor, Sol LeWitt, John McCracken, Tim Hawkinson, and Nam June Paik. In addition, the Foundation celebrates Fred's commitment to emerging artists with a selection of new and innovative work by younger artists such as Joel Morrison, Christopher Taggart, and Paolo Grassino.

I would like to thank everyone who made this project possible. Special thanks to Richard Koshalek for his eloquent preface and invaluable advice and to Dana Hutt for her editorial assistance. I am especially grateful to all those who were instrumental in creating this publication: writers Rosalind Bickel, David Rubin, and Kimberly Stämmer; editors Karen Jacobson and Alison Pearlman; designer Mark Ong; project liaison Julianne Nelson; registrar Mary-Ellen Powell; assistant registrar John Wagner; technical services consultant Sean Gray; and most of all, the Boards of Directors of the Frederick R. Weisman Philanthropic and Art Foundations.

Billie Milam Weisman

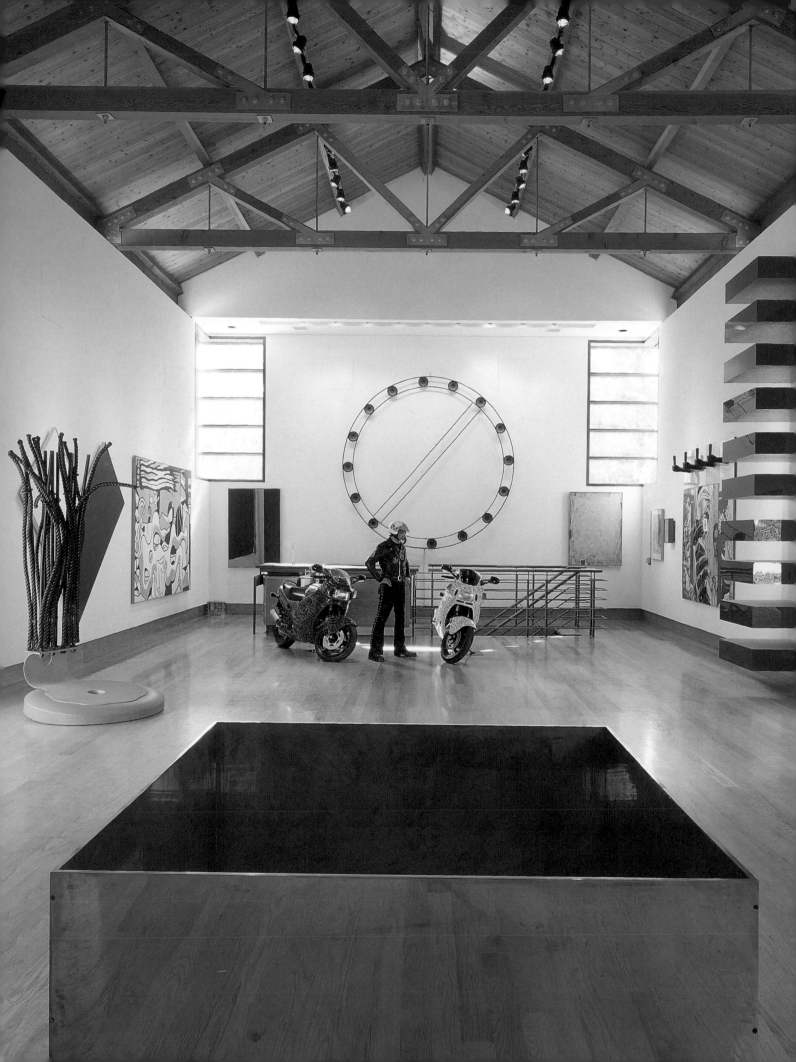

Preface

I don't think there is anything that communicates better than art—it is quicker than language and clearer than philosophy.

Frederick R. Weisman

The greatness of a city's art and culture can be measured in direct proportion to its community of artists, architects, designers, choreographers, composers, and musicians; to the strength of its arts and educational institutions, its museums, galleries, and schools; and, equally important, to the generosity, involvement, and courage of its patrons and collectors. Although frequently taken for granted, private collectors and art patrons are critical to the dynamic cultural life of the city. The dramatic evolution of Los Angeles into a major international art center over the past two decades, with a growing number of world-class artists and cultural and educational institutions, could have happened only with the tremendous support and leadership of these extraordinary patrons. Their role in the art community is immeasurable and essential, particularly as they encourage and cultivate the city's next generation of artists and creative individuals.

Frederick Weisman was a significant Los Angeles collector who became an art patron of distinction in the city and beyond. Through the Frederick R. Weisman Art Foundation, he transformed his innate love of art and art collecting into an important institution for the exhibition and sharing of modern and contemporary art. An enthusiastic and passionate collector, Fred strongly believed that an art collection should be "alive" and in a constant state of growth and change. In his own home he consistently moved works around to create ever-new juxtapositions and arrangements. (His advice to new collectors: "A collector cannot be a decorator. You have to feel it, you have to love it.") As he made few, if any, distinctions of rank among the works that he responded to—whether they were by masters or emerging artists—Fred was an important champion and patron of contemporary painting and sculpture, particularly by young, talented Southern California artists.

Continuing under the direction of his widow, art curator and conservator Billie Milam Weisman, the foundation is now entering a new phase with a bright future—one that will extend Fred's important legacy with new leadership and fresh initiatives to benefit future generations by cultivating creativity and original artistic thought.

Richard Koshalek

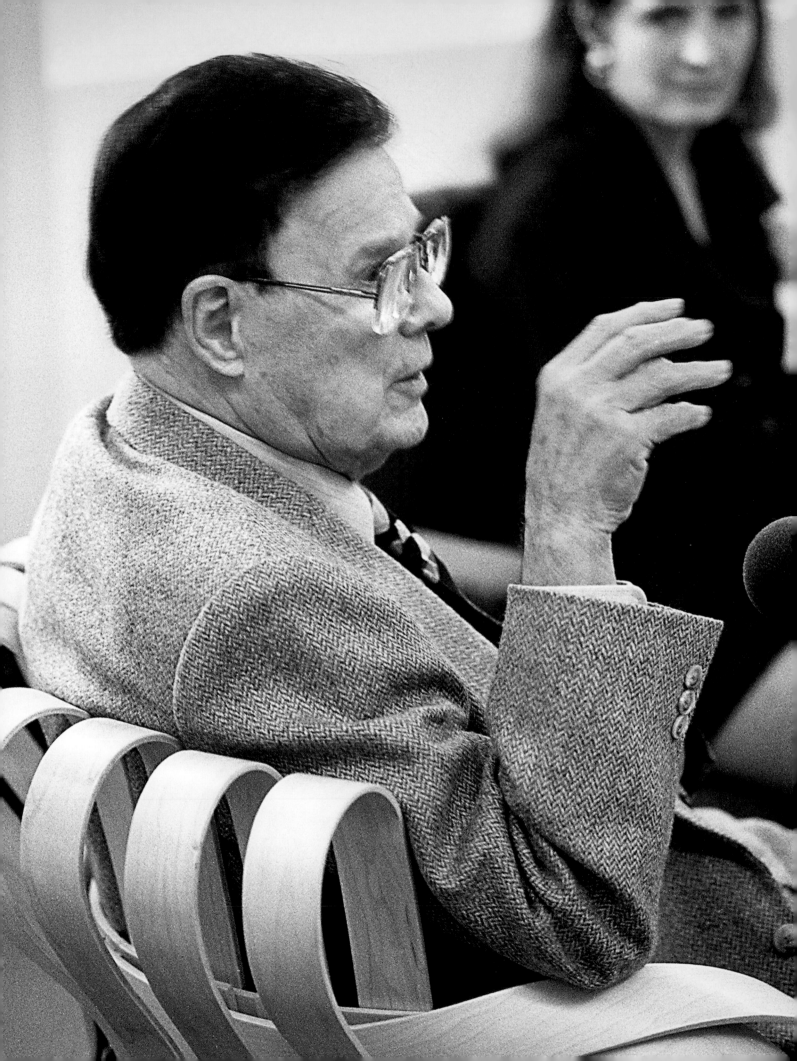

Frederick R.
Weisman

Frederick Rand Weisman was one of those rare individuals who made a contribution to the contemporary art world through a genuine respect for artists and a keen determination to give back to the cultural community. Weisman was the third of five sons born in Minneapolis to Russian immigrants who settled in Minnesota in the 1890s. His father, William, went into business for himself at the age of seventeen, later establishing successful businesses in a number of areas, including real estate, banking, and the fur industry. Like his father, Frederick Weisman would also become a very successful businessman.

Weisman launched his first entrepreneurial ventures in Los Angeles, the city where his family—his mother, Mary, and his brothers Theodore and Steven—had settled in 1918, while their father continued to travel between California and the Midwest. After graduating from Los Angeles High School, he attended classes at the University of Minnesota at Minneapolis; the University of Oregon, Eugene; and the University of California, Los Angeles, before his restless energy propelled him into the business world. He was soon recognized for his exceptional drive and flair for marketing and advertising. While working in the produce business in 1935, he met Myer Simon, the owner of Val Vita Food Products Company and a man whom Weisman admired greatly. He married Simon's daughter Marcia in 1938. At the age of thirty-one, Weisman became one of the youngest CEOs in America as president of Val Vita (which later merged with Hunt Foods) and played an instrumental role in the development of Hunt Foods into a nationally known brand. After resigning from Hunt in 1958, he went on to develop other businesses, most notably, Mid-Atlantic Toyota Distributors, which in 1970 was one of the first regional distributorships of Toyota automobiles in the United States.

In the 1950s Weisman and his wife, Marcia, began buying contemporary art for their home. Visiting galleries and attending museum exhibitions in Los Angeles and New York further cultivated this interest. Weisman soon merged their passion for art with his business savvy to accumulate what would become a remarkable blue-chip collection of masterworks of modern and contemporary American and European art. They worked closely with prominent New York dealer and collector Ben Heller, who brought an academic influence to the collection. During this time the couple acquired important Abstract Expressionist works by Willem de Kooning, Franz Kline, Clyfford Still, and Jackson Pollock, in addition to more "classic" modern works by Pablo Picasso, Paul Cézanne, Alberto Giacometti, Wassily Kandinsky, and Henry Moore, among others. Their collecting extended to Surrealism, contemporary works by Robert Rauschenberg and Jasper Johns, Post-Painterly Abstraction, Pop, and Photorealism. Unique for the range and breadth of its artistic holdings, the Weisman collection was recognized at the time as one of the most significant private collections of modern art in the United States. Part of their renowned collection—including works by de Kooning, Still, and Roy Lichtenstein—was set aside for their son Richard.

In addition to forming an acclaimed art collection, the Weismans were instrumental in elevating and establishing Los Angeles as an internationally renowned art community. As patrons and donors, the Weismans contributed generously to numerous Southern California artists, galleries, and cultural organizations. Both Frederick and Marcia Weisman helped to establish the Museum of Contemporary Art (MOCA), Los Angeles, and also began the prestigious art program at Cedars-Sinai Medical Center in Los Angeles. Frederick Weisman strongly championed the collecting of contemporary art while on the board of the Los Angeles County Museum of Art from 1985 to 1994.

In the 1970s Frederick and Marcia Weisman ended their marriage but amicably divided their art collection and remained close friends for the rest of their lives. While Frederick and Marcia each kept their original holdings from the years they were together substantially intact, Richard placed the works his parents had collected for him on the market in 1990.

Eventually, Frederick Weisman married Billie Milam, an established museum professional in the Los Angeles area. Milam brought an in-depth knowledge of art history and art conservation to the collection, which they continued to expand together during the mid-1980s and early 1990s. She also provided a new creative stimulus for Weisman and encouraged original projects including commissioning artists to paint his corporate jet, building a sculpture garden, and creating an annex for art designed by the Los Angeles architect Franklin D. Israel. The majority of the collection now on display at the Foundation in Los Angeles was acquired during this period.

Frederick Weisman enhanced the collection's underpinnings in modern and contemporary art and greatly increased the range of works by Surrealist, Pop, Photorealist, and California artists, particularly those who worked in the illusionistic style that Weisman favored. While on his extensive travels with Billie Milam, Frederick Weisman had a penchant for discovering talented artists and giving them exposure within their own communities. With exuberant enthusiasm he sought out the local art scene wherever he traveled, regularly purchasing art in the communities where his exhibitions were shown and often donating these works to museums in the area.

During the last two decades of his life, Weisman greatly expanded the purview of his art and architecture patronage and his commitment to making contemporary art accessible to the public. In the mid-1980s he purchased the estate in Los Angeles and soon thereafter opened the residence and its grounds for public tours. He believed very strongly that the art in a private collection should be shared with the public. Giving tours of the estate was a way to make art accessible, to foster interest and support for contemporary art, and to give the public an opportunity to experience art in an environment outside the museum—one that provided an example of what it was like to live with art in the late twentieth century. At this time Weisman established the Fredrick R. Weisman Art Foundation, a nonprofit organization dedicated to supporting the arts through grants, public exhibitions, tours, and

educational programs. In addition, he provided support to create two new venues for contemporary art in cities where he had important personal ties: the Frederick R. Weisman Art Museum at Pepperdine University in Malibu and the Frederick R. Weisman Art Museum, housed in the now-iconic Frank Gehry-designed building, completed in 1993, at the University of Minnesota in Minneapolis.

Frederick Weisman once said, "When you are as fortunate in business as I have been, you have a responsibility to share with others in a meaningful way." His wide range of successful business ventures enabled him to follow his philanthropic goals in the arts and social services. Individuals and institutions benefited greatly from his optimism and generosity. Directed by his Trust, the Frederick R. Weisman Philanthropic Foundation continues to support charitable institutions. After Frederick Weisman died in 1994, he left a majority of his estate to charities. His wife, Billie Milam Weisman, assumed the leadership of the Art Foundation and the Philanthropic Foundation, both of which she continues to direct. Today the Frederick R. Weisman Art Foundation is committed to honoring Weisman's brilliant vision by sustaining and expanding the programs he initiated.

Josef Albers

American, born Germany, 1888–1976

Homage to the Square: Upon Arrival, 1958
Oil on Masonite
32 x 32 in.

The exploration of abstraction and color was the lifelong preoccupation of Bauhaus master Josef Albers, who manifested his innovative praxis—the integration of theory and practice—through both his teaching and his art. Asserting a technological and empirical rigor in the study of color and design and an experimental attitude toward materials, he had an enormous impact not only on the Bauhaus school in Germany but also on postwar painting in the United States through his teaching at Black Mountain College from 1933 and at the Yale School of Art from 1950.

Albers's paintings, rendered with technical and painterly precision, demonstrate the extreme reduction of form to simple geometric elements and have been credited as a major influence on the movements of Geometric Abstraction and Minimalism. Not to be confused, however, with the hard-edged abstractions of artists such as Frank Stella—art that epitomizes Stella's epigram "What you see is what you see"—Albers's paintings instead evoke the notion that what you see and what you describe having seen may just as well be different. For integral to his work was his fascination with ambiguities of color and spatial perception, the perceptual "visual play" that is central to his most famous body of work, the series Homage to the Square.

From around 1950 until the end of his life, Albers created hundreds of Homage to the Square paintings, all based on an unvarying system of square proportions and a seemingly endless combination of colors and their illusory and unpredictable effects. In *Homage to the Square: Upon Arrival,* a black square is surrounded by concentric bands in closely related shades of red. Here, as in other works in the series, color values subtly shift depending on adjacent hues, while the forms themselves appear to advance and recede as plane and space are reciprocally perceived.

Despite the extensive number of these structural and perceptual constellations, their variety and individual optical possibilities render each a unique creation. Moreover, while prefiguring Minimalist aesthetics and Op Art, Albers's Homage to the Square paintings most poignantly portray his belief that art begins in the "discrepancy between physical fact and psychic effect"—that is, in his art, between a static mathematical absolute, the square, and the extraordinary multiplicity and variety of color and its perceptual effects.[1] *K. M. S.*

Notes
1. Albers, in Ingo F. Walther, ed., *Art of the Twentieth Century* (Cologne: Taschen, 1988), 180.

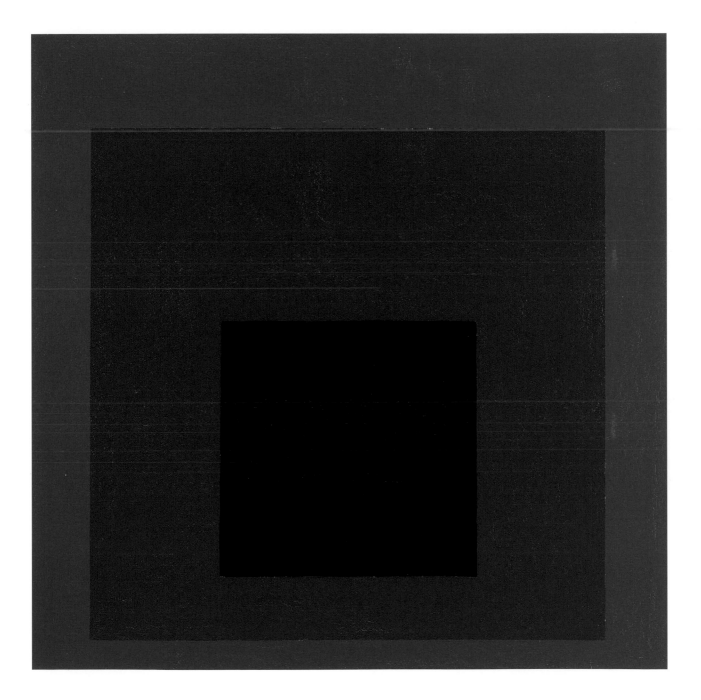

Lita
Albuquerque
American, born 1946

Elle et lui, 1982–84
Mixed media on board
Three panels, 84 x 123 x 5 in. overall

Since the mid-1970s Lita Albuquerque has based her art on a spiritual belief system. Working in many mediums—including painting, sculpture, and indoor and outdoor installation—Albuquerque explores a philosophy that mixes mind and matter, spirit and nature. She believes that the spiritual fulfillment of the human race can be realized once we connect with our primal origins in the earth, stars, planets, and unknown universes. Her works usually have inventive formats that recall traditional religious altars. They also contain luminous materials, such as raw pigments and gold or copper leaf, because these yield a visual splendor that she associates with the spiritual sublime and at the same time are raw elements from the earth's surface.

Albuquerque's holistic approach to spirituality was shaped by various early influences. She spent her childhood as a boarder in a Tunisian Catholic convent. As a teenager, she traveled throughout Europe and learned about religious symbolism in old master art. In the 1970s she earned a degree in art history, studied phenomenological psychology and Zen Buddhism, and became interested in the writings of the psychologist Carl Gustav Jung and the poet Rainer Maria Rilke. Albuquerque was especially intrigued by Jung's concept of universal religious archetypes and by his model of a self that contains both masculine and feminine aspects.

Many of these influences are evident in *Elle et lui,* whose title translates as "she and him." Recalling the triptych format of traditional Christian altars, the work employs a tripartite arrangement in both its overall structure—a central panel flanked by two smaller elements—and its internal imagery—a rock fragment with a symbolic male and female figure to either side. Albuquerque imbued the work with many layers of symbolism. The figures' connection to the earth is suggested by the presence of the rock between them and by the framing device of copper leaf, symbolizing the reflectivity of the earth's surface. The figures are aligned with the solar system and are drawn to resemble constellations. Finally, the serpentine forms at the sides are Jungian archetypes, reminders of humankind's common past. *D. S. R.*

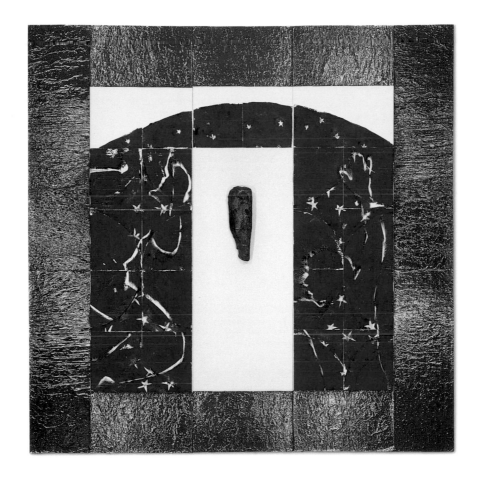

Peter Alexander

American, born 1939

Catalina Series #22: Disco Doris, 1984
Acrylic and fabric collage on velvet
47½ x 52¾ in.

One of the pioneering Southern California Light and Space artists, Peter Alexander has devoted more than thirty years to making sculptures and paintings that examine the properties of light. He graduated from the University of California, Los Angeles, in the mid-1960s, a time when Southern California artists such as Craig Kauffman and Larry Bell were being heralded for their Minimalist paintings and sculptures that emphasized and played with natural light. Alexander's earliest sculptures were similar to those of Bell in that they were simple, industrially fabricated cubes. For this body of work, Alexander used polyester resin, a material that is transparent as well as reflective. Viewers could see through each sculpture, perceiving the space within and around it; they could also observe various colors of the spectrum as light interacted with the planar surfaces of the work.

By the early 1980s Minimalist attitudes had waned and were superseded by a preference for expressionist styles with figurative references. Alexander responded to this trend without sacrificing his commitment to investigating attributes of light. He developed a unique and unprecedented series of collage paintings on black velvet, a material that had hitherto been associated with unsophisticated, amateurish paintings found at Mexican flea markets. The series was inspired by his memories of a boating trip during which a fisherman illuminated the dark waters with a powerful light, and the artist witnessed the dazzling phosphorescence of swarming sea creatures. For *Catalina Series #22: Disco Doris,* Alexander used the black velvet as if it were canvas and covered it with acrylic paint sprayed from a can, fabric cutouts, and sprinkled-on glitter to simulate the luminous effects of aquatic life swimming through the depths of the ocean in the middle of the night. *D. S. R.*

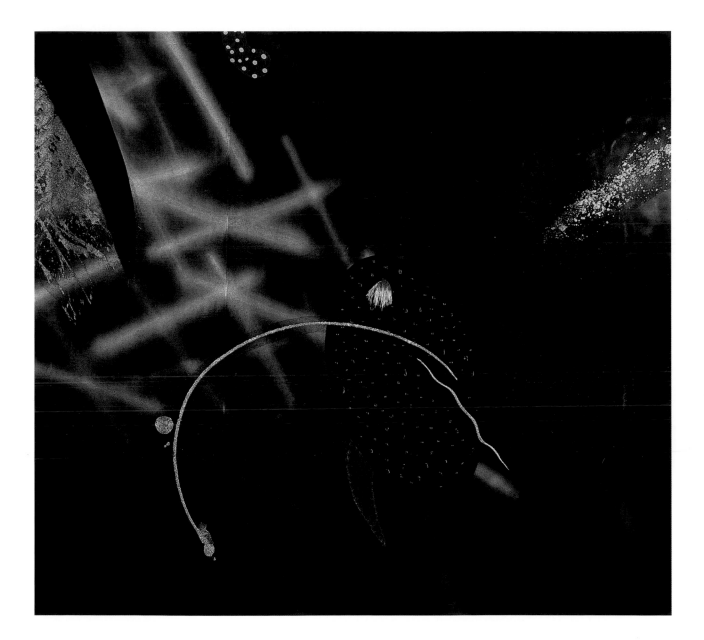

David
Amico
American, born 1951

Industrial Strength, 2001
Oil, acrylic, and Conté crayon on canvas
96 x 72 in.

David Amico's paintings explore the interplay between the stasis and structure of mechanical, industrial, and technological realms and the dynamic life of forms—the expressive gesture, the human impulse traversing the urban terrain. Since the late 1970s Amico has worked through varied approaches to achieve his characteristic expression, which he refers to as a type of urban-eclectic collage, whether or not there are actual collaged components. Employing graphic symbols, letters, graffiti scrawls, and forms referencing or taken directly from machine technology, Amico derives his source material from the environments that have inspired his work, including New York City and downtown Los Angeles.[1]

Integrating representation and abstraction, Amico's paintings often grow out of an intangible sensation he has experienced, which he "pieces together" by collecting elements that have triggered or somehow relate to that ineffable state. According to the artist, his sources are often found through the "wonderful abandonment" of "things encountered in non-encountered sites"—random items one might find, for instance, on the ground at the end of a forgotten alleyway or behind an abandoned building. Although he often incorporates the found object or its shape into his work, it is less the object itself than its "recovered social life" that interests him.

Just as associative impressions often mark an initiatory phase in Amico's work, so too are they involved in its completion. The artist titles his paintings based on his subjective response to the finished work. The title *Industrial Strength,* for Amico, most immediately refers to the intensity of the painting's turquoise—a blue that certainly seems manufactured, the color of "industrial-strength" liquid agents, color one can almost smell.

Standing in contrast to the hard-edged geometric forms drawn and collaged across the work is a piece of gracefully unraveling wire (or rather the *image* of a piece of wire) that bisects the canvas. The lyrical, almost organic quality of its tenuous lines evokes a sense of fragility in the midst of "structure" and "industry." There is also an energy, a potentiality, to its bare centrality in the piece and to its dynamism amid the surrounding stasis.

Perhaps an imperfection by industry standards, the wire's frayed quality imparts an allusive value, a certain expressiveness, to it. The fray also relates to its status as a "stray object" that is discovered and "re-placed" by the hand of the artist. Speaking to the artist's relationship to his work, the imperfection marks not only the wire but the artist's gesture and the artwork as well. According to Amico, there is a fallibility in art because it is a distinctly human endeavor, and this gives the work a certain genuineness. In his words, this human imprint is "what I'm still holding onto." *K. M. S.*

Notes
1. All quotations are from the author's interview with David Amico, August 2002, which also provided much of the background information presented here.

Doug
Argue
American, born 1962

Untitled, 2001
Watercolor on paper
80 x 98 in.

In Doug Argue's deceptively straightforward paintings, the recognition of a familiar object soon leads to a more subtle and complex experience of space, dimension, and illusion. Argue uses what he calls "friendly" subject matter to give his paintings a sense of personality and poetry, which makes them more accessible, but the technical study of space and the construction of representation interest him more than symbolism or allegory. He has noted that his primary goal as a painter is to explore "how to use space in an effective and unusual way," and he does so through very traditional methods of painting. The Minnesota-born Argue in fact looks to Renaissance sources such as Tintoretto for examples of spatial dynamics, and he has devoted several series of works to the study of perspective and the relationship between "finite and infinite space."[1]

Since 2001 Argue has explored a wide range of optic, painterly, and spatial relations through a very simple format: an object—most often a tire or group of tires, but sometimes a chicken or a book—is suspended within a painted background. This pared-down format sets up a series of oppositions between figure and ground, representation and abstraction, and plane and volume. Argue typically renders his backgrounds as abstract, sometimes painterly patterns to maximize the contrast between the volumetric object and the two-dimensional depiction of the space it inhabits.

Throughout the tire paintings, he explores the difficulty of representing a three-dimensional hole against a flatly rendered backdrop. In this work, he places the tires so that the three-dimensionality of the hole is hidden but then redefines it by threading a wire through the inner tunnel created by the tires. He thus suggests the depth otherwise occluded by the position of the tires and the flat background. Argue has suggested that the tire paintings are influenced in part by Georgia O'Keeffe's paintings of bones, which similarly encircle and define a volumetric hole. *R. B.*

Notes
1. Doug Argue, conversation with the author, May 22, 2002.

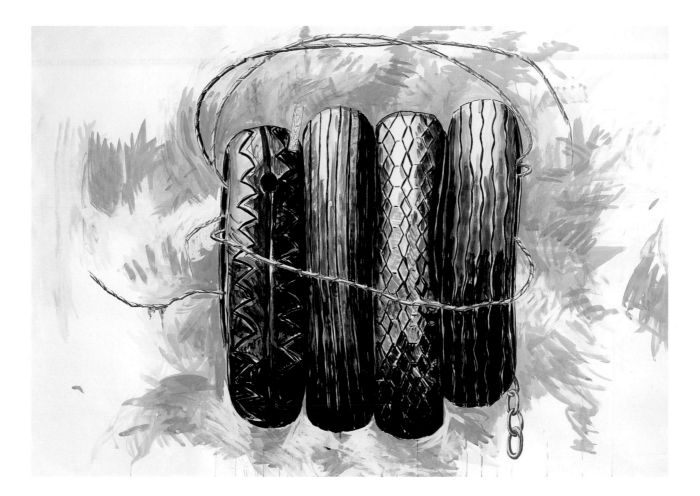

Arman

American, born France 1928

Football Shoes, 1971
Accumulation of sliced football shoes embedded
in polyester
42 x 42 x 4½ in.

By 1920 the art world had been revolutionized by Marcel Duchamp's everyday found objects, or "readymades." Placed in the museum or gallery context, these common objects—a shovel, a wheel, or a porcelain urinal, for example—served to overturn traditional notions of value, calling into question the idea of the artwork as a precious object "created" by an artist. Ironically, the selling of basic commodities as "art" highlighted the nature of the autonomous art object as a commodity. In Paris some thirty-five years later, the Nice-born Arman was among the avant-garde artists who explicitly took up the everyday object in the spirit of Duchamp, offering a radical new interpretation of the readymade.

From 1959 onward, Arman's work involved the collecting of large quantities of objects such as plates, shoes, musical instruments, dolls, jugs, or wheels, which were presented in fragmented or recombined form. His object assemblages, or "accumulations," as he called them, served to reflect on a consumer- and commodity-driven throwaway society, commenting on how we live and document our lives. "It has always been obvious," Arman explained, "that society feeds its sense of security with a packrat instinct demonstrated in its window displays, its assembly lines, its garbage piles."[1]

Football Shoes is an accumulation of approximately forty mass-produced football cleats. Arman carefully sliced each shoe in half and embedded it in polyester. Although the copious collection of almost identical cleats in *Football Shoes* was obviously deliberate, Arman's arrangement of objects was often random and led to uniquely eloquent designs. In this work the rhythm of black triangular shapes is highlighted by the movement of red lines from the bottoms of the shoes. Arman has made other accumulations of shoes, including *Madison Avenue* (1962), made of women's pumps, and *New York Marathon* (1978), made of basketball shoes. His selection of objects often has political, personal, or social meaning, and the shoe in particular is often a markedly social identifier in everyday life.

The "sociology of the object" that informed Arman's art was an integral aspect of the Nouveau Réalisme movement. Participants in this movement—including Christo, Yves Klein, Niki de Saint Phalle, Daniel Spoerri, and Jean Tinguely, as well as Arman—sought novel approaches to the perception of the real, attempting to create through the found object and its "assemblages" a more genuine link between art and life. *K. M. S.*

Notes
1. Arman, in Ingo F. Walther, ed., *Art of the Twentieth Century* (Cologne and New York: Taschen, 1998), 518.

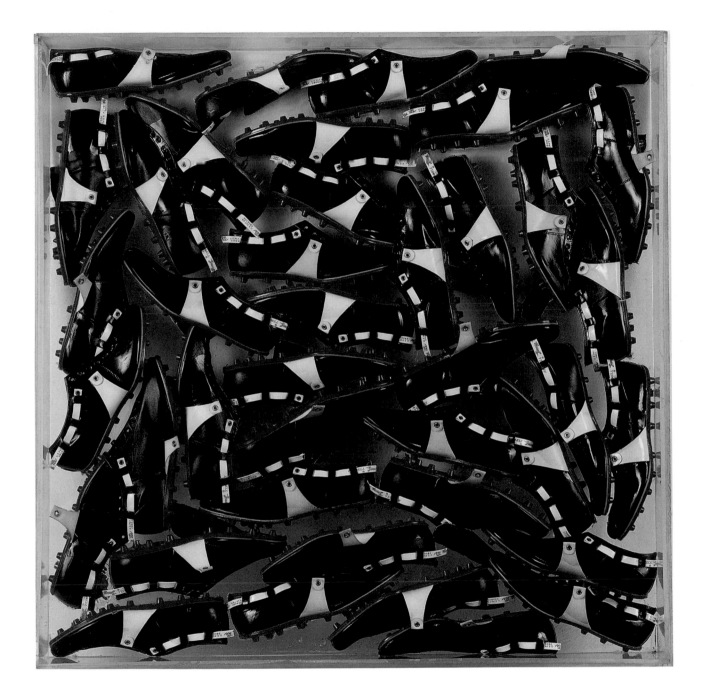

Robert
Arneson
American, 1932–1992

Rose Plate, 1966
Glazed ceramic
19 (diam.) x 6 in.

Robert Arneson is associated with a group of San Francisco Bay Area artists who pioneered a style of art known as Funk. Characteristically, Funk was an attempt to push the boundaries of acceptable taste and to expose lingering aspects of conservatism and elitism within contemporary art. Funk engaged in a dialogue with some of the most basic assumptions about artistic materials, content, and aesthetic categories in an often bitingly satirical manner. The mixed aspects of humor, rebellious irony, and impassioned search for authentic modes of expression typify the work of Arneson, a potter turned Funk artist who once proclaimed the toilet the "ultimate ceramics in Western culture."[1]

Arneson was classically trained in pottery techniques. It wasn't until he encountered the work of Los Angeles–based artist Peter Voulkos, who had revolutionized pottery by treating it essentially like abstract painting, that he first began to think about using pottery for something more than mere "craft." His interest in investigating the border between craft and fine art, kitsch and beauty, the vulgar and the sublime, is evident throughout his prolific body of work. One of his earliest and most shocking explorations of this border was his infamous *John with Art* from 1964, a ceramic toilet covered with Abstract Expressionist painting and, among other things, scatological jokes. This piece was quintessentially Funk in its reference to taboo bodily functions and in its attempt to shatter any notion of "preciousness," as Arneson termed it, in content or materials.

Rose Plate, made a few years after Arneson's groundbreaking "john" pieces, reflects a more subtle assault on aesthetic boundaries while still typifying Funk. Roses are commonly painted on china as decorative motifs. Here, however, the rose has been magnified to the point of overwhelming the plate and rendering its utilitarian function obsolete. Arneson displayed a virtuoso technique in creating the three-dimensional rose in ceramic, thus calling into question the stereotypically kitsch or craft associations of the art of china painting. Further, he added a distinctive Funk meaning to the opened, almost fleshlike rose by emphasizing its resemblance to female genitalia. The benign rose on the plate suddenly becomes charged with a highly sexual meaning, thereby subverting its common "innocent" interpretation. *R. B.*

Notes
1. Robert Arneson, transcript of a tape-recorded conversation with Maddie Jones, 1978, Archives of American Art, unpaginated; cited in Jonathan Fineberg, *Art since 1940: Strategies of Being* (New York: Harry N. Abrams, 1995), 288.

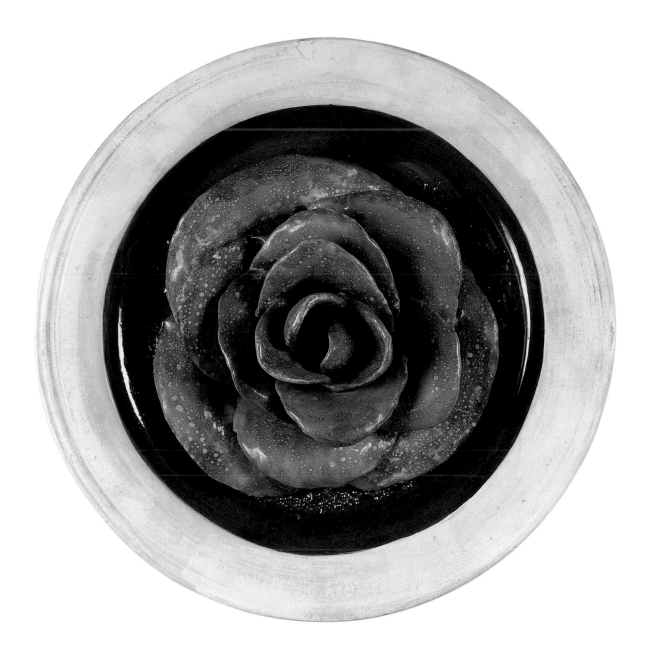

Impound, 1985
Acrylic and branches on plywood
Four panels, 92 x 154 x 11 in. overall

American Standard, 1975
Painted wood construction
20 x 20½ x 2 in.

Los Angeles artist Charles Arnoldi first came to prominence in the early 1970s with a series of twig paintings and sculptures, flat designs made from actual tree branches arranged to echo the expressive lines of modern drawing. *American Standard* is one of the earliest examples of these works. This eclectic and inventive approach was initially aligned with 1970s Conceptualism, which proclaimed traditional painting methods obsolete. Through his use of natural objects as art materials, Arnoldi made a "conceptualist" gesture while paying homage to the intrinsic beauty of natural forms.

The later work *Impound* was inspired by the eruption of the Mount Saint Helens volcano in 1980. It presents a bifurcated "panel" in which a painted relief created by a chainsaw on the left is juxtaposed with an arrangement of real twigs on top of the wood panel on the right. Arnoldi used this juxtaposition to compare and contrast nature and art, the real and the representational, sculpture and painting. The supposedly "flat" painting on the left was gouged into with a chainsaw, creating actual holes in the wooden panel. The painting is thus treated like three-dimensional sculpture, while, conversely, on the other side, actual twigs piled up in three dimensions start to look like an abstract painting or drawing. Painting dissolves into sculpture and sculpture into painting. Three dimensions become two, and two become three.

Through the title *Impound,* Arnoldi added another contrast to the series of dichotomies presented in this work, this time between the verbal and the visual. Although the painting displays and references the huge release of energy through a volcanic eruption, the word *impound* means exactly the opposite, to shut up or confine. *R. B.*

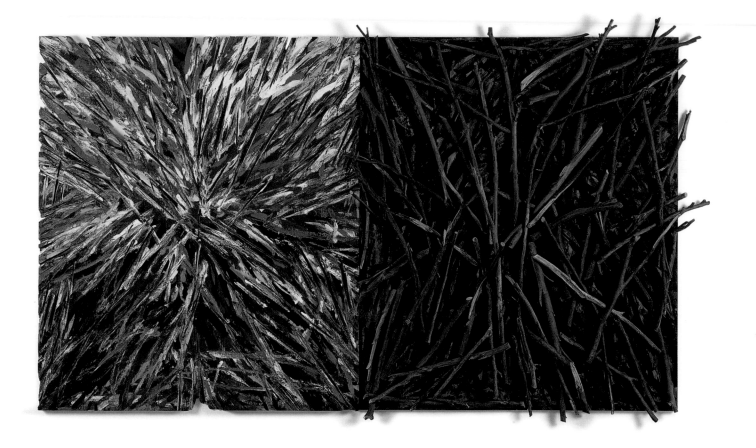

Richard Artschwager
American, born 1923

Exclamation Point, 1997
Green plastic bristles and wood
Two parts, 70 x 21 (diam.) in. overall

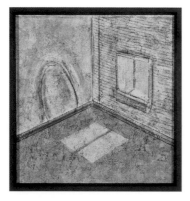

Chair and Window, 1983
Acrylic on Celotex
53¾ x 51½ in.

Confounding the boundaries of Pop, Minimal, and Conceptual Art, Richard Artschwager has consistently formulated iconic interactions between the functional, everyday object and the work of art since he began creating art in the early 1960s. Although he studied science at Cornell University, his artistic inclination and affinity for the well-crafted object led him to study art in 1949–50 and then to pursue a career as a custom furniture designer and manufacturer in the 1950s. Eventually sculpture and painting became his professional focus, but his early endeavors in furniture design and construction have continued to influence his work, with many of his sculptures ironically paraphrasing the shapes, textures, and materials of furniture and other interior structures (for example, his *Chair and Window* from 1983 in the Weisman collection).

Artschwager adopted everyday objects as the formal basis for his sculptures, an approach that he shared with his Pop contemporaries of the 1960s and 1970s. He was likewise aligned with Minimalism because of his characteristic use of industrial materials, including Formica, Celotex, latex, wood veneers, patterned melamine, and hardboard. His cerebral approach set him outside the parameters of these movements, however, and a playful conceptual bent has informed his work throughout his career.

Works such as *Door* (1990) demonstrate Artschwager's intentional emphasis on artifice and artificiality in both the material and aesthetic realms, while underscoring the often ambivalent relationship between object and art, and art and life. Made of wood-grain-patterned Formica that uncannily resembles actual wood, the life-size sculpture looks like a "real" door. (Is *Door* art because it's artifice? Can't an actual door be made of Formica? In a Duchampian vein, wouldn't an object, a real wood door, when placed in a gallery be an object of art?)

Artschwager's characteristic conceptual mode is similarly epitomized by his elegant interpretations of punctuation marks, a project that he began in 1966. An artificial construct that abets communication, punctuation is an integral yet overlooked facet of written language. To the reader, punctuation marks are usually a seamless part of textual communication; rarely does a mark stand alone. By literally objectifying punctuation marks as large sculptural works, especially the emotively connotative exclamation point—the "prince of punctuation," in Artschwager's words—the artist has aimed to "inflect objects and spaces the way real punctuation inflects the objects and spaces of the written language."[1] *K. M. S.*

Notes
1. Richard Artschwager, interviewed by Brooke Alexander, in *Richard Artschwager: Complete Multiples* (New York: Brooke Alexander Editions, 1991), unpaginated.

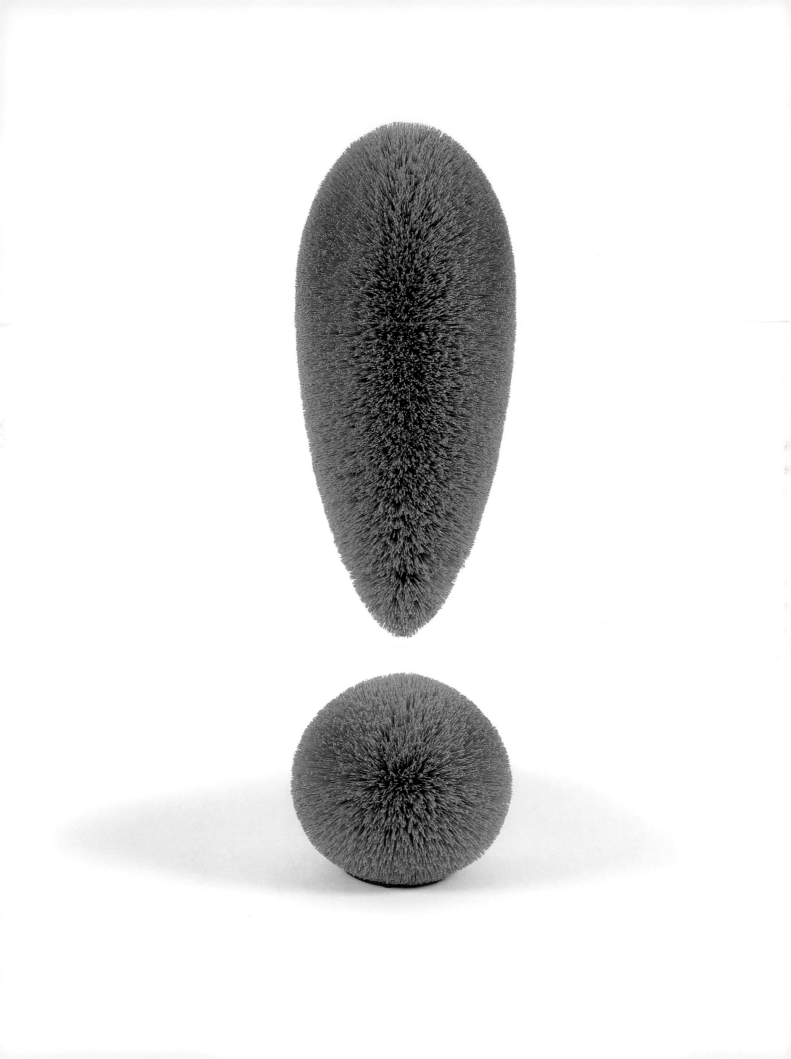

John Baldessari

American, born 1931

Horizontal Men, 1984
Gelatin silver prints on board
97¼ x 47⅝ in.

One of the pioneers of Conceptualism, John Baldessari has had an enormous influence on the development of contemporary art. While he was a teacher at the California Institute of the Arts, he proposed a theory of art that eschewed traditional concerns with personal expression, composition, and aesthetics and concentrated instead on processes of communication normally the purview of such fields as semiotics and linguistics. Baldessari made little distinction between his teaching and his art; both were aimed at opening awareness, impacting thought, and encouraging a new understanding of the relation between words and images, signs and things. In his art he has pursued these interests through his trademark technique of appropriating banal images from popular media and juxtaposing them in unforeseen ways. A surrealistic displacement of the ordinary is combined with a rigorous theoretical investigation of how the meaning of imagery is constructed.

In *Horizontal Men* Baldessari has taken several images appropriated from popular media sources and placed them in unexpected relationships so that they become defamiliarized. Each photo depicts a single man who seems to be part of a story: someone walking in the street, a dead German soldier, a sleeping trapper, a movie cowboy. The unique identity and narrative context of each figure are, however, less important than the visual pattern the images collectively make. The human figures in the photos are treated as structural elements in a visual poem that plays on symmetry and horizontality, mirroring the abstract style of Minimalism. Yet the formal is not allowed to dominate completely; each figure retains some sense of individual meaning, an enigmatic identity and history. This tension between formal structure and narrative content is a hallmark of Baldessari's work. *R. B.*

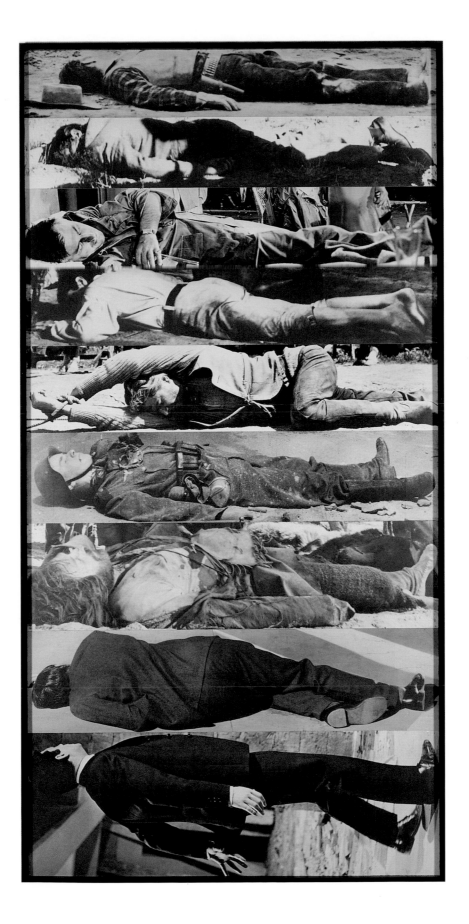

William
Baziotes

American, 1912–1963

Two Heads, c. 1948
Oil on canvas
42 x 36½ in.

William Baziotes was an important figure in the early development of the New York school of Abstract Expressionism. Like Arshile Gorky, he has been credited with forging a link between the formal sophistication of Cubism and the psychological symbolism of Surrealism, although in a very different way. Where Gorky put forth an active and dynamic approach to painting that greatly influenced Jackson Pollock and Willem de Kooning, Baziotes created a quiet, lush surface that was more important for the color-field branch of Abstract Expressionism. His canvases depict simple, striking, enigmatic figures within an extremely sensuous, brilliantly colored surface that anticipates the chromatic intensity of Mark Rothko's paintings. Frantic energy is replaced by a controlled plunge into the "primitive" realm of the unconscious through color and biomorphic forms.

Baziotes was deeply influenced by Surrealism. Together with Pollock and Robert Motherwell, he learned the technique of automatism and practiced automatic drawing with the Chilean Surrealist Roberto Matta Echaurren in the early 1940s. Automatism was a Surrealist creative technique modeled after the psychoanalytic practice of free association: by relaxing the conscious mind and letting all ideas and images emerge in an uninterrupted flow, without censorship, the realm of the unconscious could be accessed. Baziotes became very adept at the practice of automatic drawing; it was how he found his primary symbolic forms and how he began every painting. He referred to the images that emerged in this way as "phantoms."

In both content and form, *Two Heads* exemplifies the principal elements of Baziotes's paintings. The split, bifurcated head is an emblem of duality, of two things existing as one, of the doubled or dual nature of all thoughts and images from the unconscious. Baziotes often expressed an interest in bivalent meaning, the "mixture of beauty and horror" that characterizes certain dream states or certain paintings. His doubled head also blends animal (perhaps birdlike) and human forms, emphasizing the twofold nature of the human as both man and animal. This elusive yet primally suggestive symbol is rendered in the simple, controlled shapes, exquisite color, and uniquely "alive" painted surface for which Baziotes became greatly admired. He likened his liquid, undulating fields of color to the "flesh of a woman." At the same time, Baziotes stayed rigorously devoted to Cubist pictorial flatness, wishing to allude to a mysterious psychological realm not through illusion, but directly through the impact of color, form, shape, and texture. *R. B.*

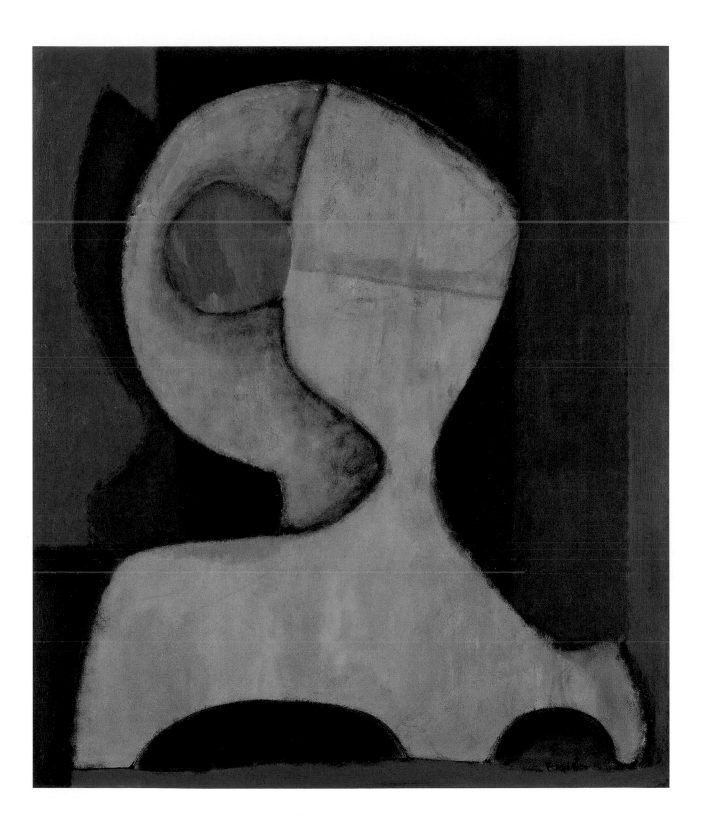

Larry Bell

American, born 1939

DB5 1981 Corner Lamp, 1981
Glass and light installation
36 x 36 in.

From his early glass installation panels and cubes to his Vapor Drawings, Mirage Paintings, and Fractions, Larry Bell's work has arisen from innovative and synergistic combinations of light and unconventional surfaces, materials, and methods. His refined elaboration of light, glass, and space linked him in the 1960s to both Minimalism and the California Light and Space movement, while his late-industrial processes and lush surfaces tied him to the Los Angeles Finish Fetish movement. Maintaining a "Perceptual Art" tendency throughout his oeuvre, Bell has pursued a complex, formalistic inquiry into the nature of visual experience.

Bell's Perceptual works of the 1960s and 1970s included large panels and cubes of etched and mirrored glass, eloquent room-installation works that engaged viewers' optical sensations of space, surface, and light. Bell plated the glass through chemical vapor deposition, a technique that led to his unprecedented Vapor Drawings, begun in 1978. These alchemically ingenious works mark his invention of a technique of using paper with high-vacuum deposition to achieve extraordinary effects of shifting, luminous color. He would place the paper in a chamber of filaments coated with aluminum and silicon monoxide; the air would then be removed, creating a vacuum, and the filaments heated. Vaporizing off the filaments, the molecules would collide with the paper in microscopically thin layers.[1]

The incandescent, metallic effects Bell has achieved in his Vapor Drawings result from sheer veneers of aluminum and silicon monoxide molecules "interfering" with light—reflecting or absorbing it—at certain wavelengths. Bell used a similar technique in his series of approximately twenty Corner Lamps produced between 1980 and 1982. In *DB5 1981 Corner Lamp,* he plated both sides of the glass, producing an exquisite spectrum of evanescent color on the lamp's surface. Projected light from a ceiling-mounted lamp streams onto the double-beveled edge of the glass (hence "DB," for double-beveled, in the title), effecting refraction and a prismatic play of colored light.

In later Mirage works, Bell formulated an almost improvisational and painterly collage technique that markedly differs from his other approaches. Elaborate arrangements of thin, often crumpled pieces of material—including rice paper, cellophane, Mylar, transparent laminating films, and paper with brush strokes—previously coated in the vacuum chamber, are fused with a mounting press onto a support such as canvas, denim, or handmade paper. Beneath a smooth layer of laminate, luminous hues and an illusion of dimensionality are variously perceived, invoking Bell's signature interplay of surface, light, and perception. K. M. S.

Notes
1. The technical information presented throughout this entry is drawn from the author's interview with Larry Bell.

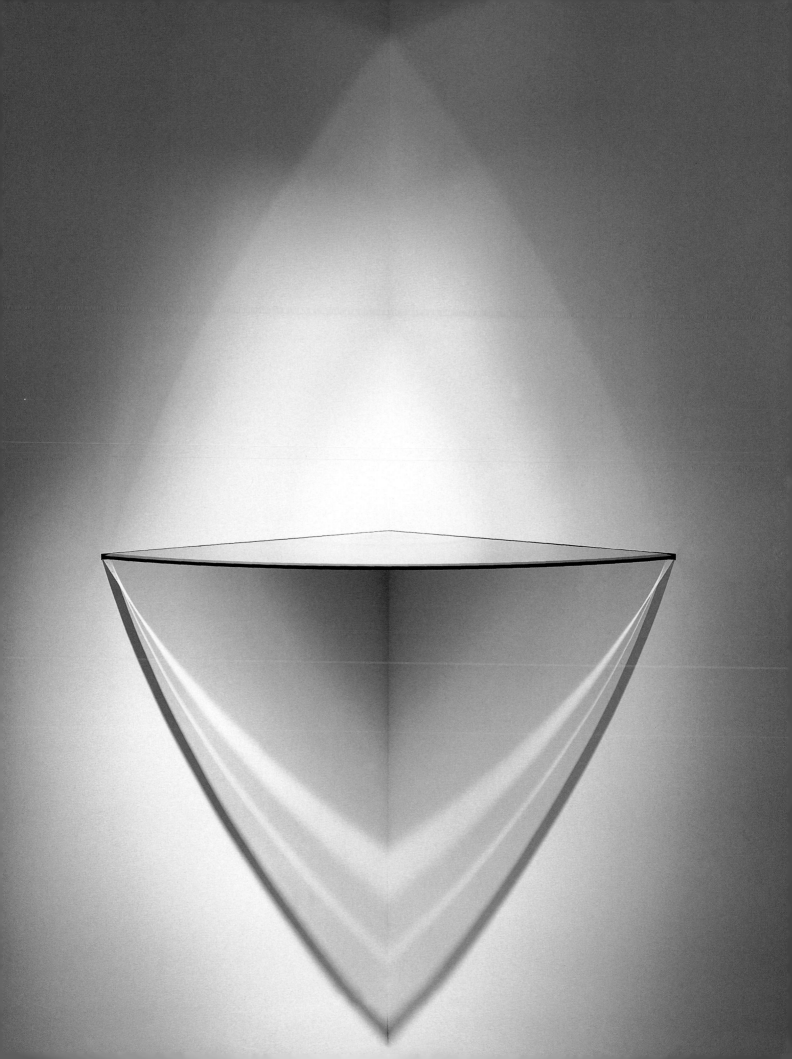

Tony
Berlant
American, born 1941

Has No Name, 1985
Metal collage on wood with tramp art frame
31 x 23½ x 3 in.

Los Angeles artist Tony Berlant is best known for the distinctive riveted surfaces of his colorful tin collage-paintings. His works in part reflect his artistic origins in the Los Angeles art scene of the 1960s, when many emerging artists sought new methods for creating slick, seductive surfaces. Berlant's smooth, shiny, all-metal objects invite comparison with the contemporaneous works of the Finish Fetish movement and the streamlined constructions of Light and Space artists, while his collage technique recalls the assemblage emphasis of Bay Area artists. Dazzling color, exacting forms, and hard, shiny materials such as glass and metal announce a distinctly Californian look.

Berlant's specific method of tin collage, however, put a different spin on the "L.A. look." Instead of expensive and technologically advanced materials and processes, he created his works entirely from discarded metallic objects such as candy and cookie tins, TV trays, wastebaskets, and old signs. Using the simplest and humblest of materials, cast-offs from the commercial world, his works reject an obsessive concern with technological advancement. Like many assemblage artists, Berlant pointedly recycled these found objects into artistic creations that echoed the most "sophisticated" aesthetic of the time. Likewise, his painstaking method of cutting, pasting, and riveting the pieces of tin scrap metal back together invokes not industrial methods, but rather an old-fashioned process of sewing by hand. Berlant's tin paintings are tapestries woven from the detritus of modern civilization.

It is particularly appropriate, therefore, that the work *Has No Name* incorporates into its construction a kind of folk art known as tramp art. The frame surrounding this piece is a typical example of this woodworking style popular at the turn of the century that used recycled wood from old cigar boxes and packing crates. Associated with hobos, wanderers, and amateur artists, it epitomizes the improvisational, humble, and eclectic spirit of Berlant's work. *R. B.*

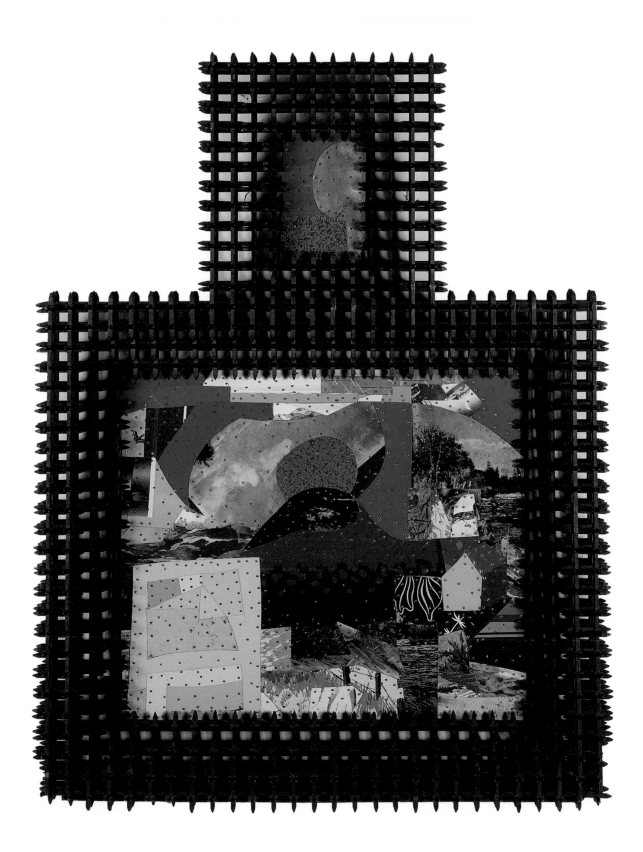

Los Carpinteros

Alexandre Arrechea: Cuban, born 1970
Marco Castillo: Cuban, born 1971
Dagoberto Rodríguez: Cuban, born 1969

Bloque suspendido, 2000
Watercolor on paper
40½ x 29½ in.

Alexandre Arrechea, Marco Castillo, and Dagoberto Rodríguez are the innovative Cuban artists who form the group Los Carpinteros. The trio began making art together in 1991, and it was through their early, carefully hand-tooled woodworks, such as miniature furniture and mementos, that the group earned its name, which translates as "the carpenters."[1] Los Carpinteros's work also includes elaborate drawings, watercolor paintings, sculptures, and large-scale installation works. Their watercolor sketches, such as *Bloque suspendido,* are an integral component of the group's working method. These watercolors do not always lead to sculptures or installations, but they hold primary significance, according to the artists, as "correspondences" or "discussions" among themselves.[2]

Although *Bloque suspendido* neither led directly to other works nor was part of a formal series, the watercolor sketch represents a subject and a theme that pervade Los Carpinteros's work. The group has created several paintings, sculptures, and installation pieces that depict building materials, including bricks or cinderblocks, such as those being hoisted or suspended in this work. The theme of building, creating, and the labor involved—signified in *Bloque suspendido* by the lifting or suspending of blocks, a construction "in process"—is an integral facet of the group's art. As Marco Castillo once explained, "To speak of a carpenter is to speak of the way something is made."[3]

Los Carpinteros's art reflects a culture without abundant resources, where old things often need fixing and found materials are recycled. Remnants and fragments of items from daily life are frequently incorporated into their sculptures, which transcend geographical and temporal bounds, alluding to any culture in which scarcity breeds ingenuity and recycling implies the creative reuse of materials. The group eloquently conveyed the notion of adaptation in the face of impermanence in its large-scale traveling installation *Transportable City* (2000–2001). The installation was composed of ten tents made of nylon and aluminum tubing in the form of iconic buildings—including a domed capitol, church, factory, hospital, and university—which were designed to be dismantled, folded up, and transported.

The labor implied in Los Carpinteros's collective name and in works such as *Bloque suspendido* and *Transportable City* includes building and creating, fixing and repairing. These notions convey not only the group's role as artistic inventors and craftsmen but also the productive activities of those who, facing the hardships of existence, prevail through creative ingenuity. *K. M. S.*

Notes
1. Alexandre Arrechea left Los Carpinteros in July 2003 to work independently.
2. Los Carpinteros, in Rosa Lowinger, "The Artist as Protagonist: An Interview with Los Carpinteros," *Sculpture* 18 (December 1999): 31.
3. Marco Castillo, ibid., 25.

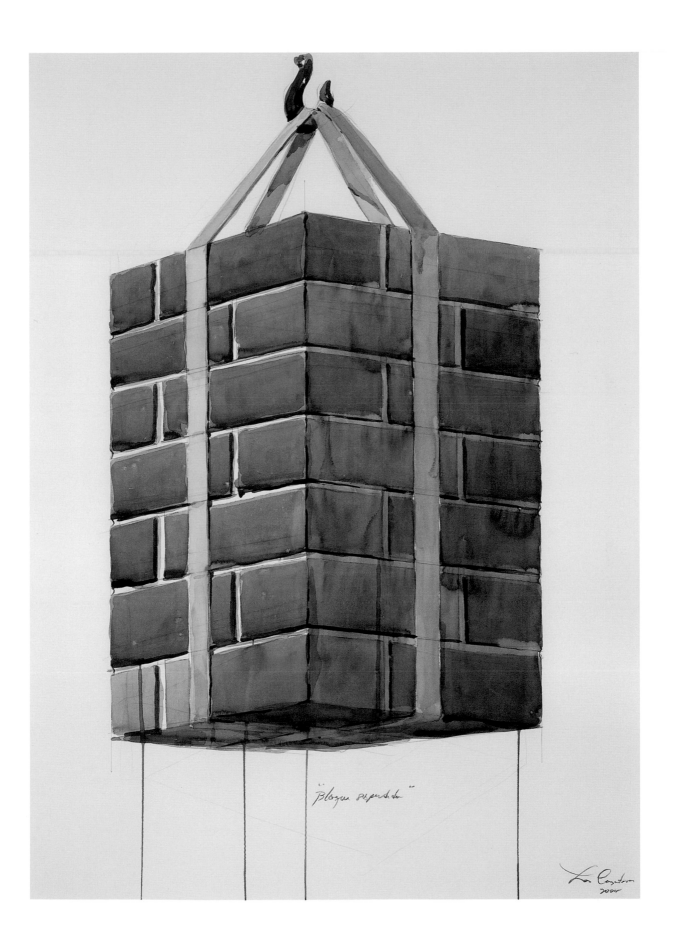

"Bloque suspendido"

John
Chamberlain

American, born 1927

Magnet Eyes, 1989
Painted chromium-plated steel
35¾ x 53 x 34 in.

In the late 1950s, when artists were exploring alternatives to Abstract Expressionism, John Chamberlain made his first assemblages from auto-body parts. Although strongly influenced by Abstract Expressionism, the sculptures may also be appreciated within the context of a just-emerging Pop Art. On the one hand, the welding together of industrial metal for expressive purposes had a precedent in the art of David Smith. On the other hand, the recognizable presence of the automobile linked the work to that of artists such as Robert Rauschenberg and Claes Oldenburg, who were also using commercial materials and subjects in their sculptures.

After some early successes in making freestanding sculptures by shaping and crumpling auto-body parts, Chamberlain shifted his attention in the 1960s to materials such as foam, Plexiglas, aluminum foil, and galvanized steel. In the mid-1970s, however, he renewed his interest in automobile parts and even began purchasing car metal directly from the manufacturer. Continuing to work within an Abstract Expressionist idiom, he shapes, bends, molds, crumples, and sometimes paints the body parts of a car in a spontaneous manner that recalls the energetic gestures of painters Willem de Kooning and Franz Kline. In keeping with Abstract Expressionism, Chamberlain's titles are often arbitrary and chosen by interpreting the completed abstract sculpture.

Until the late 1980s Chamberlain's auto-body pieces tended to be made from large sheets of metal. In the 1980s he began to work with smaller sections—thinner, lighter strips and segments that are crunched up or twisted in a more delicate manner than his earlier works. *Magnet Eyes* from 1989 shows the more fluid and open formal composition of these later works. Chamberlain transforms these scraps, which might suggest or allude to an auto accident, into animated abstract sculptural forms.

Although an abstract artist, Chamberlain acknowledges a hint of eroticism in the sculptures through an implied parallel between the malleability of metal and the pliability of human skin. This work's title, *Magnet Eyes,* furthers the sensual association, with its humorous allusion to the power of a seductive gaze. *D. S. R.*

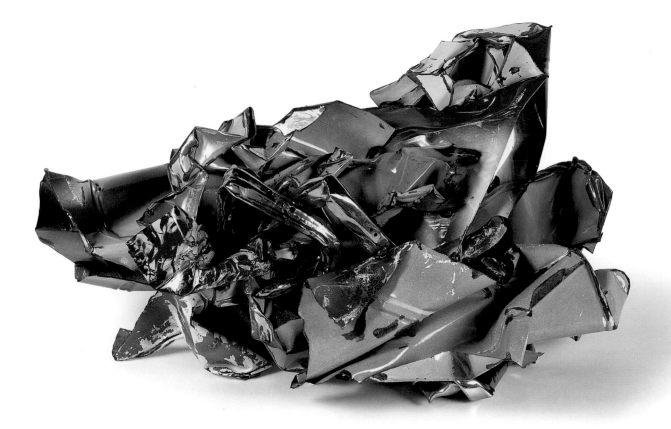

Les
Christensen

American, born 1960

Why Should I Walk If I Have Wings to Fly?
2000
Shoes and wood
108 x 88 x 56 in.

Les Christensen's work explores the complexity of meaning that underlies appearances. Her sculptures are composed of thousands of objects—nails, shoes, glass shards, china plates—that result from an obsessive process of accumulation. Through their scale, craft, and beauty, Christensen's works have an immediate visual impact; at the same time, most of them are very personal, and many are based on her close relationships.[1] *Why Should I Walk If I Have Wings to Fly?* weaves together complex psychic and social dimensions to ultimately communicate universal facets of the artist's personal experience.

Christensen created this ambitious set of wings from fifty-three hundred women's worn dress shoes attached to a wooden armature—a "feat" of artistry, engineering, and visual poetry that evokes multiple significations. It is the highly charged association of the *worn* shoe that is particularly compelling in this work. Here a worn, disembodied shoe may serve as a metaphor for an individual's life experience and for the empathy invoked by the expression "to put oneself in someone else's shoes." The nexus of wings and worn shoes may also suggest a state of mind or a path in life "walked," then left behind, circumstances overcome or risen above, a new beginning.

For Christensen the sculpture grew out of a need for personal renewal and a decision to "start" her life. After months of reflecting and making sketches around this yearning, she realized that she "couldn't keep waiting for [her] life to begin," and she drew a small pair of wings in her notebook with the words, "Why should I walk if I have wings to fly?" A few days later she came across a drawing in Frida Kahlo's diary of two disembodied feet, which Kahlo made after she was told that she would have to lose one of her legs. On the sketch Kahlo had written, "Feet, what do I want them for if I have wings to fly?"

Kahlo's words not only coincided with Christensen's own but also resonated with a tragic accident that had left Christensen's brother paralyzed. Christensen had previously created works for and about him—in part to address her own grief and empathy for him. The sudden concurrence of words, thoughts, and emotions, together with the inspiration of Kahlo's art sprouting from loss, carried the sculpture to realization. These wings would be for Christensen's brother, expressing a wish for his symbolic transformation, and they would be the last work that she would need to create about him; the wings would liberate her too.

Although essentially made for her brother, *Why Should I Walk If I Have Wings to Fly?* concerns the artist's own rebirth through overcoming grief and renewing her sense of self and life. Transcending its origins, however, the sculpture ultimately communicates the universal relevance of learning to stand in one's own shoes, placing oneself in the shoes of another, and discovering in those experiences perspective, illumination, liberation, and the ability to begin life anew. *K. M. S.*

Notes
1. The information presented here is drawn from the author's interviews with Les Christensen.

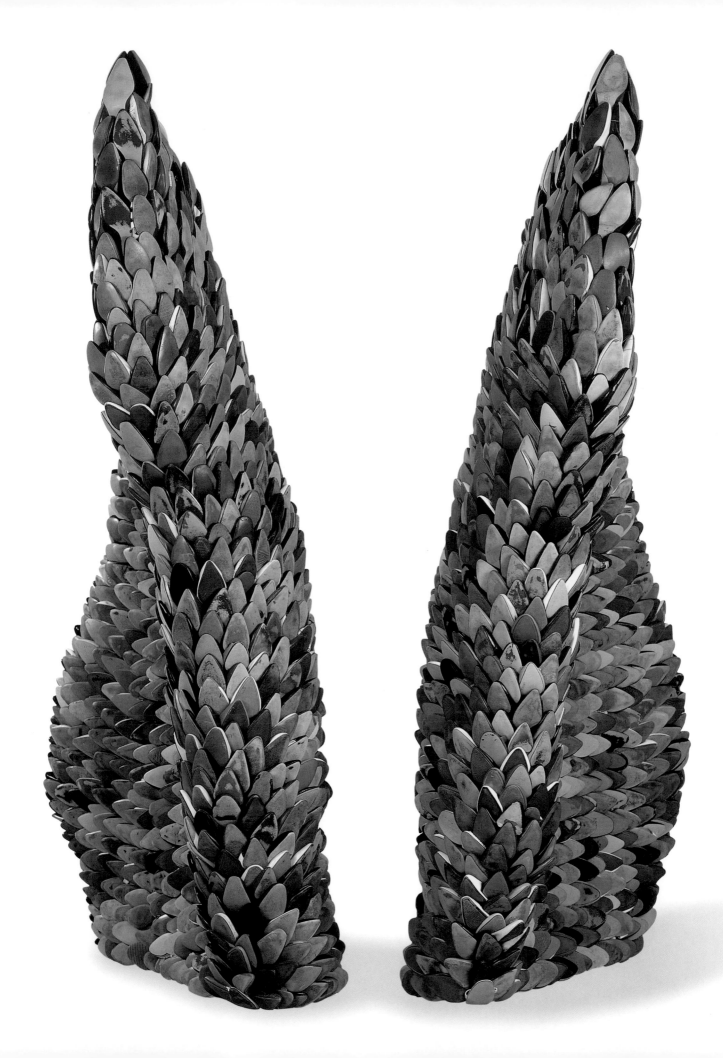

Christo

American, born Bulgaria 1935

**_Wrapped Monument to Cristóbal Colón
(Project for Barcelona.) Drawing 1976,_**
1976
Pencil, fabric, twine, wax crayon, pastel, and
charcoal on paper
28 x 22 in.

**_Running Fence (Project for Sonoma and
Marin Counties, State of California.)
Collage 1976,_** 1976
Pencil, wax crayon, and fabric on paper
22 x 28 in.

Christo and his collaborator, Jeanne-Claude, are recognized around the world for site-specific projects that usually involve the temporary use of fabric for grand transformations of rural or urban sites. Some of their most ambitious projects include _Wrapped Coast, Little Bay, Australia, 1969,_ for which they covered one and one half miles of coastline with one million square feet of synthetic woven fabric; _Valley Curtain, Rifle, Colorado, 1970–72,_ which involved filling a mountain gap with two hundred thousand square feet of nylon; and _Running Fence, Sonoma and Marin Counties, California, 1972–76,_ an eighteen-foot-high and twenty-four-and-one-half-mile-long nylon fabric fence that extended east-west from north of San Francisco to the Pacific Ocean at Bodega Bay.

In the mid-1960s, in keeping with widespread interest in common materials, Christo re-created storefronts from found materials as large assemblage works; made sculptures from fabric, rope, and twine; and soon began wrapping everyday objects. At the same time, Christo and Jeanne-Claude developed proposals for using entire buildings. The larger environmental projects that followed have each begun with detailed visualization and an enormous amount of planning, usually including intensive collaborations with local governmental agencies and citizens. _Running Fence,_ for example, entailed forty-two months of preparation, marked by public hearings, court appearances, and the drafting of a 450-page environmental impact report. Also important in the developmental stages of a project are preparatory drawings and collages by Christo that the artists sell in order to provide the means of paying for the projects. Although considered works of art in their own right, the drawings function as architectural blueprints. They include technical information, text, and collaged elements indicating materials.

Since the 1960s Christo and Jeanne-Claude have made proposals for more projects than they have actually realized. Although _Running Fence_ was completed and was on view for two weeks, the artists canceled _Monument to Cristóbal Colón._ They had been seeking permission for nine years to cover the statue of Christopher Columbus in Barcelona. By the time the city's mayor finally granted them approval, they had lost interest and were already committed to larger, more elaborate endeavors. _D. S. R._

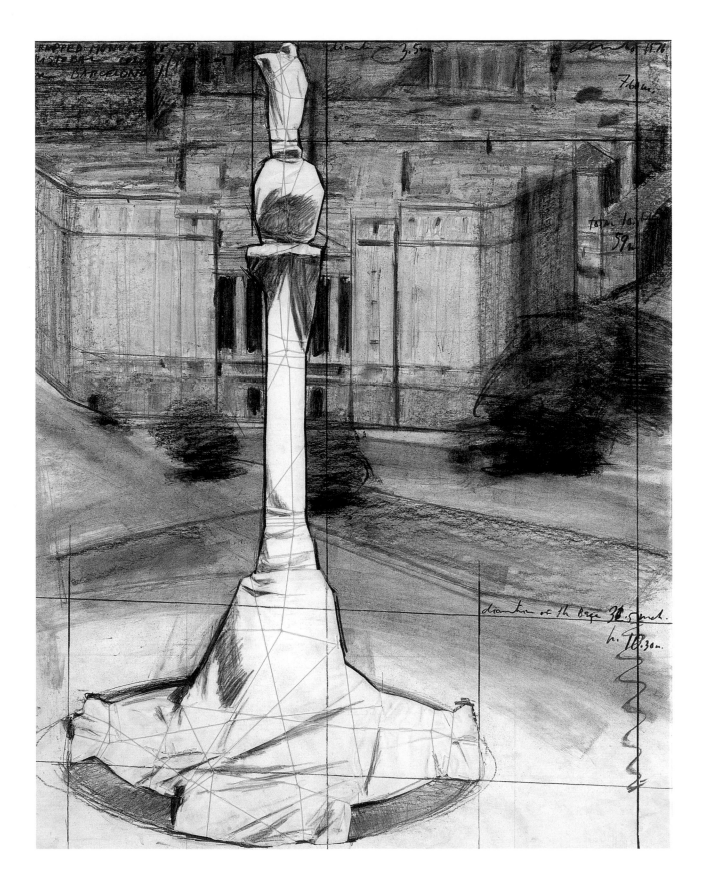

Chema Cobo

Spanish, born 1952

Map of the Sky—to Jürgen Glaesemer, 1988
Oil on canvas
94½ x 129½ in.

Chema Cobo has remarked that his painting is a "perpetual journey in search of a legend."[1] He weaves themes of traveling, metamorphosing, creating, and exploring into layered symbols and myths. Although he acknowledges a wealth of artistic influences, from El Greco and Diego Velázquez to Jackson Pollock and Jasper Johns, Cobo's works are most indebted to his Spanish background—the "rich formal expressiveness of the Andalusian baroque," the emotional and political intensity of Francisco de Goya, and the experimental energy of Pablo Picasso.[2]

Linking many of Cobo's works is the metaphor of mapmaking. It makes reference to the special function held by the artist, who creates inroads, signposts, and paths into the unknown. Cobo does not simply reproduce reality but takes the viewer on unforeseen metaphoric journeys. He paints "maps" that often include words, puns, and dizzying Escher-like illusions that are as paradoxical as the games of logic played by René Magritte.

Map of the Sky—to Jürgen Glaesemer presents several major themes of Cobo's work. The title dedicates the piece to a friend, German art historian Jürgen Glaesemer. The painting consists of an illusionistically rendered flat brick wall, within which the artist set glowing orbs of bright light. A trompe l'oeil knotted rope hangs over the "side" of the wall. All of these elements—the rope, brick wall, and glowing orbs—recur in Cobo's paintings. The orbs reflect his consistent use of light as a metaphor for creative freedom and inspiration. Here they could be read either as gigantic celestial bodies, such as suns or stars, or as tiny flickering candles. Their proximity and size are intentionally difficult to decipher. Framed and set within the flat brick wall, the balls of light complete the work's contrast of infinite expansion with immobile rigidity. A single painted rope holds out the potential for escape and, like the glowing orbs, serves as a metaphor for the imagination. *R. B.*

Notes
1. Chema Cobo, quoted in Mar Villaespesa, "The Fish with Its Tail in Its Mouth: From Charting the Straits to Camouflage Maps," in *Chema Cobo: El laberinto de la brújula* (Seville: Centro Andaluz de Arte Contemporáneo, 1998), 194.
2. Ibid.

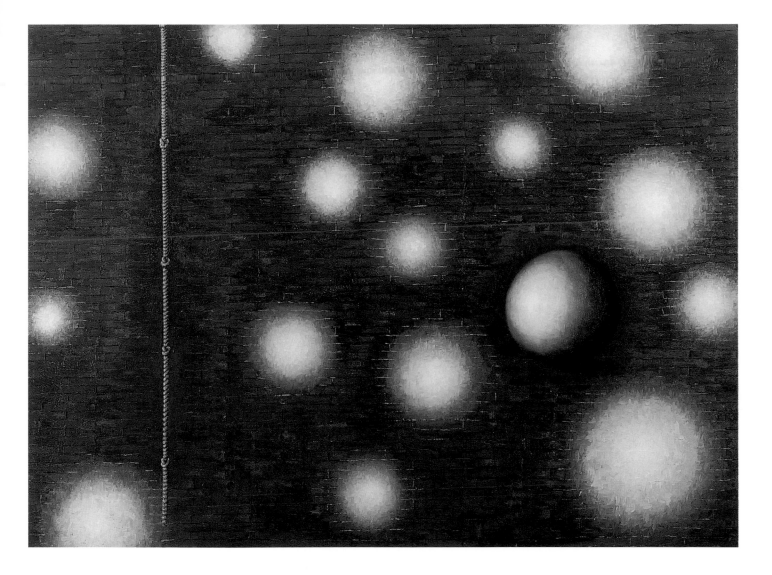

Bruce
Conner
American, born 1933

Suitcase, 1962
Mixed media
23 x 24 x 9 in.

Bruce Conner has worked with a wide variety of media and methods, including assemblage, film, painting, drawing, sculpture, collage, and printmaking. *Suitcase* is an example of the assemblage work that brought him recognition very early in his career. Although he discontinued making assemblages after 1964, the few years that he devoted to this method and the powerful works that resulted had a lasting influence on the development of art in California.

Conner's assemblages are constructed from fragments of objects either bought or found in the urban environment. Bearing the traces of use, the objects are often punctured, torn, worn, ripped, or dirty and thus not conventionally beautiful. In fact, his assemblage work pointedly challenges notions of beauty in art and raises questions about what constitutes a meaningful artistic experience or object. Incorporating references to sex, death, cultural and social problems, and psychological suffering and terror, the narrative content of his work is often as raw and gritty as the material he uses to compose it. At the same time, Conner, who had friendships with many writers and poets of the Beat movement, adds a more lyrical, hopeful, and sometimes overtly religious or spiritual sensibility to his work.

Suitcase is part of a series of works Conner made during and after a year spent traveling in Mexico, from 1961 to 1962. He transformed a plain suitcase into a religious shrine by decorating it with candles, fringe, and a picture of Jesus within a double-pyramid "eye" symbol. Like most of his objects, the suitcase appears old and tattered. Covered with fragments of things taken from the way stations of its many journeys, it is an emblem of earthbound movement and encounters with new places. Conner's *Suitcase* brings together and conflates sacred and profane, ugly and beautiful, transitory use and aesthetic permanence. *R. B.*

Joseph
Cornell

American, 1903–1972

Hôtel de l'Étoile, 1950–54
Mixed-media construction
16½ x 10½ x 4½ in.

The creator of mysterious box constructions, paintings, collages, and experimental films, Joseph Cornell had no formal art training and made all his works in the cellar of his home in Flushing, New York, where he lived until his death. Although his art frequently references foreign cultures and cosmopolitan subjects, as an adult he apparently never left the New York area. One finds in Cornell's work, instead, the traces of a mind that avidly journeyed through the illimitable realm of his own eloquently strange imagination.

Cornell became best known for his distinctive box assemblages—self-contained magical worlds composed of unique and evocative arrangements of tiny found objects. His early constructions were first shown at the Julien Levy Gallery's 1932 show *Surréalisme,* the first exhibition in the United States devoted to Surrealist art. Fascinated by fragments of once beautiful and precious objects, Cornell invoked the Surrealist technique of irrational juxtaposition and a refined sense of nostalgia in his gently fetishistic accumulations. Victorian dolls, engravings, baubles, antique scientific instruments, withered maps, aged pieces of programs from performances long since past are captured behind glass as precious artifacts of bygone eras. In Cornell's work the past returns in the form of a meticulously composed poem—each object, each bit of history, a metaphor; each box, a discrete place of memory, a vitrine holding a dream.

In *Hôtel de l'Étoile* (Star hotel), the dreamscape is composed of a star map, an image of a unicorn pasted inside the box beside a "window" to another world, a piece of wire screen, a hoop, and a tiny bird perch dangling from above. Like other "celestial hotels" that Cornell created—including *Grand Hôtel de l'Univers, Hotel Night Sky,* and *Hôtel Andromeda—Hôtel de l'Étoile* relays the notion of a journey through both human and cosmic dimensions of time.

The metaphor of the hotel as a place of temporary respite on a journey is joined in *Hôtel de l'Étoile* with the infinite and timeless expanse of the celestial heavens signified by the unicorn. Cornell bridges the two realms—earthly/transitory and cosmic/ageless—through the meaning of *constellation* as both a configuration of stars and an assemblage, collection, or gathering of things—objects which, to the artist, are salvaged bits of history, fragments of time. The ephemeral and timeless converge in this work; as Cornell once wrote in his diary, "Collage *Hôtel de l'Étoile* . . . the moment in and out of time."[1]

Cornell's words echo the reflections of T. S. Eliot, a poet he admired, who wrote that humanity's "curiosity searches past and future and clings to that dimension . . . the timeless moment . . . *the moment in and out of time*."[2] *Hôtel de l'Étoile* embodies that moment, that place—celestial hotel, repository of the past—where glimpses of metaphoric wisdom are offered and the "intersection of the timeless"[3] is revealed. *K. M. S.*

Notes
1. Mary Ann Caws, ed., *Joseph Cornell's Theater of the Mind: Selected Diaries, Letters, Files* (London: Thames and Hudson, 1993).
2. T. S. Eliot, "The Dry Salvages" (1941), from *Four Quartets* (emphasis added).
3. Ibid

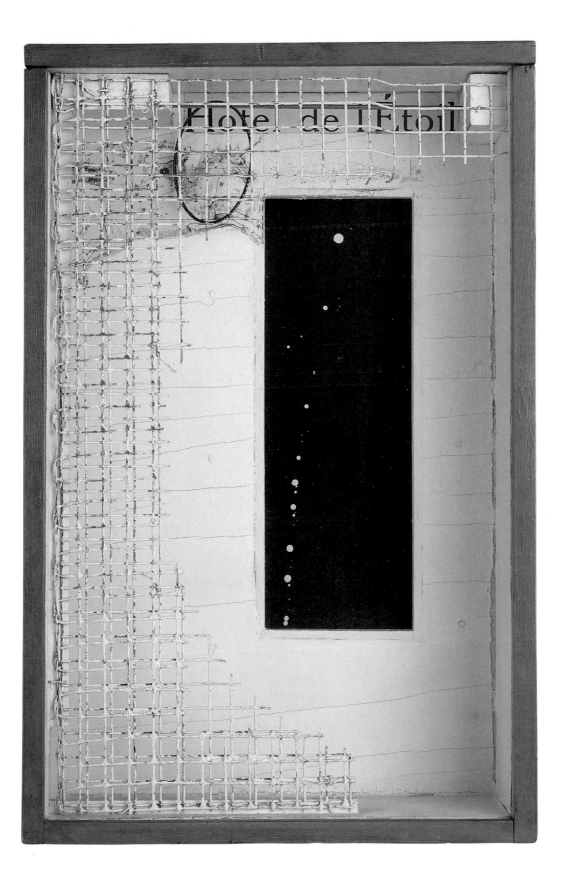

Mary
Corse

American, born 1945

Untitled (Center Yellow Band), 2001
Glass microspheres in acrylic on canvas
42 x 42 in.

Mary Corse first developed her signature banded paintings made from light-sensitive materials in the context of the Los Angeles Light and Space movement of the 1960s. Like many artists associated with that movement, Corse was interested in developing a phenomenological approach to painting that incorporated the viewer's subjective position and the perceptual process into the experience of the work. While usually working with the simple geometric shapes and structures characteristic of Minimalism, Light and Space artists added subtle touches, such as lighting and reflective surfaces, to incorporate aspects of the actual environment and the participation of the viewer into the shifting appearance of the object.

Corse's reductive, geometric paintings derive their structure from a grid format that is historically linked to the work of Kazimir Malevich and Piet Mondrian, as well as that of later artists such as Ad Reinhardt. A quintessential modernist form, the grid represents regularity, order, and stability, as well as an impersonal, objective structure beyond or outside the subjectivity of the painter or viewer. Corse used a grid in her early White Light series from 1968 and then eventually modified the grid so that it took the form of elongated, vertical bands. This geometry is the stable backdrop or matrix against which she explores subtle effects of light and color, effects that are ephemeral and unstable, impermanent and contingent on a number of extrinsic factors. Since her earliest works Corse has used paint embedded with microspheres—tiny glass prisms—to achieve these unstable light effects. The prisms reflect light from the environment, causing the painting to look different depending on the point of view and light conditions, while also imparting a soft inner glow to the surface.

Corse has worked with the vertical band format for more than thirty years, subtly and slowly adding minute changes. In her "inner band" format, a central band seems to separate or cleave in two the framing outer bands, creating a rippling effect. A subtle visual movement or tension is created that breaks up the fixed geometry just as the flickering light adds instability to the forms. Through a very controlled and precise use of color, she has amplified and complemented the subtle relations of the band forms. Her earliest paintings were white on white; she eventually added black and later monochrome bands, as in this untitled work. Here the brilliant yellow inner band provides an intense chromatic contrast to the black and white. Occupying the central place, flanked by two bands on either side, it holds a third position and introduces a third color, thus breaking up the stark black-and-white dualism of the surrounding geometry. *R. B.*

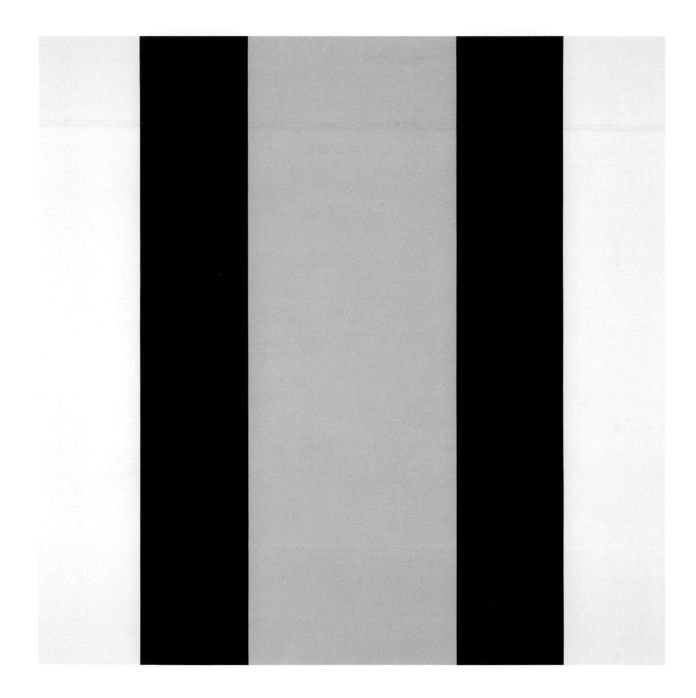

Ronald
Davis

American, born 1937

Inside Light, 1969
Fiberglass and polyester resin
56½ x 136 x 2½ in.

Wedge Wave, 1978
Acrylic on canvas
69¾ x 65¼ in.

Extending the accomplishments of Abstract Expressionism, Ronald Davis's geometrically shaped paintings of the late 1960s and early 1970s utilized new materials and techniques in a uniquely refined fusion of color, perspective, and illusionism. As "abstract illusionist" or "lyrical abstractionist" art, his work debunked the established formalist demand that important abstract painting eschew illusionism. Using colored polyester resin and fiberglass, Davis achieved a rhythmic play between variegated color and balanced geometric precision. He would apply lush, colored planes of solid and spattered resin to the bottom of his molds and then pour fiberglass on top of them so that the color would reside behind the work's glasslike surface. The subtle dimensionality achieved through this technique—along with the interplay of gloss, color, and perspectival illusionism—endows these works with a profound poetry.

Davis's aesthetic and technical innovations gave rise to his two best-known groups of works, the Slab series and the Dodecagon series, the latter of which includes twelve-sided paintings such as *Inside Light.* In these works color is not applied to the surface like paint on canvas, but instead seems to lie somewhere behind it. Paint and ground (the pigment and the plastic resin) are the same substance, part of the same surface plane. These works are paradigmatically Californian in their polished illusionism and impressive use of new materials—specifically those used in surfboards, boats, and automobiles.

Davis was born in California, grew up in Wyoming, studied art in San Francisco, and moved in 1965 to Los Angeles, where he developed his fiberglass-resin technique. In 1972, for health and aesthetic reasons, he stopped using this unconventional medium. He instead turned to acrylic paint on canvas, continuing to produce large-scale geometric and illusionistic works such as *Wedge Wave,* which resembles a three-dimensional checkerboard created by two-point perspective. Further demonstrating his remarkable abilities as an innovator, in 1988 Davis began designing his paintings with a Macintosh computer and 3D-rendering and animation software, again employing new technology in the service of his lyrical, optically sophisticated creations. *K. M. S.*

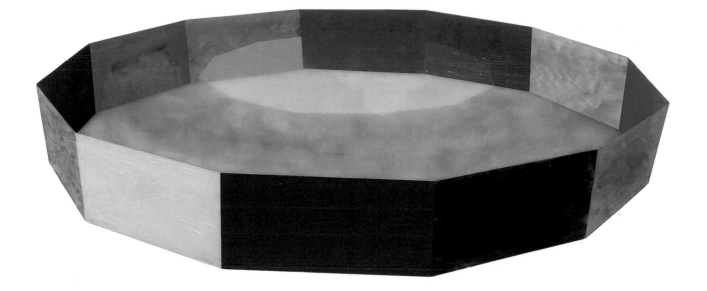

Willem
de Kooning

American, born the Netherlands,
1904–1997

Untitled III, 1979
Oil on canvas
60¼ x 54 in.

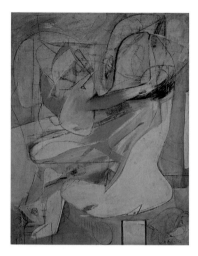

Pink Angels, 1945
Oil and charcoal on canvas
52 x 40 in.

Willem de Kooning was acclaimed in the late 1940s as a pioneer of a new, distinctly American approach to abstract painting known as Abstract Expressionism, or "Action Painting," as the critic Harold Rosenberg famously named it. Along with Jackson Pollock, he became mythologized as a heroic figure whose canvases transformed New York into the global center of avant-garde modernist painting.

Like many artists of the New York School, de Kooning arrived at what would become his signature mode of painting only after a long process of studying modernism. Along with his friends Arshile Gorky and Stuart Davis, de Kooning studied Cubist principles and the work of Picasso especially closely throughout the 1930s. Like Gorky, de Kooning began to continually repaint his canvases. Increasingly, the continual starts and stops, additions and subtractions, experiments and failures became incorporated into the final image. De Kooning eventually developed a uniquely dynamic, physical treatment of forms, heralded by the seminal *Pink Angels* of 1945 and *Excavation* of 1950, in which the *process* of painting itself fully takes over the canvas as the central subject. As he stated, "I didn't work on it with the idea of perfection, but only to see how far I could go."[1]

The appearance of struggle and inconclusiveness, of process and openness, evident in de Kooning's complex interweave of heavily laden brush strokes, became his trademark—a struggle realized, in contrast to Pollock's work, in wide swaths of paint pushed rather than dripped onto the canvas. A rich physicality of paint is combined with extremely elusive, fragmented figuration that echoes Gorky's work and its basis in Surrealism. In de Kooning's well-known series of Woman paintings from the 1950s, for example, the female figure is reduced to a mouth or a pair of eyes embedded in a frenzy of brush strokes that document the artist's subjective "battle" with painting the figure.

Beginning in the late 1950s, after he had moved to Long Island from Manhattan, de Kooning embarked on a series of what became known as "Pastorals"—abstract landscapes in a lighter palette composed of fewer and larger brush strokes. Evoking a softer, less frenzied surface, paintings such as *Montauk Highway* (1958) and *Door to the River* (1960) play with scale and appear as large, magnified sections of his earlier works. Evoking the wide expanse of landscape or highway, simple horizontals and verticals create a more stable sense of structure amid the thick paint. De Kooning's *Untitled III* from 1979 looks back to the Pastoral paintings. Wide, thick brush strokes loaded with paint were applied in a deliberate manner, building a sense of architectural stability, even suggesting a door or opening in the center of the canvas. The viewer is brought up close to a dynamic canvas energetically covered with paint in a quintessential assertion of the heroic "action" or "gesture" that is the essence of Abstract Expressionism. *R. B.*

Notes
1. De Kooning, quoted in Daniel Wheeler, *Art since Mid-Century: 1945 to the Present* (New York: Vendome Press, 1991), 36.

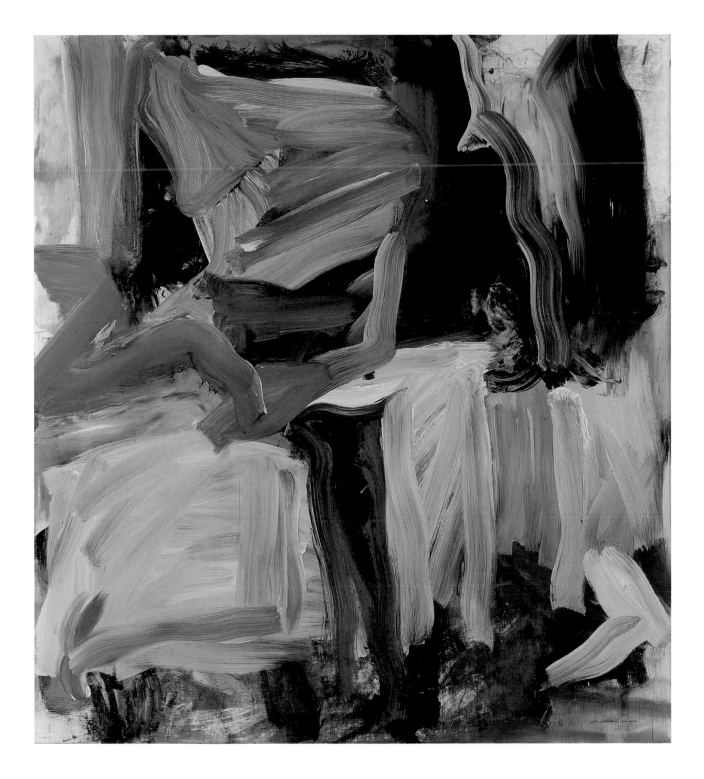

Lesley
Dill

American, born 1950

Large Copper Poem Dress, 1996
Copper and wire
68 x 55 x 13 in.

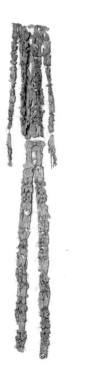

**Copper Poem Armor with Crazy Hands
(Painted),** 1992
Copper
64 x 30 x 3 in.

Lesley Dill explores the aesthetic potential of the visual appearance of written language. Poetry has in fact been the primary literary source for her art since the early 1990s. Working in a variety of mediums—including paper, mixed media, and photography—Dill employs verse to structure imagery that is usually associated with the human body. The artist has explained, "I think of words, and especially the poems of Emily Dickinson (for their embodiment of psychological states of despair and euphoria), as a kind of spiritual armor, an intervening skin between ourselves and the world."[1]

Dill's first use of Dickinson's writing dates to 1990, when she covered a mixed-media sculpture of a man's suit with an entire text by the poet. Initially she viewed the addition of words as a contemporary parallel to the way African artists make figurative sculptures that are akin to fetishes by adding nails or pouches. She then realized that the words reinforced the ideas of absence and fragility suggested by a bodiless, freestanding piece of clothing. So Dill began her current use of a variety of materials—paper, muslin, copper, and wire—to construct clothing, body parts, falling leaves, and other evocative imagery from letters and text. *Copper Poem Armor with Crazy Hands (Painted)* from 1992, is an example from this early period.

Large Copper Poem Dress is one of a few works in which Dill has utilized text from a poet other than Dickinson. Turning to the German poet Rainer Maria Rilke, she constructed a woman's dress from the words of a poem about music. In it, Rilke describes music as a stranger emanating from the human heart, which elevates the soul to a higher plane. Considered within the context of the poem, the fabric of the dress may assume various meanings. Latticelike in structure but made from durable copper, it might be a withered gown from Rilke's lifetime that has survived the tribulations of the ages. At the same time, one could easily view the dress as a metaphor for the heart itself, at once vulnerable and resilient. *D. S. R.*

Notes
1. Lesley Dill, quoted in *Lesley Dill* (New Orleans: Arthur Roger Gallery, 1994), unpaginated.

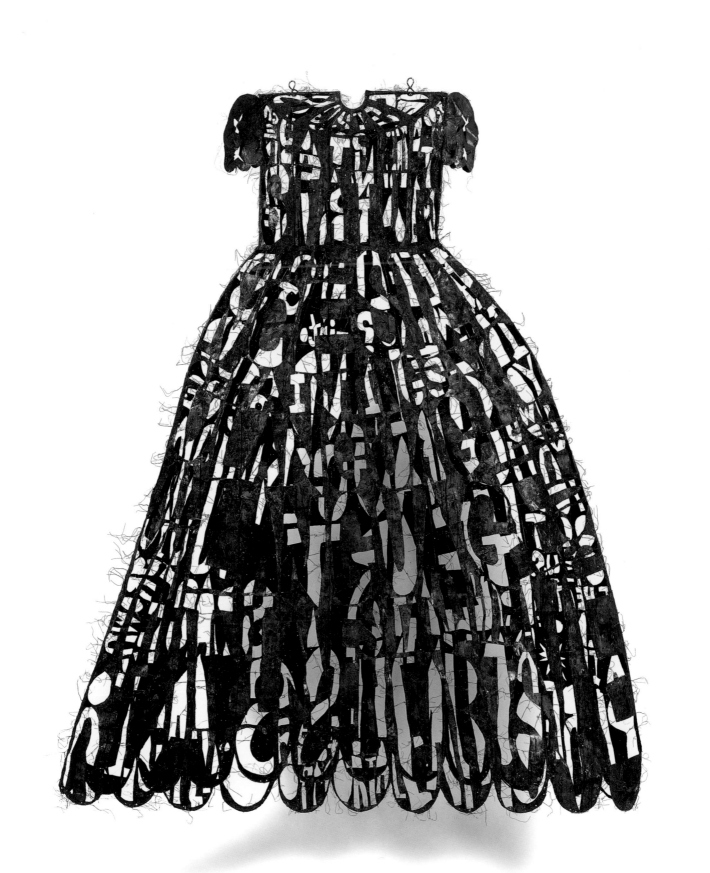

Jim
Dine
American, born 1935

Red Palettes, 1963
Oil on canvas with collage
60 x 36 x 4 in.

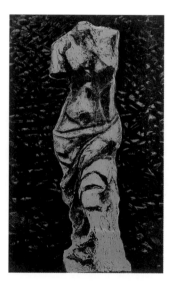

The Yellow Venus, 1984
Four-color woodcut
60 x 37 in.

Jim Dine came of age as an artist in the late 1950s, when the influence of Abstract Expressionism was still dominant in American art. Dine did not reject the gestural quality or the emotional and autobiographical goals of Abstract Expressionism, as did so many of his contemporaries. Rather, like Jasper Johns and Robert Rauschenberg, he combined Abstract Expressionist ideas and methods with a more structured and controlled imagery and process, and with a greater emphasis on objects. Along with Johns, Dine depicted repeating series of seemingly banal objects with a lush, painterly physicality. As a result, Dine's paintings of hearts, bathrobes, and other mundane objects become, like Johns's flags and targets, intimate, personal, and emotionally evocative. Although he has most often been labeled a Pop artist, Dine distanced himself from Pop Art, claiming that he was a "child of Abstract Expressionism" and that he painted "personal, not popular" objects.

Dine said, "If I picked up what I considered neutral objects, they lost their neutrality when I put my hand to them, or when I put them in conjunction with something else."[1] His paintings and prints play upon the transformative moment when the ordinary becomes "something else." Like Abstract Expressionism, this approach highlights and celebrates the aesthetic act, the creative moment, but by including everyday objects, it keeps this act grounded in a relation to simple, recognizable things. Not quite neutral, Dine's favorite subjects—including hearts, bathrobes, Venuses (such as *The Yellow Venus*, 1984), trees, tools, and palettes—have a thematic coherence or biographical reference, and his images become almost like self-portraits.

Red Palettes from 1963 is one of many paintings of palettes Dine made in the early 1960s. Like his paintings of color charts and wheels, these works focus on the technical and preparatory components of painting—components not generally made into subjects in their own right. They are close in spirit to his focus on tools—the "background" objects that one needs to construct, create, and, in this case, paint. Dine pays homage to the tools of his craft, rendering the palettes as he does his hearts—keeping the unity of the object itself while layering it with thick, expressive, and colorful brush strokes. *R. B.*

Notes
1. Jim Dine, "Walking Memory: Interview, Catalogue, and Artist's Writings," in *Jim Dine: Walking Memory, 1959–1969* (New York: Guggenheim Museum, 1999), 208.

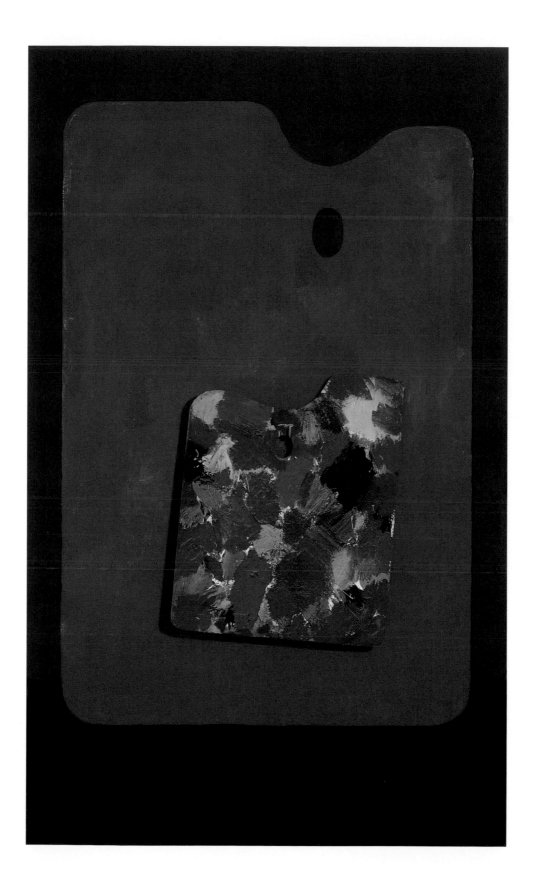

Charles
Fine

American, born 1951

Radiant Row, 1995–2001
Oil, asphaltum, and alkyd resin on canvas
96 x 120 in.

Frozen Landscape III, 1991
Encaustic on resin with wood and lead
21½ x 12 x 5 in.

The work of Charles Fine expresses themes of memory, emergence, loss, and time through processes of layering and excavation. His paintings, primarily abstractions, are composed of translucent layers of oil paint or other materials veiling shapes that resemble natural forms and objects from indigenous cultures. In *Radiant Row*, the layered effects of the paint engender a sense that the underlying forms are in flux, materializing or dematerializing on the canvas surface.

Creating the appearance of shifting dimensions in his art while mapping connections between the past and the present, Fine has consistently and eloquently apprehended form as inseparable from an intuition of movement and time. His extended sojourns in rural regions of Mexico engaged his interest in nature and the distant past while providing him with source material in the landscape itself and in the ancient tools, seed pods, stone and bone utensils, and ceremonial objects that he collected. It was at a foundry in Moralia, Mexico, that Fine created his first bronze sculptures, in essence "extracting" the ephemeral shapes from his earlier paintings and "releasing" them into form.[1]

This movement between industry and nature alludes to Fine's concern with the destruction of the environment and the irrevocable loss of nature. He distills this loss with a sense of recollection, a "cultivation" of the past through metaphors of ancient excavation and tilling. Recalling the furrowed patterns of field cultivation and irrigation, vertical and horizontal striations pervade his work, as in *Radiant Row*. For Fine, these patterns signify an excavating of the layered depths of collective memory—of nature and ancient civilization, of what is lost, what is searched for and uncovered, and the connections that are retained.

Inspired by the lost-wax method of bronze casting, Fine eventually began using encaustic—a fusion of wax, varnish, and pigment. He would heat his found metal tools and brand them vertically into the white encaustic surfaces, leaving the literal impression of gravity, of striated atmospheric dimensions receding or emerging—artworks always "becoming," their surfaces forever pushing outward or falling away. These paintings evolved into more sculptural, three-dimensional "wall works" that distinctly articulate processes of layering and excavation and themes of movement and time.

In *Frozen Landscape III*, actual tree branches are faintly perceptible in the five-inch depths where the encaustic has been scraped away—a miniature landscape frozen in time in the confines of fiberglass and resin. The natural element of the tree branches contrasts with the industrial-like structure at the bottom of the work, a compartment darkened by shadow and adorned with lead. Fine cut the lead pieces from a sheet, shaping some by curling them around the branches that would become part of the work. The uncurling lead forms describe motion and organic processes, a vision of industrialism unfurling back into a natural state. *K. M. S.*

Notes
1. The information presented here is drawn from the author's interview with Charles Fine.

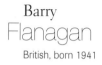

Barry
Flanagan
British, born 1941

Relevé, 1996
Bronze
63¾ x 13½ x 10 in.

Barry Flanagan introduced a series of hares made through traditional clay-modeling and bronze-casting techniques in the late 1970s, following a decade of conceptually based installation work. After the dominance of Minimalism, his rediscovery of old-fashioned sculpting methods and his revival of figurative subjects ironically became an invigorating and refreshing gesture in the history of postmodern sculpture. The figure of the hare—anthropomorphized and depicted in a range of activities, such as boxing, bowling, and dancing—has since become Flanagan's trademark. While introducing a much-needed note of wit and playfulness into contemporary sculpture, his hare is also richly symbolic.

Flanagan was first inspired to use the hare as a subject by a book entitled *The Leaping Hare* by George Ewart Evans, a study of the symbolism of the hare in art, literature, and popular culture from prehistoric times to the present. Flanagan was fascinated both by the hare's symbolism and by the lithe and supple form it could lend to modeling in clay. Traditionally the hare represents procreation and regeneration as well as lust and sexual friskiness, all associations alluded to in the title *Relevé,* meaning "erect." Yet, thanks to such modern characters as Bugs Bunny, it has also become an emblem of subversive humor and sly intelligence. At the same time Flanagan stresses the wildness of the hare, the sense that it is never completely contained by culture. In his works it becomes a symbol of things that have been left behind, excluded, or passed over by a technological culture.

Made from ancient and simple modeling techniques that Flanagan learned from artisans in Italy, the hare becomes an antitechnological formal statement, a return to manual craft. As in *Relevé,* Flanagan often renders the hare in rough, lumpy form, leaving fingerprints and the marks of his hands as they squeezed and shaped the clay. Just as the hare represents an animal nature not quite tamed by civilization, Flanagan's technique stresses a deliberately unfinished, "raw" surface. *R. B.*

Sam
Francis
American, 1923–1994

White, 1951
Oil on canvas
56 x 40¼ in.

Untitled, 1983
Monotype
78 x 30 in.

Sam Francis was a distinguished second-generation Abstract Expressionist whose affinity for brilliant colors, extension of white space to an infinite "void" beyond the canvas, and receptivity to Eastern philosophical and spiritual influences made him a distinctively West Coast artist. During World War II Francis's premedical studies at the University of California, Berkeley, were interrupted by his conscription into military service. He suffered a traumatic injury during the war, which left him in compromised health and sometimes excruciating pain for the rest of his life. Seeking solace, he began to paint while in the hospital and developed a deep interest in Eastern philosophy and Jungian psychology. He returned to Berkeley, where he earned his master of fine arts degree and began to translate these profound influences into his work.

Francis's signature paintings of the 1950s were luminous and painterly, layering shapes and biomorphic forms saturated with vivid hues of ruby, sapphire, emerald, and lemon—colors that he viewed as "holy substance," holding a poetic, dreamlike power. From the late 1950s through the 1960s, Francis's works became airier and more light-filled, engaging negative space or the "void." This aesthetic was presaged by his series of White paintings of the early 1950s, which brought him to the attention of critics in France, where he was living at the time.

In the White paintings, Francis applied gray and white paint like a dye, staining and rubbing it into the canvas while retaining the subtle presence of biomorphic forms. By the 1970s he was creating large canvases dominated by white, works that were more structured than before, yet with space punctuated by the visual energy of colorful, clustered forms. While this remained his vocabulary for the rest of his career, a greater degree of structure emerged in the late 1970s and 1980s, as demonstrated by the shardlike geometries of this untitled monotype of 1983. Francis's monotypes, unique prints made from a painted plate, display a spontaneity and freshness that make them a key facet of his artistic expression. *K. M. S.*

Viola Frey

American, born 1933

He Man, 1983
Ceramic
109 x 37 x 27 in.

Viola Frey is one of the San Francisco Bay Area artists who have revolutionized the ceramic arts. Until the 1970s ceramics was usually regarded as a craft medium reserved for functional objects. Frey—along with other California artists such as Robert Arneson, Peter Voulkos, and Ken Price—proved that clay objects could be not only utilitarian but also representational, expressive, and, in her case, heroic.

In the early 1950s Frey studied painting under Richard Diebenkorn at the California College of Arts and Crafts (CCAC). Diebenkorn and other pioneers of the Bay Area Figurative School were responding to contemporaneous Abstract Expressionist painting, based in New York. Whereas the East Coast artists eschewed or downplayed references to identifiable subject matter, the Bay Area artists preferred to render subjects such as still life, the human figure, and landscape. They did so, however, while employing gestural, heavily pigmented brushwork.

Frey studied ceramics in 1957 at Tulane University and continued at CCAC after returning to the Bay Area in 1960. She built a ceramics studio in 1965 and, a decade later, made her first assembled ceramic sculptures by casting clay sections and then joining them together vertically. Working initially with still-life imagery, Frey soon turned to the figure. By the mid-1980s she had produced a significant number of imposing, larger-than-life anonymous men and women in middle-class attire.

He Man, a characteristic work from the series, shows a middle-aged businessman dressed in a blue suit. More than nine feet tall, the stiffly postured figure hovers well above the viewer with a facial expression of pent-up anxiety. By painting agitated brushwork in the manner of the Bay Area Figurative School over a deliberately roughhewn surface, as well as by enlarging the figure's head and hands, Frey made the figure seem to intrude into the viewer's space. *D. S. R.*

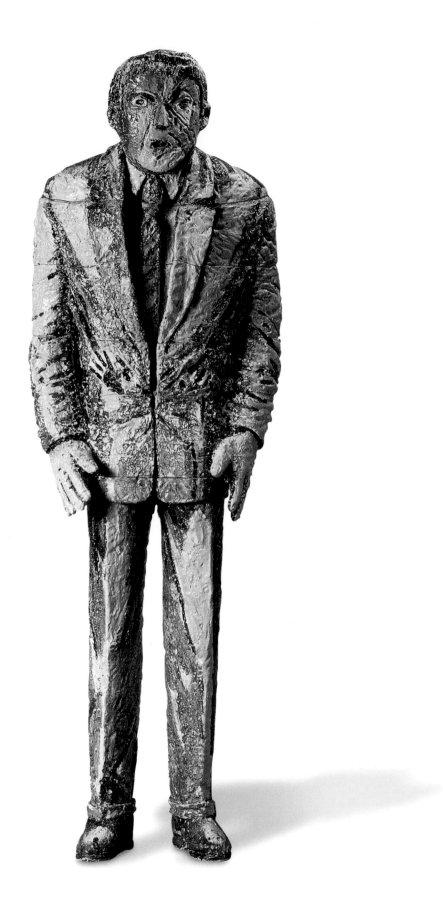

Katharina
Fritsch

German, born 1956

Pudel (Poodle), 1995
Plaster and paint
16 x 6½ x 16½ in.

German artist Katharina Fritsch explores the shifting ground between the familiar and the strange. Although her sculptural work depicts ordinary objects with pristine, simple contours and bold colors, it is full of allusions to nightmares, folk tales, and cultural symbols without being reducible to a single meaning or source. Intrigued by the sensation of seeing something as if for the first time, and fascinated by the peripherally haunting impression of dreams and the unconscious, Fritsch aims to create living tension between solid reality and the fantastic. She achieves this effect of estrangement through a defamiliarizing play on scale, color, installation, and unnerving simplicity: a bookcase with books that bear no titles and contain no text; a formidable gathering of colossal rats; a life-size elephant, anatomically correct and precisely detailed but painted an ethereal aqua; a man lying in bed, facing a giant mouse crouching ominously on his chest. Fritsch's sculptures yield presence to the fleeting apparitions of the imagination, unfolding archetypes and deep-seated anxieties of collective consciousness.

Fritsch fuses techniques of industrial production with those of traditional sculpture to create her works; she uses models to form molds from which the final forms are cast in materials such as plaster, polyester, and aluminum. She has produced many of her sculptures as editions, with multiple casts made from a single model, and often the multiples have formed individual installations. *Pudel (Poodle)* was originally part of an installation of 224 painted plaster poodles that were arranged concentrically en masse—a precisely arranged pack—with each dog facing the circle's center, where a lone baby doll lay vulnerably on its back. Although immediately recognizable as a dog, this individual poodle is painted entirely matte black.

Devoid of facial details or bodily features that would imbue this representation of a living creature with some degree of vitality, the sculpture appears disconcertingly inert. From the disturbingly static, like *Pudel,* to the eerily mundane or the fully fantastic, Fritsch's sculptures combine elegant craft with a subtle sense of the extraordinary. *K. M. S.*

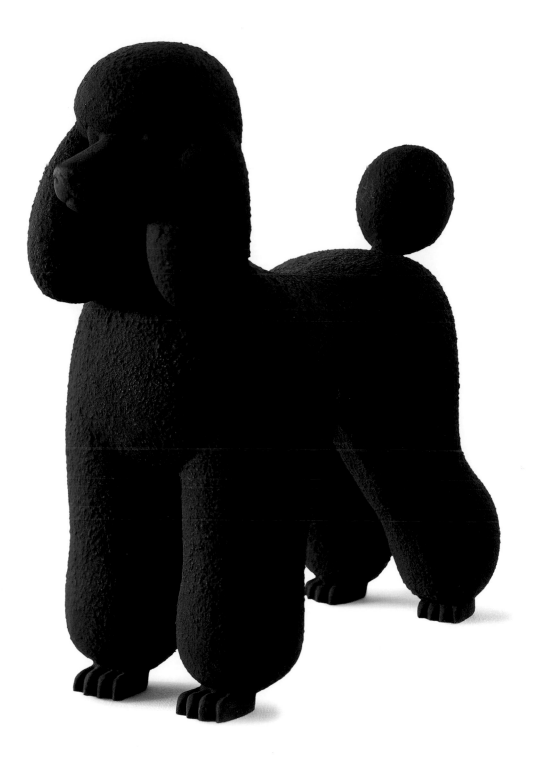

Torben
Giehler
German, born 1973

Mont Blanc, 2002
Acrylic on canvas
83 x 143½ in.

In the 1990s computer-enhanced imagery and digital technology assumed an important presence in contemporary art. While some artists fully embraced these new technologies, others, such as German artist Torben Giehler, adopted a more synthetic approach that blends computerized imagery and techniques with traditional painting and drawing. Giehler's paintings typically go through several stages of production. He begins with a free-hand drawing, then takes a digital photograph of it and downloads it into a computer. He then uses a computer-imaging program to manipulate the hand drawing into a new, stylized blueprint for the final painting, which is rendered in thick, colorful acrylic paint.

Giehler is best known for his engagement with the genre of landscape painting—either through renderings of actual places, such as *Mont Blanc,* or entirely imaginary, futuristic vistas that combine references to perspective drawing, early modernist grid paintings, and the intricate surface of computer chips. Traditionally landscape painting has provided an image of social reality—a kind of cultural map that frames and stabilizes a communal image of space and place. In Giehler's paintings the "landscape" has become almost entirely removed from any "real" nature: it is a purely synthetic, manipulated place woven from past, present, and future technologies. Using the basic grid as a guide, he renders the "landscape" as a controlled and measured space subject to an infinitely extendable structured system that is similar to both the Renaissance perspective system and the two-dimensional grid of painter Piet Mondrian. (In fact, one of Giehler's landscapes is entitled *Boogie Woogie,* after Mondrian's famous *Broadway Boogie Woogie.*)

While many of Giehler's landscapes are entirely flat expanses of checkerboard patterns extending in every direction, works such as *Mont Blanc* (the title refers to a peak in the Savoy Alps) show the grid imposed upon the coordinates of a real place—the rocky projections of a mountain or other geological structure. Giehler used the mountain to fracture and break up the otherwise rigidly structured grid, the symbol of a perfectly articulated mathematical system. The checkerboard structure has become a sinuous paving of organic forms that assert an illusion of projection and three-dimensionality. He has further broken up the flatness and rigidity of the grid by literally altering the "flat" picture plane; the surface of the canvas is raised and uneven due to sharp ridges of thick acrylic paint. Through a careful use of light and color, Giehler creates dazzling surfaces that combine handcrafted materials with sleek, digitized designs, giving a new impetus to the landscape genre for the twenty-first century. *R. B.*

Gilbert & George

Gilbert: British, born 1943
George: British, born 1942

Outspan Lick, 1982
Photo-picture (mounted and framed)
95 x 79 in.

Gilbert & George are the irreverent patron saints of contemporary British art. In the more than three decades since their first meeting in art school in 1967, the two have worked as a seamless team of artistic explorers. As "living sculptures," they are famous for making themselves the subject of their own art. One of their first recognized works was *The Singing Sculpture* (1970), in which they wore face paint, sang, and moved to music while standing on a table. After presenting the piece for a few years in numerous locations, the duo determined that they *were* "art" and needed no other subject matter but themselves. They also realized their desire and capacity to be what they called the "speaking art object"—their own form of artistic communication that would serve as an anti-elitist "art for all."

Gilbert & George continued their public art appearances through the 1970s. Consistently attired in proper suits and ties, executing robotic movements or assuming static poses, the pair problematized identity as something vacuous, stereotypical, and "normal." In tandem with their living art, the duo created large-scale assembled charcoal self-portraits; the Postal Sculptures and Magazine Sculptures series, in which they detailed their daily lives through print ephemera; and large-scale photographic works, a form they have continued to explore. By the late 1970s these gridlike black-and-white photo-assemblages had developed into larger collages enhanced with vivid colors, which emphasized the slick, stylized appearance of the works.

The content of Gilbert & George's work at that time also began to shift to a more pointed articulation of contemporary social issues, including diverse and ironic commentaries on the art world, politics, sexuality, homosexuality, and certain taboos (sometimes featuring various bodily fluids and waste). In the erotically charged *Outspan Lick,* composed of sixteen lusciously hand-dyed black-and-white photographs, the duo (re)present themselves through the body and references to homosexuality. Although Gilbert & George are still the subject of their own art in this piece, two vertically curving tongues stand in for them, muscles explicitly erect and infused with independent life. The theme of homosexuality is implicit not only in this erotic association but also in the fact that the tongues themselves are "homo," or the same, "facing" each other as mirror images. Gilbert & George have foregrounded not themselves as performers but the highly sexualized stereotype of gay culture. In their typically subversive way, the two do not aim to critique this somewhat stereotypical image of homosexuality, but instead embrace it, perform it, celebrate it. *K. M. S.*

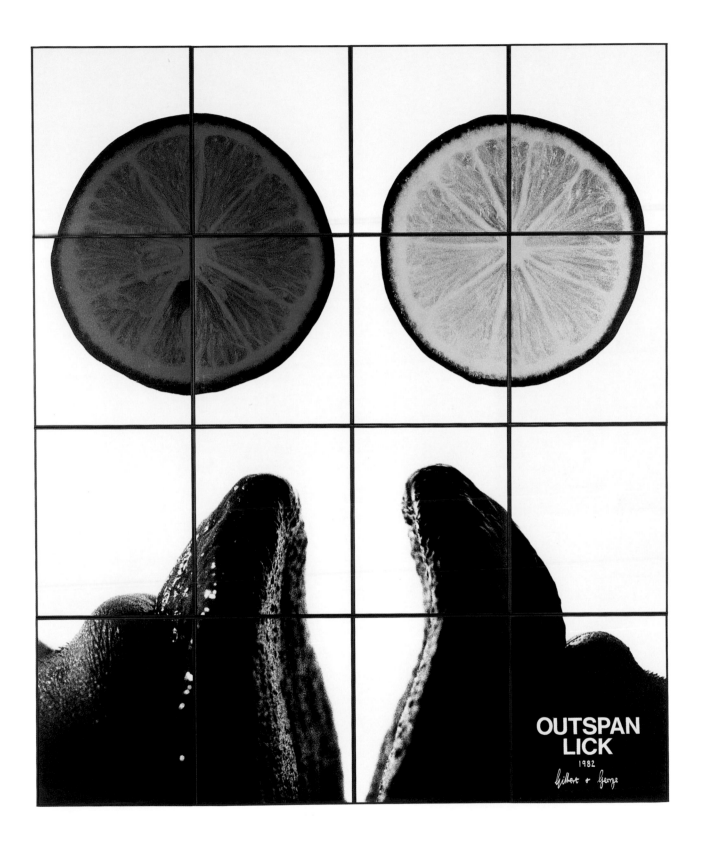

OUTSPAN
LICK
1982
Gilbert + George

Jack
Goldstein

Canadian, 1945–2003

Untitled, 1988
Acrylic and metallic pigment on canvas
Two panels, 100 x 96 x 6 in. overall

Untitled, 1983
Acrylic on canvas
96 x 96 in.

Jack Goldstein achieved success in New York in the late 1970s for his performance, film, and sound-recording works that explored the conjunction of human subjectivity and technology. His signature work, *The Jump* (1978), epitomizes the somewhat melancholic sensibility of his art. In this mediated "performance" film, Goldstein first transformed an appropriated film image of a high diver using a rotoscopic animation technique, then reshot the animated film through a special effects lens that dispersed the image into thousands of jewel-like facets or points of light. Stressing an extreme distance from the natural or the real, the film posed the human body as a barely-there referent within a complex and multi-layered technological screen.

In the early 1980s Goldstein turned toward painting (as in the untitled work from 1983), creating images that depict the realm of nature—landscape, space, the human body—seen by and through layers of technological manipulation in a way that recalls his earlier performances. Goldstein would typically appropriate a found image and then enlarge, segment, and paint the source image with an intricate airbrush technique.

The untitled painting from 1988 is one of a series of paintings that resemble enlargements of images transmitted via heat-sensitive monitors or other electro-magnetic imaging techniques. The underlying source object is ambiguous—Goldstein has used topographical maps, human skin, eggshells and other various sources—as he focuses only on the abstract, glowing shapes that define the painted surface. Goldstein shows how first technology—the infrared photography—and then artistic technique—the airbrushed painting—create a compounded distance between the viewer and the natural object. This distancing is emphasized by the black, white, and gold circles that mimic the sprocket holes of a photographic negative and thus turn the painted surface into an illusion of a strip of celluloid. The photographed image of nature is thus seamlessly merged into the flat space of abstract painting, where photography, film, and painting converge in the space between nature and ourselves. *R. B.*

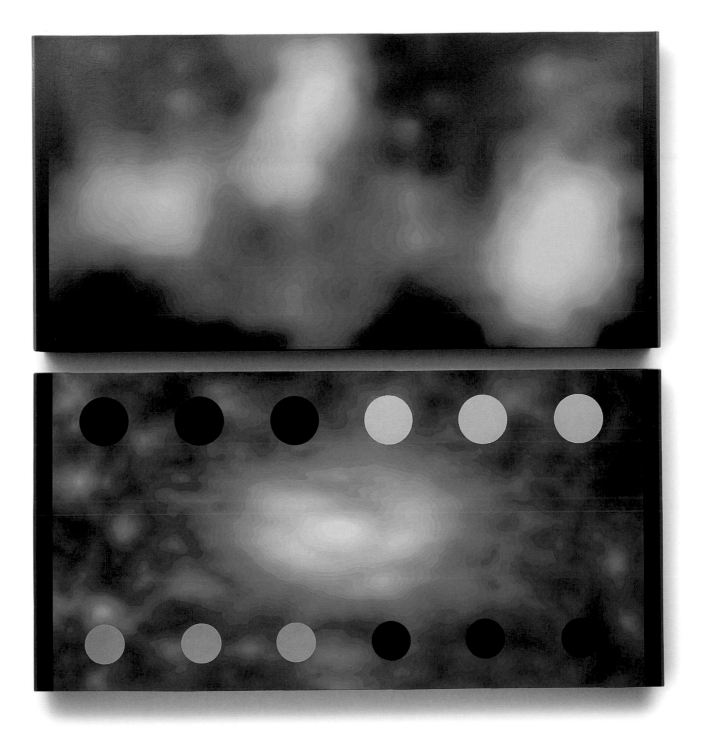

Joe Goode

American, born 1937

Commissioned Work (Three Panels), 1979
Oil on canvas
Three panels, 60½ x 127½ in. overall

53%

Untitled, 1962
Oil on canvas with glass bottle
67½ x 65½ in.

Joe Goode first attained national notice in the early 1960s under the rubric of West Coast Pop. His inclusion in the Pop category was largely based on his series of Milk Bottle paintings (such as this untitled work from 1962), in which he placed an actual milk bottle in front of an abstractly painted canvas, asking the viewer to compare the two objects and question the difference between a manufactured "real" object and a representation. After these initial works, Goode began to take landscape and nature as his central subjects, applying some of the conceptual and perceptual issues he had raised in his earlier work to the depiction of nature.

In the mid-1970s Goode began what would become a celebrated series of paintings of skies known as Torn Sky. In this series, Goode focused primarily on the physical treatment of the canvas and the interaction of image and surface. The works generally consist of two layers of paintings presented simultaneously: one layer of canvas that has been torn or punctured is placed in front of a second layer, which is thus visible through the holes of the first. Generally he painted both canvases with an illusionistically rendered sky in various ecological conditions. *Commissioned Work (Three Panels)* features a clear blue sky behind and a brown, smog-filled sky in front. The broken, almost disintegrating canvas of the top "sky" echoes the environmentally damaged sky it represents, suggesting that vandalism has damaged a once pristine sky. Below, Goode reveals and conceals a serene expanse of blue connoting a "healed," healthy sky that is at the same time a restored and whole painting.

The skies that fill Goode's works have been interpreted as symbols of California and its mythic place in the American imagination. While enticing and emblematic of a natural paradise, they also depict it as endangered. As in some of Ed Ruscha's images of the Southern California landscape, an undertone of violence and disintegration, unease and ruin, coexists with the image of California as the land of "eternally blue skies." *R. B.*

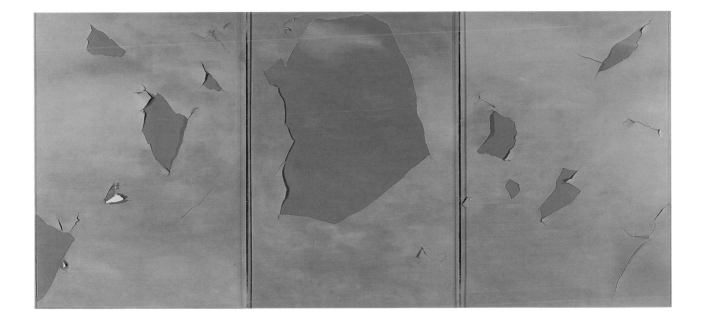

Arshile
Gorky
American, born Armenia, 1904–1948

Untitled—1946, 1946
Pastel and crayon on paper
19 x 25 in.

As a painter, teacher, and theorist, Arshile Gorky played a crucial role in the early development of Abstract Expressionism. He was a legendary figure and mentor to many young artists of the New York School, and his unique approach to the well-known forms of modern art was seen as revolutionary and groundbreaking. Gorky was perceived as the first artist to find a true synthesis of Cubism and Surrealism. His canvases were admired as much for their formal and structural sophistication as for the almost manic energy swirling in their unstable, constantly shifting forms. Further, he built into his works a highly esoteric and hermetic system of symbols that referred to his past and his personal memories. His technical innovations were primarily a way of constructing and showing the process of memory. This autobiographical subtext and the aura of tragedy that surrounded Gorky, who committed suicide in 1948, made him a prototype of the suffering, heroic artist associated with Abstract Expressionism.

The untitled drawing is most likely a preliminary study for an oil painting; Gorky often made hundreds of such sketches as preparatory drawings for his major canvases. While his finished paintings are noted for the way they teem with enigmatic symbols and smears of paint, the studies are relatively empty and simplified. They reveal Gorky systematically working out an approach to the space and basic forms of the composition. Particularly in this work, we see how he juxtaposed precise, linear drawings that seem to depict objects with patches of pure, fluid paint. In the finished paintings the linear drawing and the fluid paint typically merge, leading to the sense of an obscured or buried content, a "secret" meaning hovering amid the density of paint.

In this way Gorky built up his abstract, autobiographical allegories with seductive fragments of images—bits of trees, bodies, and places. Ultimately his paintings disclose neither a memory nor an image in any recognizable form. Rather, the intensity of the quest, the memory process as acted out in paint, itself becomes the subject and the image. The surface is redefined as a psychological stage or theater, an "arena in which to act," as it would later be called in the context of Abstract Expressionism. *R. B.*

Paolo
Grassino
Italian, born 1967

Cagna, 2002
PVC foam carpet
96 x 70 x 48 in.

Paolo Grassino works in the tradition of Arte Povera, Italy's best-known modern art move-
ment, which emerged in the 1960s. Arte Povera, or "poor art," was a diverse mixture of
Conceptual, Pop, and Minimalist trends in sculpture. Arte Povera took an improvisational
approach to sculpture and site-specific installation, stressing simple industrial materials,
formal experimentation, and social and political content.

Cagna is a freestanding sculpture originally made in connection with a larger instal-
lation from 2002 entitled *Perennial Themes.* This show comprised a series of rooms cov-
ered with tapestries made from PVC foam carpet, a synthetic industrial material. Depict-
ing landscapes populated by deer, stags, and dogs, the *Perennial Themes* walls deliberately
referenced hunting tapestries that traditionally decorated the houses of the Italian aris-
tocracy. Using the hunt as a metaphor for class relations, Grassino depicts deer and stags
pursued by vicious dogs, which symbolize the upper classes, thus presenting an image
of a society based on "survival of the fittest." The *Perennial Themes* installation included a
loud broadcast of grinding noises and sounds of barking dogs in each room, conjuring
up the sound of a machine of destructiveness found in both nature and culture.

Like the tapestries from the *Perennial Themes* show, Grassino's *Cagna* is also made
from PVC foam carpet. Grassino employed it here chiefly because its commonplace, every-
day associations counter the aristocratic origins of the tapestry format and because it is
inexpensive and easily available. In the hunt tapestries the dog is an extremely aggressive
and violent creature, while here it has been literally turned upside down. Formerly a sym-
bol of aristocratic privilege and superiority, it is now rendered in humble materials and
placed in an awkward position. The upending of the dog overturns its previous status as
a symbol of economic and social domination, instead turning it into a playful animal ren-
dered in beautiful colors and patterns. *R. B.*

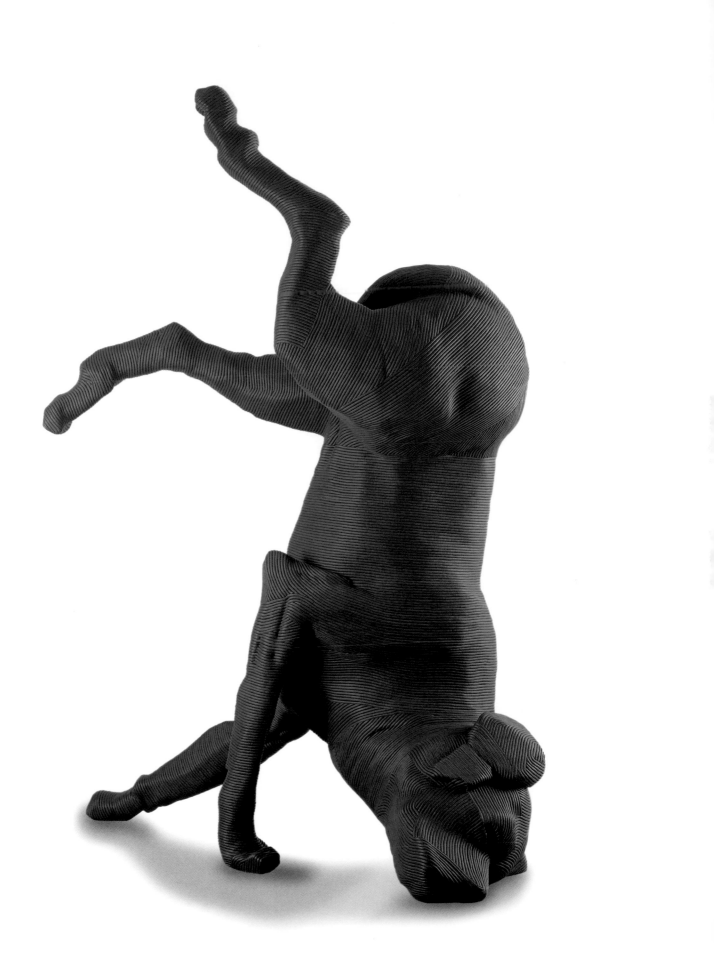

Red
Grooms

American, born 1937

L'Ours (The Bear), 1989
Wood and acrylic
47 x 67½ x 12½ in.

Mondrian, 1990
Painted bronze
24 x 19 x 14¾ in.

The Blue Restaurant, 1983
Oil on canvas
90 x 74 in.

Maverick artist Red Grooms has worked in a variety of media, ranging from the mixed media of his three-dimensional constructions to metal sculptures, prints, and watercolors. He was also a performance artist and filmmaker in the 1950s. His affinity for theater and dramatic eclecticism later became evident in the generously scaled tableau-like works—or "sculpto-pictoramas"—for which he is best known. Employing an eccentric, graphic, almost cartoon style, he offers his own highly personal take on Pop Art.

Celebrated for its whimsical and sometimes satirical humor, Grooms's art chronicles the pleasures and absurdities of modern culture and ordinary American life. Many of his sculpto-pictoramas situate the viewer among everyday yet peculiar scenes. *L'Ours* (*The Bear*) was inspired by an actual event that the artist, his wife, and his mother-in-law experienced. The group was dining at a friend's cabin in Wyoming when a bear broke through the front door. It walked inside, circled the table where they sat (and stopped and viewed a picture on the wall, according to Grooms), then ambled back out through the door. Grooms created the artwork to commemorate this frightening yet delightfully remarkable event.

Born in Nashville, Tennessee, and based in New York City, Grooms has expressed through his art a lifelong fascination with urban culture, particularly that of New York. His loving portrayals of city life often merge with his characteristically irreverent glimpses of the art world and society's fascination with fame, glamour, sports, and entertainment. Celebrities, from actors to art stars, appear throughout the artist's work, and their depiction combines elements of parody and tribute. Homage is also paid to his art historical predecessors, as in the painted-bronze work *Mondrian,* which caricatures the Dutch painter. Piet Mondrian was one of the founders of De Stijl, a seminal movement in modern art and design whose principles were highly intellectual, a point Grooms makes by placing a structural girding around the artist's head. Similarly, in his painting *The Blue Restaurant,* Grooms played directly on a work by Vincent van Gogh—*The Night Café*—including the original's billiard table and café characters but adding a distinctively upbeat, Grooms-style American twist. *K. M. S.*

Rocker, 1972
Oil and mixed media on polyester resin
72 x 32½ x 14 in.

**Mary Weisman (Mother of Frederick R.
Weisman),** 1994
Oil on bronze with cloth apparel
62 x 60 x 39 in.

Executive in Blue Chair, 1988
Oil on bronze with cloth apparel
44½ x 52 x 30 in.

Duane Hanson captured the attention of the art world in the mid-1960s, when he began creating disarmingly lifelike "superrealist" sculptures based on prototypes of unheroic humanity. Presenting generic "types" of the common man and woman, the artist portrayed people at the margins of society, such as drug addicts and the homeless, as well as typical middle-class Americans, including tourists, grocery shoppers, manual laborers, janitors, children, and the elderly.

Hanson achieved the eerily realistic appearance of his life-size figures by creating plaster casts from live models, whose bodily replicas, not personas or identities per se, would be incorporated into the work. Hanson would cast each figure in several sections with various materials, including polyester resin, fiberglass, Bondo, and vinyl. He later would also cast figures in bronze. After painting the "skin" in flesh tones and in such detail as to resemble human flesh, he would then finish the sculptures with hair and dress them in actual clothing and accessories befitting their social group. In the polyester resin sculpture *Rocker,* a stereotypical representation of a leather-clad biker, Hanson has included the requisite helmet, jacket, and boots to further the reality effect.

Through an aesthetic that is immediately accessible to the average person, and through meticulously detailed representations of anonymous, ordinary individuals, Hanson's art engenders empathy with the unremarkable and illuminates the humanity of everyday people and their lives. Only once was he commissioned to create portraits of specific individuals. *Executive in Blue Chair* and *Mary Weisman* are painted bronze sculptures that Hanson created of William and Mary Weisman, Frederick Weisman's parents. Weisman requested the commission as a tribute to and commemoration of his parents, who had passed away several years before.

The artist faced a formidable challenge when accepting the commission, for these were meant to be not stereotypes but dignified portraits of actual individuals, sculptures that were meant to capture not only an exact resemblance but also the essence of Weisman's parents. Most significantly, Hanson was unable to use his customary body-casting technique from the live model; he instead had to rely on photographs and family members' descriptions to achieve in three dimensions a proximity to the lived appearances. After months of creating studies and preliminary models, working closely with the family's input, Hanson finally completed the figures of William and Mary. They were clothed in appropriate attire, enhanced by personalized accessories, such as pearls and a purse for Mary, and an office chair and telephone for William, a business executive.

Executive in Blue Chair and *Mary Weisman* were commissioned by Weisman in three sets, one for each of William and Mary's three sons. One of these sets was given to the University of Minnesota in Minneapolis, one set was reserved for traveling exhibitions, and one is on permanent display at the Weisman Art Foundation in Los Angeles. *K. M. S.*

Keith
Haring
American, 1958–1990

Untitled, 1983
Ink on vinyl tarpaulin
78½ x 78½ in.

Untitled (Motorcycle), 1987
Acrylic and marker on metal and plastic
48 x 86 x 32 in.

First known for his graffiti-inspired chalk drawings in the subways of New York—simple, iconic images that became a familiar sight along the underground commuter's daily route—Keith Haring later extended his visual language to a multitude of everyday surfaces, including walls, doors, furniture, appliances, the human body, and materials such as the vinyl tarpaulin of his untitled painting of 1983. He also mass-marketed his art on buttons, bags, coffee mugs, T-shirts, and other items through his Pop Shop—so that "everyone can own a Haring," as he explained. He believed that art should be a part of everyday life, accessible to and enjoyed by everyone.

Allied with Haring's outlook on art is the simple, highly graphic style of his iconic lexicon. Thick contour lines, bright colors, lively action, and morphing imagery convey his often joyful and innocent vision. In this untitled painting, Haring created a mazelike design that appears in various forms throughout his work. As in many of his images, the pattern is transformative. Linear motifs, figures, and symbols morph in and out of one another in a style that is located somewhere between writing, pictographic code, and pure abstract design.

Dissolving the boundary between the gallery and the street, Haring quite literally took his fusion of art with the everyday to the streets in 1987 with custom-painted motorcycles such as this Honda CBR. Covered with the artist's slick, interlocking designs, this work of art registered significant mileage and received ample public view before entering the Weisman collection. The "street art" movement of which Haring was an integral part was more than a mere artistic style of the 1970s and 1980s; it was a powerful and innovative subcultural manifestation. The movement was made up predominantly of artists struggling outside the gallery system, unrepresented and underpaid, and Haring played a significant role in bringing recognition and legitimacy to the movement and "breaking into" the established fine art system.

Haring was driven by an impassioned desire to communicate, and by his death at the age of thirty-one, he had established himself as one of the world's most famous culturally and socially committed artists. With innumerable commissions for public murals and sculptures in the United States and overseas—and while continuing his use of consumer goods as a "message board"—he gave his voice and talent to many social causes, including gay- and AIDS-related concerns, as a means of increasing public awareness and raising financial support. The nonprofit organizations that Haring supported in his lifetime continue to receive assistance today from the artist's foundation, and his art continues to reach broad audiences worldwide. *K. M. S.*

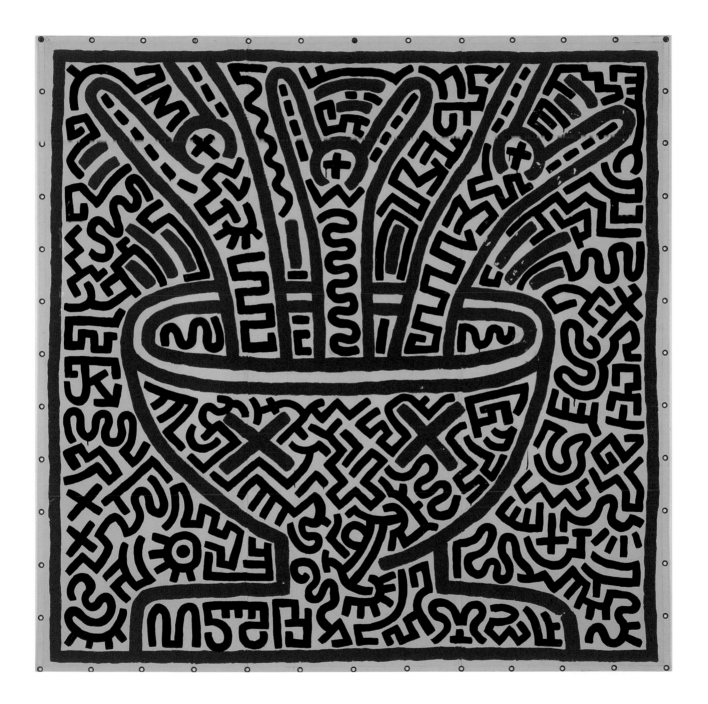

Tim

Hawkinson
American, born 1960

Scribe, 2001
Ink on rag paper on panel
77 x 18 in.

The Fin Within, 1998
Aluminum with unique patina
36 x 15 x 15 in.

Life-Size Mirror Self-Portrait, 2000
Aluminum foil and acrylic on polyester
80⅞ x 22 in.

Los Angeles–based artist Tim Hawkinson works with vastly diverse methods, materials, scales, and approaches. His range of creation is evident not merely from one point in his career to another, but literally from one work to the next. While his art has often been identified as a departure from that of other innovative California Conceptualist sculptors—such as Chris Burden, Bruce Nauman, and Charles Ray—it defies ready categorization.

Hawkinson's unique modes of self-portraiture transcend documentation and self-expression to contemplate, at once universally and individually, the terrain of the human body, perception, and the transience of existence. In *Life-Size Mirror Self-Portrait,* the artist has translated a full-length view of himself in the mirror. The upper body of the resultant figure is foreshortened, while the legs, feet, and toes are drastically attenuated, resembling flippers or fins. Placed on a reflective material that simulates water and echoes the mirror in which he has become an "other," the distorted form has a haunting quality that suggests an evolutionary mutation from a watery primordial state into a Paleolithic being or, alternately, the sensation of seeing a stranger when contemplating one's own reflection.

Hawkinson's art often deals with the human form as a universe, microcosmically embodied, and the empirical charting of its topography. The spiraling, maplike forms that make up *Scribe* are in fact the artist's intricate mappings of his own bodily dimensions. In one-inch intervals from head to toe, Hawkinson took circumference measurements of himself and created a formula to plot the documented mass on a grid. Using a special drill-and-pen device that he created, he was able to control variations in the spiral proportions. Often based on scientific or mathematical principles, Hawkinson's work is gracefully poetic and often obsessive in its meticulous detail, examination, and documentation. As epitomized in *Scribe,* the self as physical body in his art becomes a koan—a riddle or paradox to be meditated on and explored—and an utterly new territory to be discovered.

Hawkinson's art lyrically engenders subtle yet profound reflections on the body and time, effects often alluded to in salient, multivalent titles. *The Fin Within,* for example, in both dimension and name, invokes differing notions of the human trace—the mark that is the body's impression of negative space (between the artist's own legs) and the embodied shadow of a possible evolutionary past. Creating intriguing, incongruous worlds of possibility, Hawkinson calls upon viewers to enter visual and intellectual grounds of play, to read between the lines—or, as it were, to see "the fin within." *K. M. S.*

David
Hockney
English, born 1937

Ann Upton Combing Her Hair, 1979
Acrylic on canvas
60 x 30 in.

**Metropolitan Opera House, New York,
December 14, 1982,** 1982
Photocollage on board
61½ x 51½ in.

The theme of vision unifies David Hockney's many styles and subjects. Throughout his development, he has investigated questions pertaining to the gaze—how we look, how objects are seen, and how "scenes" are created and experienced. The two works represented here evidence the various aspects of his interest in vision: the earlier work explores a seemingly simple scene of looking through traditional painting methods, while the later work is a more complicated photographic construction that explores multiple points of view.

Hockney has always been very interested in how earlier artists dealt with the interrelationships among vision, perspective, temporality, and spatiality. His ongoing dialogue with the history of vision and painting is evident in *Ann Upton Combing Her Hair,* which combines a seemingly realistic, ordinary scene of a woman combing her hair with more "traditional" questions about painting and perspective. Indeed, through the tilted background space, receding table, deliberate brush strokes, and characteristic shades of blue, Hockney seems to be explicitly referencing Paul Cézanne in this work. An ordinary event—a woman combing her hair in front of a mirror—suddenly becomes intriguing once we consider the many gazes built into the painting. We see what the artist sees as he watches and paints a woman seeing herself. The painting both reveals, like a mirror, and conceals, like a screen, for we "see" in the painted mirror the face of the woman whose back, in the painting, is turned toward us.

Metropolitan Opera House, New York, December 14, 1982 comes from Hockney's series of photocollages from 1982–86 called "joiners," which grew out of his studies of Analytic Cubism. Using a camera, Hockney sought to re-create through photography the fractured, splintered, and multiple perspectives that typify Cubist painting. He has noted, "I realized that this sort of picture came closer to how we actually see . . . in discrete, separate glimpses which we then build up into our continuous experience of the world."[1] This work is an especially witty and self-referential example of the photocollage, for the scene that Hockney has splintered and conjoined into multiple points of view and multiple temporalities is a theater, where hundreds of chairs—and thus pairs of eyes—are directed toward one central place at the same time. *R. B.*

Notes
1. David Hockney, quoted in Lawrence Weschler, *Cameraworks: David Hockney* (New York: Alfred A. Knopf, 1984), 11.

Hans
Hofmann
American, born Germany, 1880–1966

Orbiting Shapes, 1959
Oil on canvas
50 x 40 in.

As a teacher of abstract painting in New York for more than forty years, Hans Hofmann sought to create a systematic philosophical and aesthetic theory of modern art that could unite an almost mystical belief in the emotional and spiritual power of paint with a rigorously logical and technical understanding of space, plane, and surface. For Hofmann, the goal of painting was to represent a synthesis of dualities. Each canvas was to be a place where oppositions coexisted and vied: the painterly and the structural, the analytic and the emotional, the preconceived and the impulsive, the romantic and the classic.

Orbiting Shapes presents a paradox to the viewer, for it claims to represent an "orbit"— a spatial circuit possible only in three-dimensional space—on a flat surface. The problem of how to convey the depth and volume of three dimensions on a two-dimensional canvas was for Hofmann *the* central dialectical process informing all abstract art. While Renaissance painters had responded to this problem with the invention of perspective, Hofmann responded with the idea of "push-and-pull," or the juxtaposition and overlapping of colored planes on the surface to create a sense of movement. In *Orbiting Shapes,* this movement is most clearly created through the strong contrasts of light and dark forms. A fan-shaped array of forms orbit in a left-to-right circular spiral around the canvas. Pushed by large, gestural brush strokes, the moving planes then meet a series of vertical planes pushing in the opposite direction. The expressive use of paint helps reinforce a rhythmic motion, demonstrating the idea that each time the picture plane is activated, it reacts automatically in the opposite direction to the stimulus received.

While full of motion, *Orbiting Shapes* completes Hofmann's interest in dialectical structure by simultaneously creating a strong architectural sense of static stability. The circular orbit is contained within a balanced geometry of deliberately placed squares. Movement and structure are united by thick paint and a vibrant interplay of the primary colors, which Hofmann saw as having a direct spiritual and metaphysical impact. Painting was ultimately seen as one step in a larger "progress of the spirit," in which oppositional terms would be united or transcended by a higher reality. *R. B.*

Jenny
Holzer

American, born 1950

Selections from the **Survival** series, 1983
Electronic LED sign with red diodes
6½ x 60¼ x 4½ in.

Socially committed artist Jenny Holzer moves art out of the gallery and into the broad public domain through her subversive appropriation of mass-media and advertising techniques. Since 1977 she has displayed her signature slogans—pithy social, political, and personal commentaries—on various public surfaces, including street posters, bench placards, stadium scoreboards, large-scale electronic advertising boards, and smaller LED displays, such as this electronic work from the Survival series. The effect of such phrases as "Abuse of Power Comes as No Surprise," "Grass Roots Agitation Is the Only Hope," or "Protect Me from What I Want" is the shock of estrangement. One expects the inanity of mindless advertising or media messages from these familiar vehicles, but what one encounters instead are provocative and often uncompromising statements that incite reflection. Holzer's tone of anonymous authority provokes viewers to question the authenticity of the displays (advertising or not?), the source of the declarations, and their personal or sociopolitical validity. The artist's methods alone undermine the stereotyped messages of mass communication and its powerful role as a tool of social conditioning, while the disconcertingly impersonal tone of her works ironically underscores the inherent emptiness of the media and of media-manipulated society.

Holzer first introduced language into her art while completing her master of fine arts degree at Rhode Island School of Design. She then moved to New York City in 1977 and participated in the Independent Study Program at the Whitney Museum. During that year she created her first fully textual pieces—the series entitled Truisms—with the intention of making complex issues intelligible as public art. Then, as now, Holzer infused her work with often complicated psychological, political, social, and economic themes, examining the relationship between language and experience, on one level, and between the individual and society, on another. In addition to her interactive "street" displays, her work has been shown in prominent institutions throughout the world, including the Solomon R. Guggenheim Museum in New York and the Centre Pompidou in Paris. *K. M. S.*

YOU ARE TRAPPED ON THE EARTH SO YOU WILL EXPLODE…PUT FOOD OUT IN THE SAME PLACE EVERY DAY AND TALK TO THE PEOPLE WHO COME TO EAT AND ORGANIZE THEM…SAVOR KIND-NESS BECAUSE CRUELTY IS ALWAYS POSSIBLE LATER…DANCE ON DOWN TO THE GOVERNMENT AND TELL THEM YOU'RE EAGER TO RULE BECAUSE YOU KNOW WHAT'S GOOD FOR YOU…SPIT ALL OVER SOMEONE WITH A MOUTHFUL OF MILK IF YOU WANT TO FIND OUT SOMETHING ABOUT HIS PERSONALITY FAST…MOTHERS WITH REASONS TO SOB SHOULD DO IT IN GROUPS IN PUBLIC AND WAIT FOR OFFERS…OUTER SPACE IS WHERE YOU DISCOVER WONDER, WHERE YOU FIGHT AND NEVER HURT EARTH. IF YOU STOP BELIEVING THIS, YOUR MOOD TURNS UGLY…DIE FAST AND QUIET WHEN THEY INTERROGATE YOU OR LIVE SO LONG THAT THEY ARE ASHAMED TO HURT YOU ANYMORE…IN A DREAM YOU SAW A WAY TO SURVIVE AND YOU WERE FULL OF JOY…IF YOU'RE CONSIDERED USELESS NO ONE WILL FEED YOU ANYMORE…WHEN YOU EXPECT FAIR PLAY YOU CRE-ATE AN INFECTIOUS BUBBLE OF MADNESS AROUND YOU…YOU ARE SO COMPLEX THAT YOU DON'T ALWAYS RESPOND TO DANGER…MEN DON'T PROTECT YOU ANYMORE…WITH ALL THE HOLES IN YOU ALREADY THERE'S NO REASON TO DEFINE THE OUTSIDE ENVIRONMENT AS ALIEN…WHEN SOME-ONE BEATS YOU WITH A FLASHLIGHT YOU MAKE LIGHT SHINE IN ALL DIRECTIONS…FINDING

EXTREME PLEASURE WILL MAKE YOU A BETTER PERSON IF YOU'RE CAREFUL ABOUT WHAT THRILLS YOU…IT IS IN YOUR SELF-INTEREST TO FIND A WAY TO BE VERY TENDER…THE BEGIN-NING OF THE WAR WILL BE SECRET…THE CONVERSATION ALWAYS TURNS TO LIVING LONG ENOUGH TO HAVE FUN…WHAT COUNTRY SHOULD YOU ADOPT IF YOU HATE POOR PEOPLE?..USE WHAT IS DOMINANT IN A CULTURE TO CHANGE IT QUICKLY…PROTECT ME FROM WHAT I WANT…IT'S HARD TO KNOW IF YOU'RE CRAZY IF YOU FEEL YOU'RE IN DANGER ALL THE TIME NOW…THE FUTURE IS STUPID…HIDE UNDERWATER OR ANYWHERE SO UNDISTURBED YOU FEEL THE JERK OF PLEAS-URE WHEN AN IDEA COMES…SOMEONE ELSE'S BODY IS A PLACE FOR YOUR MIND TO GO…WHEN THERE IS NO SAFE PLACE TO SLEEP YOU'RE TIRED FROM WALKING ALL DAY AND EXHAUSTED FROM THE NIGHT BECAUSE IT'S TWICE AS DANGEROUS THEN…IT'S EASY TO GET MILLIONS OF PEOPLE ON EVERY CONTINENT TO PLEDGE ALLEGIANCE TO EATING AND EQUAL OPPORTUNITY…GO WHERE PEOPLE SLEEP AND SEE IF THEY'RE SAFE…HANDS ON YOUR BREAST CAN KEEP YOUR HEART BEATING…TURN SOFT AND LOVELY ANY TIME YOU HAVE A CHANCE…YOU LIVE THE SUR-PRISE RESULTS OF OLD PLANS…LET YOUR HAND WANDER ON FLESH TO MAKE POSSIBILITY MUL-TIPLY…SHOOT INTO INFINITE SPACE TO HIT A TARGET IN TIME AND CALL IT INEVITABLE…YOU

Robert
Irwin
American, born 1928

Untitled, 1968
Acrylic lacquer on plastic, installation
Plastic disc: 54 in. (diam.)

Best known for art that engages the perceptual play of light, space, and form, Robert Irwin has aptly described himself as a Perceptual artist. He has explained that his art is about experience itself, with the "act of art" serving as a tool for extending and articulating the "shape of our perception." Like many emerging artists of the late 1950s and early 1960s, Irwin began his career as an Abstract Expressionist painter, already questioning conventional pictorial approaches. In the mid to late 1960s he broke with painting and initiated his pivotal inquiry into more radical reductions of traditional "frame and object" art forms. Irwin's goal was to eliminate the art object—to "dematerialize" it through phenomenological means.

Focusing on experimentation and exploration of sensory perception, Irwin and fellow California artist James Turrell formed the nexus of the distinctly West Coast Light and Space movement. Employing the effects of light, color, space, and innovative materials such as cast resin, fiberglass, acrylic, and lacquer, these artists aimed to confound the boundaries of painting, sculpture, and architecture. While demonstrating certain principles of Minimalism, their perceptual focus was distinct from the Minimalists' concrete, objective endeavors.

This untitled work demonstrates Irwin's attempt not merely to reduce the object in a Minimalist sense, but to "dematerialize" it through the interplay of lushly colored, semitransparent materials—acrylic lacquer on cast acrylic—and the surrounding light and environment. Articulating the "shaping of perception," the surface of the work "dissolves" in the effects of light moving through it, in the space around it, and reflecting from its surface.

The object was further dematerialized in Irwin's celebrated Light and Space installations, for space was treated as an independent subject. Partly inspired by the principles of Gestalt psychology, Irwin would manipulate various ephemeral elements—different types of light and shifting light and shadow—through architectural frameworks of transparent scrims and screens that he would design and construct inside a space.

For the viewer, each installation was a whole yet ephemeral sensory experience. One could experience a heightened awareness of self in relation to the perceptually "shifting" surroundings, and the eye could be deceived into perceiving something other than what was actually there. These effects have inspired critics to suggest metaphysical and scientific interpretations of Irwin's art. Since the 1980s he has carried his investigations into existing spaces as site-generated or site-specific projects, including major installations at the Dia Center for the Arts in New York and the celebrated Central Garden of the J. Paul Getty Museum in Los Angeles. *K. M. S.*

Vincent
James
English, born 1972

Bullets, 2000
Acrylic, neoprene, and styrofoam
Six parts: 13 x 3½ in.; 12 x 4 in.; 12 x 3½ in.;
11 x 4 in.; 9 x 3 in.; 7 x 4 in.

British artist Vincent James's sculptural installations translate images from the world of cartoons into fully realized three-dimensional objects and environments. Combining comic book imagery such as that explored by Roy Lichtenstein with the surreal sculptural humor of Claes Oldenburg, James's work links the legacy of Pop to a postmodern investigation of art as a form of child's play. Delving into the bizarre plastic visuality of cartoon animation, James examines some of the same questions that Lichtenstein was looking at in his comic strip paintings: the relation between narrative and vision, movement and stasis, temporality and timelessness, and how these essentially semiotic questions are bound up with a problem of violence. Displaying affinities with the work of contemporary artists such as Tom Otterness, James's resulting view of the seemingly innocent world of childhood, as epitomized by the Saturday morning cartoon, is troubled by potential, implied, and explicit violence.

Thus, James's *Bullets* might be read in relation to Lichtenstein's famous series of "Blam!" paintings, which depict pixilated guns at the moment of explosion, caught in a strange netherworld that mixes action with stasis, adult violence with "innocent" cartoons. James's carrot-bullets are similarly caught in a frozen aesthetic moment that turns a fantastic element from cartoon animation into a three-dimensional sculptural environment. The force of an implied explosion is slowed down, just as the flow of an implied animated movie is morphed into a static, surreal world where carrots can be embedded into walls. While indexing the fictional and fun world of Bugs Bunny, the carrots become very real objects with solid substance, casting crisp shadows on the wall. Placed at an unstable border where fiction becomes reality, James's carrots seem to take us into an imaginary realm peculiar to childhood, yet not idealized into a pastoral, purely innocent world. Other objects from this series include axes slicing into walls and large saws cutting through the floor, thus bringing out a consistent problematic of violence and destruction that seems to be intrinsic to the childhood imaginary. *R. B.*

Jasper
Johns

American, born 1930

Untitled (from Untitled, 1972), 1975
Ink wash on plastic
16 x 39 in.

Target, 1963
Watercolor
25½ x 19½ in.

Jasper Johns's seminal paintings of flags, targets, and numbers from the mid-1950s brought him rapid acclaim as a master of cool, detached literalism. By closing the gap between a thing and its representation (for example, creating a painting of a target that *is* a target), Johns's self-reflexive formalism helped foster Pop Art, Minimalism, and Conceptualism. By the late 1950s Johns had shifted away from his impassive style, contrasting the deadpan reserve of previous works with the use of energetic brush strokes and "rocket bursts," or clusters of strokes, and a more layered spatial field. In the 1960s he began to collage everyday objects into his paintings, while continuing his iconic use of flags, targets (as in *Target* of 1963), numbers, and then maps.

Johns's increasing attention to craft, materials, and process was stimulated by his initiation into printmaking in 1960. From that point on, he would use paint for a new motif while simultaneously producing printed works referencing earlier motifs. The rocket bursts, crosshatches, and flagstones are among the patterns that have moved through his oeuvre from painting to print, along with his iconic motifs, which have included ale cans and cast body parts. Johns has also explored these themes through drawing in a variety of media, such as the ink on plastic of his untitled work from 1975.

Encapsulating the manifold artistic and temporal layers that characterize Johns's work, this drawing is directly based on the artist's major transitional painting from 1972, also untitled. In the painting, Johns introduced his use of hatch-mark patterning, which became the principal motif in his work from 1973 to 1981. A four-panel oil and encaustic work on canvas, the 1972 painting is an anthology of themes from various points in Johns's career, including the new crosshatch design in one segment, flagstones (which he began using in 1967) in the center panels, and cast body fragments (begun in 1955) superimposed on flagstones in the fourth panel.

By layering motifs from different phases of his work, Johns has sustained an ongoing temporal dialogue with his own creative process. Concerns with time, memory, and autobiography are reflected in his oeuvre, as the artist has engaged what he views as the "fragmentary experience of life," whose facets and meanings one pieces together over time. *K. M. S.*

Donald Judd

American, 1928–1994

Untitled, 1984
Painted aluminum
11¾ x 35 x 11¾ in.

Untitled, 1967/1980
Steel and Plexiglass
Ten elements: 9 x 40 x 31 in. each

With an affinity for the cool detachment of industrial materials and processes, Minimalist Donald Judd often used Plexiglas, stainless steel, galvanized metal, and aluminum to fabricate works marked by extreme formal reduction. His rejection of the expressive, representational, and illusionistic qualities of painting led him to abandon the medium altogether in the early 1960s and to focus instead on sculptural form. For Judd, art's last vestige of illusionism could be eliminated only by working in three dimensions, and concerns with representation and expression could be eliminated only when the portrayal and the portrayed were somehow one and the same. To this end, Judd built "specific objects"—objects simply as objects—which he insisted lacked any significance beyond what was literally there. While Minimalism was intensely theoretically driven, Judd's inclination toward concrete experience and search for an experientially verifiable truth were perhaps already grounded in his earlier interest in philosophy, which he studied as an undergraduate before pursuing art.

Like the work of other Minimalists, Judd's art concentrated on basic geometry, seriality, and progression, while inspiring viewers' physical sense and aesthetic apprehension through an innovative employment of industrial materials and astute use of color, angle, rhythm, and scale. Instead of exploring perception itself, however, like many of the other major Minimalists, Judd programmed perception *into* his "specific objects," most richly integrating considerations of the viewer into the work. This untitled object, for example—which is made up of individually painted, open modular forms—has a complex internal character that is derived not only from variation in shape but also from the interrelation of different colors. The compartmentalization of form and color sharpens viewers' awareness and perception of the object as a whole. With its "reason to be" residing in its literal objectivity, this Minimal work is prototypically without "expression," "content," or "meaning" and restricts itself to the interaction of object, space, and viewer. Although other Minimalists may have employed a similar geometric modularity and semantically reductive approach, Judd's famous box reliefs, floor boxes, and stacked wall boxes achieved a singularity of focus, form, and effect that was genuinely new. *K. M. S.*

Anish Kapoor

British, born India 1954

Blood Mirror III, 2000
Stainless steel and lacquer
78½ (diam.) x 18⅛ in.

Anish Kapoor first gained recognition in the early 1980s for a project entitled *1,000 Names*—a series of delicate, ephemeral sculptures made from vibrant powdered paint pigment. Brilliantly colored vertical mounds, columns, spheres, and cones were strewn across an otherwise empty floor. They seemed to be disintegrating, so fragile that the slightest breath would crumble them further into dust. With this early work, Kapoor introduced what would become his central concern as a sculptor: undoing what he calls the "phallic form" of modernist sculpture. Since the *1,000 Names* project, he has developed a unique approach to form that explores more traditionally female-associated spaces such as holes and voids. He acknowledges the strong influence of a "matriarchal view of creativity," noting that he "has always been engaged with interiority, that which is inside."[1]

In his effort to deconstruct form, Kapoor began to introduce round mirrors into his work in the mid-1990s. Previously he had used highly polished steel for the surface of some of his sculptures to produce a mirrored effect. Viewing one of his usually spherical works at close range, one would have seen an inverted, anamorphically distorted world spread out across the surface of the sculpture. Through this technique, Kapoor created another kind of "interior" within the space of the gallery—the virtual world of the mirror.

Blood Mirror III combines Kapoor's use of brilliant color and mirror effects. It is tinted a vibrant red and was originally displayed with flat, fluid sculptures that represented drips and pools of crimson blood. Countering "phallic" form, his bloody works suggest wounds, cuts, and liquids flowing from the body in unstable and amorphous shapes. The traditional associations of blood and open, flowing forms with femininity are echoed in this work's round mirror, which contains a womblike circular universe. Peering into its depths, the viewer is drawn into a virtual vortex that opens up an imaginary hole in the wall. *R. B.*

Notes
1. Anish Kapoor, in Constance Lewallen, "Anish Kapoor" (interview), *View* 7, no. 4 (1991), cited in Germano Celant, *Anish Kapoor* (Milan: Edizioni Charta, 1998), 27.

Craig
Kauffman

American, born 1932

Yellow-Blue, 1965
Vacuum-formed acrylic
90 x 46½ x 4½ in.

Craig Kauffman was one of the first artists to make paintings with vacuum-formed plastic, an industrial technique commonly used in advertising. In the 1960s Kauffman and other Southern Californian artists shared an interest in car and surf culture, as well as in how light affects the perception of space. With both concerns in mind, he adapted the commercial manufacturing process to art making, producing low-relief paintings characterized by smooth contours and highly polished reflective surfaces. These attributes were common to automobiles and surfboards but hitherto rarely seen in painting.

As early as 1961, Kauffman experimented with plastic, painting organic abstractions on Plexiglas. In 1964, after observing vacuum-formed objects and plastic electric signs in restaurants, he interviewed factory workers to learn about the process. Later that year, he began using a mold to make low-relief paintings identical in shape but varied in color.

Yellow-Blue is from Kauffman's first series of vacuum-formed paintings. Although the central amoebic shape with extending bars is derived from his earlier abstract paintings, the presence of the artist's hand has been eliminated in favor of industrial fabrication, an approach that was favored at the time by New York Minimalists such as Donald Judd, Carl Andre, and Dan Flavin. As in the color-field paintings of Ellsworth Kelly, the composition is divided into two areas of color that provide the work's title. Yet, in contrast to the art of Kauffman's East Coast counterparts, *Yellow-Blue* is more animated. With light properly directed toward its pristine surface, and as viewers move about a room, the work appears to fluctuate subtly, paralleling the effects of light on shimmering cars or surfboards. *D. S. R.*

Ellsworth Kelly

American, born 1923

Red-Orange Panel, 1982
Painted aluminum
30 x 31⅜ x 3/16 in.

American abstract painter Ellsworth Kelly is known for the reductive visual language that he has explored and elaborated throughout his career. While living in France, Kelly began to develop his characteristic approach, with many of his early paintings consisting of a mere section of color floating on a neutral background. He returned to New York in the mid-1950s, and the innovative shaped panels and flatly painted, geometric style that he employed from 1958 on stood at odds with the gestural brushwork of Abstract Expressionism, which was then the dominant abstract style in the United States. By eschewing all referential content (brush marks, subject matter, and so on), Kelly reduced the whole "picture" to a painted surface and its support; subject and painting were one.

Kelly's sole concern with the internal relationship between color and form, usually explored through shaped panels, embodied an impressive economy of means. Working from sketches and photographs of his reference material—architecture, bridges, stairways, shadows, plants—the artist would hone these forms until they ceased to depict the object at all. The resultant shape of the support, which determined the form and scope of the painted surface, articulated the surface as a single field of color, a field that visually became the form. Kelly's formal reduction and undermining of the conventional rectangular canvas were key contributions to the Minimalist assertion of the painting as object.

The severity of his singularly shaped pictorial structures was occasionally moderated by the superimposition of multiple forms, and while the brilliant colors of his works were an integral facet of their objective statement, the marked contrast between stark white and deep black also fascinated him. In their objectlike character, particularly in the case of the Shaped Canvases and the Painted Wall Sculpture series, Kelly's works often transcended the border between painting and sculpture. Although he occasionally created freestanding sculptures as well, it was through his spare, "hard-edge" painted abstractions, in which shape and color achieved an irreducible clarity, that Kelly played a pivotal role in the development of American abstract art. *K. M. S.*

Edward and Nancy Reddin
Kienholz

Edward Kienholz: American, 1927–1994
Nancy Reddin Kienholz: American, born 1943

Pedicord Apts. (Drawing), 1985
Mixed-media construction
47 x 90¼ x 15 in.

Edward Kienholz and Nancy Reddin Kienholz were renowned assemblage artists of the 1970s. Based primarily in Los Angeles, they collaborated on projects from the time of their meeting and marriage in 1972. Nancy began her career as a photographer, while Edward was a self-taught sculptor whose artistic legacy dates to the mid-1950s, when he began assembling "collage-paintings" of everyday objects. His offbeat, improvisational creations— nailed together from fragments of furniture, appliances, fabric remnants, wood, and other discarded materials—revealed his inspiration in the Beat poetry of the 1950s, while linking him to California's Funk Art movement. These works soon evolved into his signature life-size, freestanding tableaux, on which he and Nancy later collaborated.

Although made from scrap materials like those employed in his earlier works, these staged environments are meticulously constructed and often incorporate figures cast from life. Compelling and sometimes bizarre juxtapositions of found objects, imagery, and materials charge these tableaux with psychological intensity and lurid surrealistic associations. As psychosocial allegories of the ebb and loneliness of urban existence, the Kienholzes' art is renowned for its haunting portrayal of the human condition.

Pedicord Apts. is one such sign—literally—of urban decay and human nostalgia. This mixed-media construction is partly made up of the original sign from the old Pedicord Hotel in Spokane, Washington, in Edward's home state. Salvaged from the hotel wreckage, the sign itself marks a derelict piece of Spokane history, while its artistic reclamation alludes to a nostalgic salvaging of Edward's personal past, a fragment of time that has been reclaimed and transformed.

The Pedicord sign not only inspired Edward and Nancy's mixed-media construction but also became the impetus for their walk-in tableau of 1982–83, also titled *Pedicord Apts.,* which is permanently on view at the Frederick R. Weisman Museum, Minneapolis. Constructed of materials from the demolished building, the tableau invokes both a reminiscence of the Pedicord Hotel and a memory Edward had of once walking through the corridor of a rundown residential hotel in Berkeley. The disquieting installation he and Nancy created universalized that experience, providing entering visitors with a visually and aurally interactive experience, including a life-size lobby and a darkened hallway with sounds of a television droning, a woman sobbing, and a dog barking behind separate closed doors. The tableau epitomizes the dead-end residential hotel, infused with the past and its sensations, suspended in time. *K. M. S.*

Louise
Lawler
American, born 1947

You Can't Buy One without the Other,
1999–2000
Cibachrome and black-and-white photographs
Two parts: 39¼ x 48 in., 15⅛ x 17⅝ in.

Since the 1980s Louise Lawler has examined the economics, politics, and social structure of the art market by photographing works by well-known artists in a variety of settings. As with most Conceptual artists of her generation, Lawler's interests lie outside mere representation or documentation. She seeks to call viewers' attention to the way the significance of art objects is shaped by their institutional contexts. She does this by exposing the strategies and mechanisms of art presentation that normally go unnoticed by museum and gallery visitors. Whether photographing works by historically recognized figures such as Jackson Pollock, Jasper Johns, and Andy Warhol, or by contemporary artists such as Cindy Sherman and Damien Hirst, Lawler rarely depicts an art object in isolation.

Over the years Lawler has photographed works in private collectors' homes (including the Weisman Art Foundation collection in Los Angeles), as well as in corporate offices, auction houses, and museums. Rather than focus on the art object itself, she meticulously records as much information as possible about the setting and modes of presentation. Pedestals, display cases, didactic wall labels, nearby furniture, and elements of architecture are integral to her photographs. She often shows objects in groupings or partially obscured, devices that call attention to the relationships among objects in the same spaces.

In the photographic diptych *You Can't Buy One without the Other,* Lawler juxtaposed two different photographic formats—color Cibachrome and black-and-white print—to examine two different art objects on view at Christie's auction house—a painting by Gerhard Richter and a sculpture by Richard Serra. In so doing, she created an entirely new artwork that triggers viewers to think of the many possible meanings of the pairing. For instance, one may interpret it in terms of the coincidence of the painting and sculpture in their original setting; what Lawler's two different views of them reveals; the contrast in the works' styles, one representational and the other abstract; or the social significance of contrasting photographic technologies and presentation styles, unframed Cibachrome versus framed and matted black-and-white print. Lawler provokes consideration of the value of the depicted objects, her own work, and the currency of the institutions in which they are exhibited. *D. S. R.*

Sol LeWitt

American, born 1928

Bands in Four Directions, 1991
Gouache on paper
29¾ x 22¼ in.

Sol LeWitt's work of the 1960s fluidly bridged Minimal and Conceptual Art. Exploring rhythms of repetition and variation in shapes and lines, LeWitt began creating art based on simple, impersonal forms, and he achieved a rich complexity of effects in schematic compositions. Unlike other Minimalists, however, LeWitt did not maintain an interest in the literal art "object" per se, but he instead focused Minimalism's characteristic literalness and systematic logic on his generative process.

By the mid-1960s LeWitt had intellectualized his artistic approach, moving it beyond the artwork into the cerebral plane of Conceptual Art. (LeWitt in fact coined the term "conceptual art," which first appeared in his seminal 1967 *Artforum* article, "Paragraphs on Conceptual Art.") In 1965 he began constructing sculptural modules of open and closed cubes based on predetermined ratios of dimensional form to space. Some of these works appeared as highly complicated, multidimensional frameworks. LeWitt referred to the concept or preconceived system of rules from which the modules were created as "grammar." Viewers could infer the simple structural ideas from the modules' visually complex forms.

Among LeWitt's most noted conceptual innovations were his wall drawings, which he began making in 1968. These works involved sets of directions, devised by the artist, for the creation of each drawing. The instructions were carried out directly on the wall by others (usually his assistants) in various media. In some of the works, the actual directions that generated each line of the drawings were written beside the lines on the wall.

LeWitt's paintings on canvas and works on paper in ink, pencil, or gouache, such as *Bands in Four Directions,* are a continuation of his "grammatical" generating of art. Consisting of a pattern of four squares with horizontal bands or stripes placed in four directions, *Bands in Four Directions* marks out a preconceived set of rules that, to the artist, *is* the artwork, rendering the actual creation of the work "perfunctory."

The pattern or "language" in this gouache work appears throughout the artist's oeuvre, and the optical impression it engenders, as with other LeWitt patterns, allies it with Perceptual Art. However, the underlying grammar that makes LeWitt's conceptual systems recognizable—extrapolated by the viewer from the forms—sustains his fundamentally conceptual aesthetic, in which, to use his words, "the idea becomes a machine that makes the art."[1] *K. M. S.*

Notes
1. Sol LeWitt, "Paragraphs on Conceptual Art," *Artforum* 5 (summer 1967): 80.

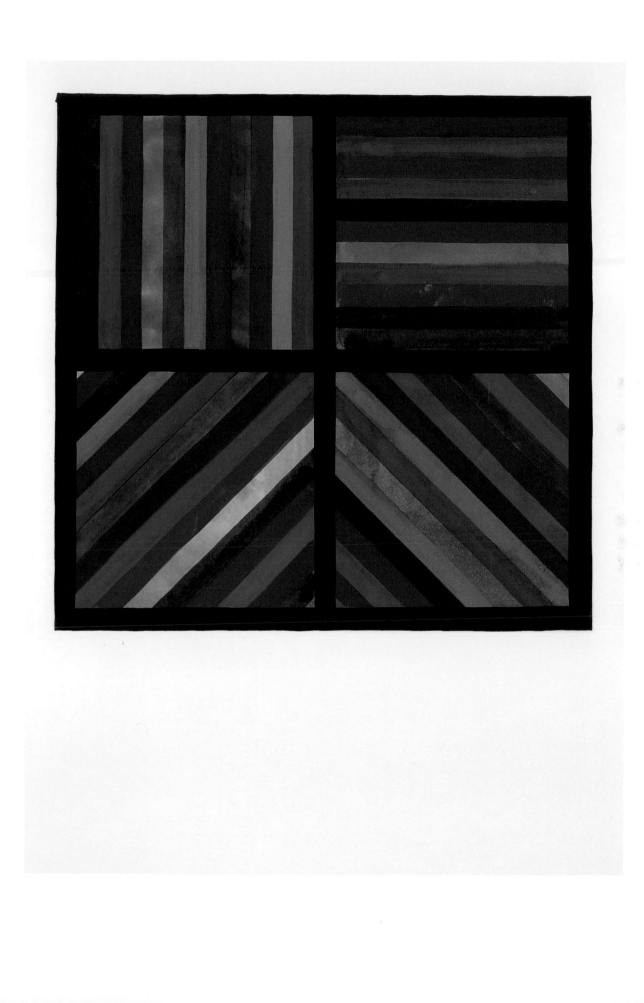

Roy
Lichtenstein
American, 1923–1997

Reclining Nude, 1977
Oil and magna on canvas
84 x 120 in.

Modern Painting with Floral Forms, 1967
Oil and magna on canvas
68 x 36 in.

Pop artist Roy Lichtenstein flouted traditions of high art—from the subjects of Western art history and the allure of illusionistic representation to the emotion-infused brush strokes of Abstract Expressionism—with slick paintings based on the "lowbrow" and conventionalized imagery of comics and commercial graphics. He began in the 1950s with satirical works that stylistically emulated the Abstract Expressionism of Willem de Kooning's *Women* but featured Mickey Mouse and Donald Duck. By 1961 he had established his signature style of painted comic frames, modified and enlarged from cartoon strips.

By translating comic book imagery and balloon text into fine art, Lichtenstein's paintings called attention to the mass medium's tendency to homogenize its subject matter. Although he featured such comic-strip clichés as the romantically distressed girlfriend, dogfighting jets, and the embracing couple, his true subject was the medium itself and its detachment from any explicit subject. To achieve this objectivity, he emulated the formal, surface qualities of commercial printing techniques. He made stencils to imitate benday-dot patterning and contrasted these areas with thick, graphic lines and solid color patches to achieve the visual impact of mass-produced imagery.

Lichtenstein's formal refinement and simplicity were attended by an underlying classicism. He was trained in fine art and drew inspiration from art history—from Piet Mondrian and Theo van Doesburg, the De Stijl masters of precision and primary color; the works of Pablo Picasso and the smooth Cubism of Fernand Léger; and the thick, almost decorative contours of the late works of Henri Matisse. By the end of the 1970s Lichtenstein's work had become more of an art about art—not only commercial or comic-book art, or even the stylistic influence of early modernism, but also the subjects of the modern masters themselves, which he took as his subject.

Reclining Nude bears traces of works by Picasso, René Magritte, and Giorgio de Chirico. Also featured is a graphically rendered single brush stroke—Lichtenstein's reference to his own 1965 satirical painting of an Abstract Expressionist brush stroke, entitled *Little Big Painting.* The ironic art historical layering of *Reclining Nude*—along with its facetiously conventional title—allude to a simultaneous subversion and celebration of the traditions of both "high" and "low" art. *K. M. S.*

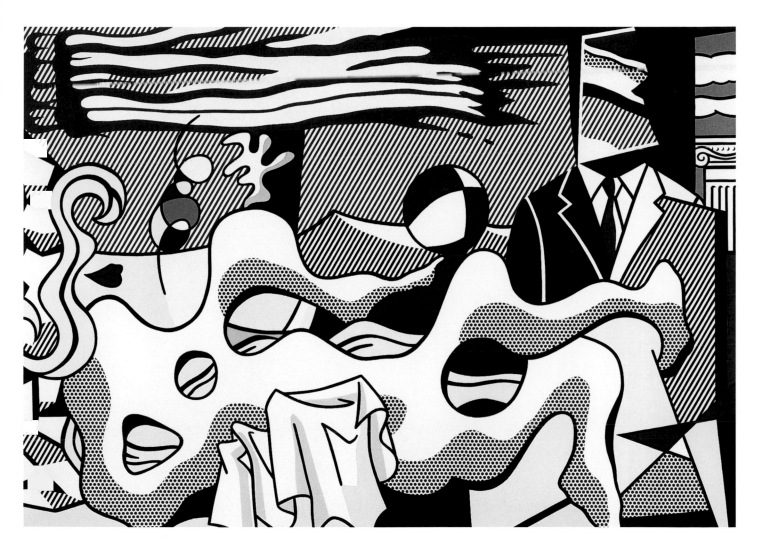

John
McCracken

American, born 1934

The Case for Fakery in Beauty, 1967
Polyester resin and fiberglass on plywood
120 x 20¼ x 3¼ in.

Like the reductive abstractions of fellow West Coast artist John McLaughlin, the influential work of John McCracken is a bridge between East Coast Minimalism and West Coast developments in Conceptualism and Perceptualism. By 1963 McCracken was working in the spare geometric style of artists Donald Judd and Dan Flavin, and engaging in a close study of the theory of Minimalism. The culmination of his studies was his series of "plank" sculptures of the mid-1960s—a condensed and eloquent realization of McCracken's aesthetic goals that brought him instant notoriety and success. *The Case for Fakery in Beauty* is a classic example from the seminal plank series.

McCracken's deceptively simple planks consist of single plywood boards coated with many layers of paint and propped against a wall. Here, as in many Minimalist works, anything extraneous to the "primary structure" is omitted. Like the artists of the developing Los Angeles Light and Space movement, however, McCracken added a colorful, sensuous surface to create an opposition between solid, three-dimensional structure and dematerialized surface color. The shiny surface also links the work to the slick surfaces employed by Craig Kauffman, Ronald Davis, and other Finish Fetish artists during the same period and to the Los Angeles car culture that inspired these artists.

McCracken saw the color as something "psychological" and "purely perceptual." He envisioned his planks as symbolic bridges between the mind and body: "I see the plank as existing between two worlds—the floor representing the physical world of standing objects, trees, cars, buildings . . . and the wall representing the world of the imagination, illusionistic painting space, and human mental space."[1] *R. B.*

Notes
1. John McCracken, in Thomas Kellein, "Interview with John McCracken," in *McCracken* (Basel: Kunsthalle Basel, 1995), 32.

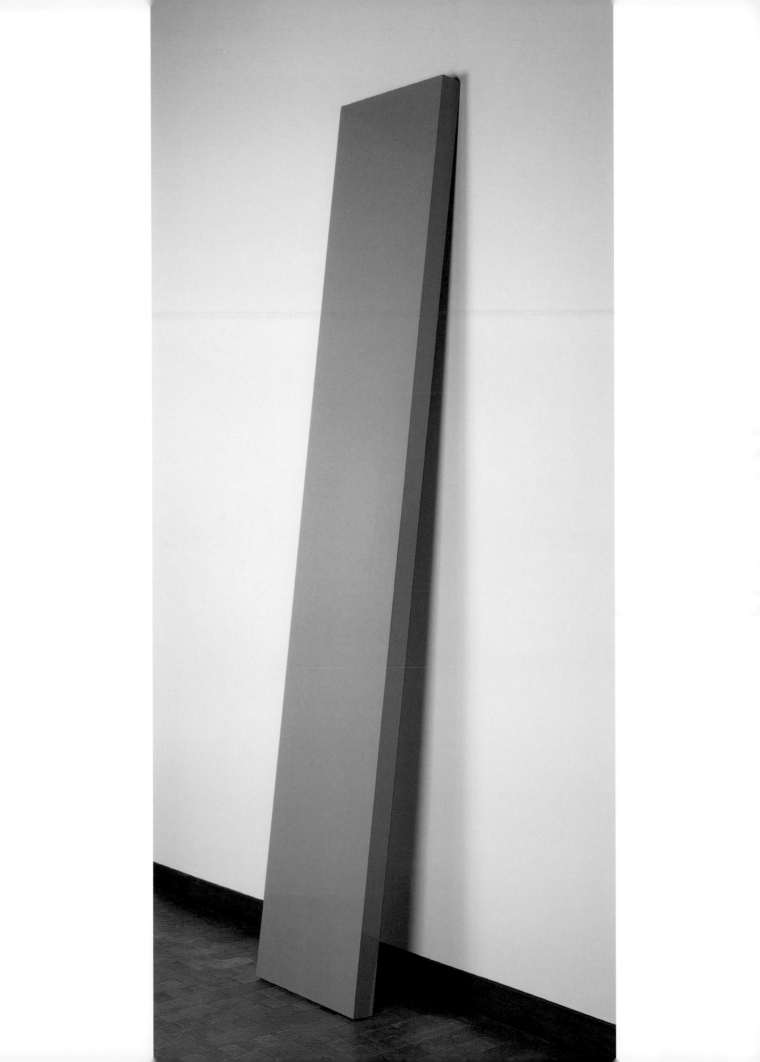

John
McLaughlin
American, 1898–1976

#5, 1965
Oil on canvas
48 x 59¾ in.

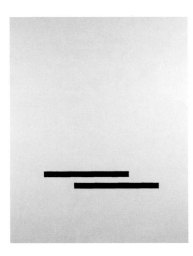

#21, 1974
Acrylic on canvas
60 x 48 in.

John McLaughlin is considered one of the founders of modern California painting. His canvases helped define a West Coast mode of minimal abstract painting that was enormously influential on later artists of the Light and Space and Finish Fetish movements. McLaughlin did not begin painting until he was in his thirties. He worked as a translator of Chinese and Japanese, lived for several years in Japan, and was steeped in Buddhist and Zen Buddhist philosophy. When he turned to painting after moving to Dana Point, California, in 1946, he sought to bring Western abstraction into dialogue with Eastern philosophy and aesthetics. His abstraction is strongly grounded in the Constructivist ideas of Kazimir Malevich and Piet Mondrian, and his dedication to the achievement of a "totally abstract" art combines the nonobjective formalism of the Constructivists with the Eastern impetus toward spirituality and meditation.

McLaughlin's *#5* from 1965 demonstrates the extreme geometric and chromatic simplification of his earlier works, while also displaying a lightening of the surface and an almost glowing quality that is characteristic of his late paintings. McLaughlin sought to negate any trace of the artist's presence and of subject matter and thus to "free the viewer from the demands of special qualities imposed by the particular." Through an extreme neutrality and simplicity, he attempted to "induce and intensify the viewer's natural desire for contemplation without benefit of a guiding principle." Here, four identical rectangles and a bichromatic palette provide the extreme neutrality. Citing fifteenth- and sixteenth-century Japanese painters as his most significant aesthetic influences, McLaughlin advocated a "total experience reflected by the void and anonymous form."[1] Another work by the artist in the Weisman collection, *#21* from 1974, seems to epitomize the notion of a void, as the surface is entirely blank except for two small black rectangles. Releasing the viewer into a transcendent state of hyperawareness through a reductive surface became a central tenet of California abstract painting. *R. B.*

Notes
1. John McLaughlin, quoted in *John McLaughlin* (Pasadena, Calif.: Pasadena Art Museum, 1963), unpaginated.

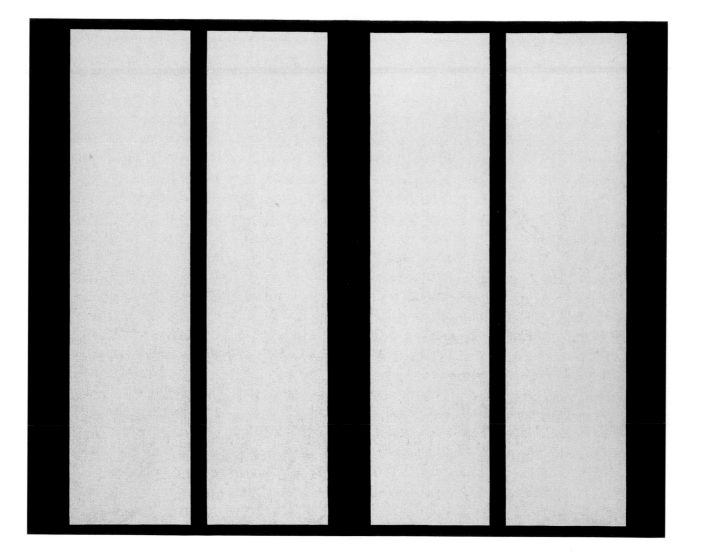

Arnold Mesches

American, born 1923

Frederick R. Weisman, 1984
Acrylic on canvas
72½ x 60 in.

For more than fifty years, Arnold Mesches has been a practicing painter and social activist. Always guided by a humanistic outlook, he has focused his art on a wide range of subject matter, including life and death, war and devastation, the excesses of decadence, and personal memories. Believing in the power of relationships between form and content to convey depth of emotion and conviction, he often works from multiple image sources and freely combines drawing, collage, and paint to achieve maximum expressive impact within a single composition.

From the 1940s through the 1960s Mesches divided his time between painting in the studio and political activism, marching on Hollywood picket lines at the dawn of the McCarthy era and playing a leadership role in the protests against the Vietnam War. In 1974, following a dry spell in his art making, he experienced a strong urge to return to painting and embarked on a series of large-scale portraits. For a period of about six years he studied the faces of people he admired, including his mother and a number of social and cultural leaders, and characteristically rendered these in varied styles, academic as well as abstract. To begin a portrait, Mesches took numerous color slides of each sitter and from these selected an image based on the compositional strength of its structure. He then projected it on canvas and, after making preliminary color sketches, laid down tonal ground in a color that seemed reflective of the sitter's personality. The facial flesh and features, in which a person's history and character are embodied, would next be built up in triangular applications of paint.

When Frederick R. Weisman approached Mesches in 1984 about painting his portrait, the artist had moved on from his portrait series to other subjects. Nevertheless, as a longtime friend and admirer of Weisman, Mesches did not hesitate to accept the commission. Although the artist had previously been commissioned by Weisman to paint portraits of his business associates, he knew at once that this one was to be more personal— a testament to a long and valued friendship.

In his usual manner, Mesches prepared for the portrait by taking numerous slides of his subject and ultimately choosing a cropped frontal view. After laying down a tonal ground of blue, he layered the face with bold brush gestures in vibrant oranges and yellows and saturated the background with a lush, rosy pink. As a fitting tribute to a friend for whom he felt much affection, Mesches chose these vibrant hues because they perfectly captured the human warmth and generosity of a man he knew as always accessible and open, deeply passionate about art, and immensely supportive of the artists of his own time. *D. S. R.*

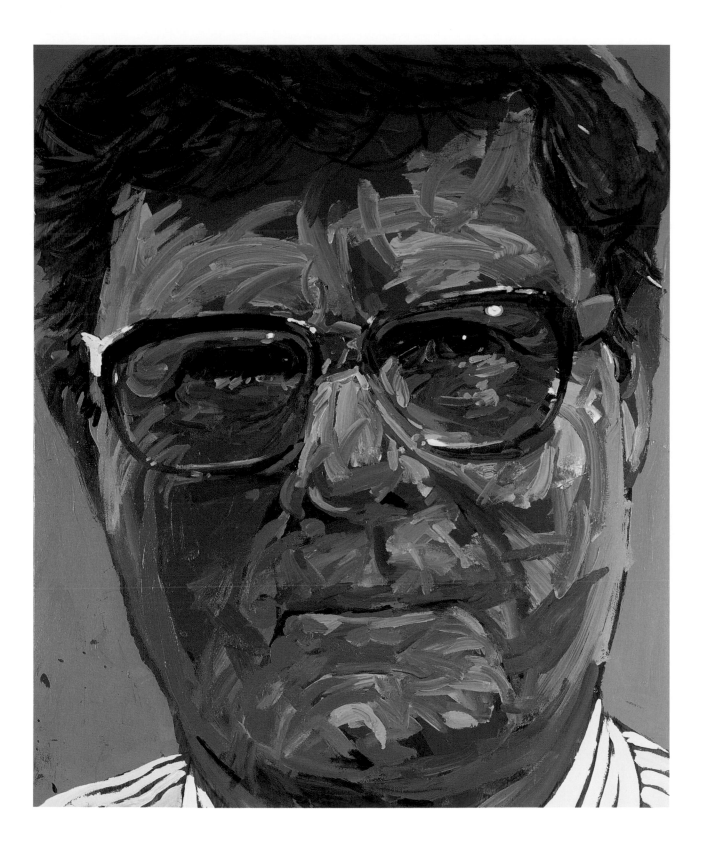

Henry
Moore
British, 1898–1986

Girl Seated against Square Wall, 1957–58
Bronze with brown patina
42 x 33½ x 27½ in.

Invoking the cool smoothness of stone, letting the grain of wood guide the lines of a limb, or modeling with plaster in pursuit of the fluid lustrousness of bronze, Henry Moore united natural forms and the inherent nature of his materials through fundamentals of abstraction. His affinity for organic morphology and the human figure characterized his art, in which the vital human presence within natural forms is infused with symbolic resonance. As the writer Herbert Read suggested, in Moore's sculpture there exists "a buried treasury of universal shapes which are humanly significant, and [Moore] may recognize such shapes in natural objects and base his work as a sculptor on the forms they suggest."[1]

Indeed Moore once expressed his beliefs that landscape was impressed in his psyche and that humanity itself was an inextricable part of the natural world. His sculptures articulate such connections, as hollows, holes, and concavities within his figures invoke dynamic relations between the figure and its surroundings, between humanity and nature, substance and air, physical and immaterial realms. The weight, mass, and biomorphic essence of his reclining female figures in particular have been associated with psychological connections with nature, specifically in the archetype of the nature or earth goddess.[2]

"There are universal shapes to which everyone is subconsciously conditioned and to which they can respond,"[3] Moore once noted. His intuitive approach to sculpture reached its peak in the late 1930s, when his art most closely approached pure abstraction and when the theme of the female nude assumed a prominent place in his work. By 1950 bronze had eclipsed wood and stone as his preferred medium, quite possibly for the greater facility of figural modeling it allows. Bronze can also be treated in both intimate and monumental terms, as Moore proved in his immense bronze figures which recall the giant stone monoliths of Rapa Nui (Easter Island) or the traditional art of Oceanic, African, and ancient Sumerian and Egyptian cultures.

The haunting hollowed eyes, frontal poses, and primitively attenuated heads that characterize these works are also evident in *Girl Seated against Square Wall.* From an edition of twelve, this sculpture is one of two in the Weisman collection. The "square wall" in this work exemplifies Moore's practice, beginning in the 1950s, of integrating architectural elements into his work. In spite of the weight and stasis of the wall, and despite the solid appearance of the seated girl, an organic grace guides her smoothly bending limbs and the unfolding of bronze into pathways, the holes of her eyes, that join figure and surrounding space. As in many of his sculptures, Moore dissolved distinctions between humanity and nature, time and place, imparting a primal beauty to the work that asserts the dignity and graceful resilience of human life. *K. M. S.*

Notes
1. Herbert Read, *A Concise History of Modern Sculpture* (London: Thames and Hudson, 1964), 177, 180.
2. Erich Neumann, *The Archetypal World of Henry Moore* (London: Routledge, 1959), 17.
3. Brian McAvera, "The Enigma of Henry Moore," *Sculpture* 20 (July–August 2001): 16.

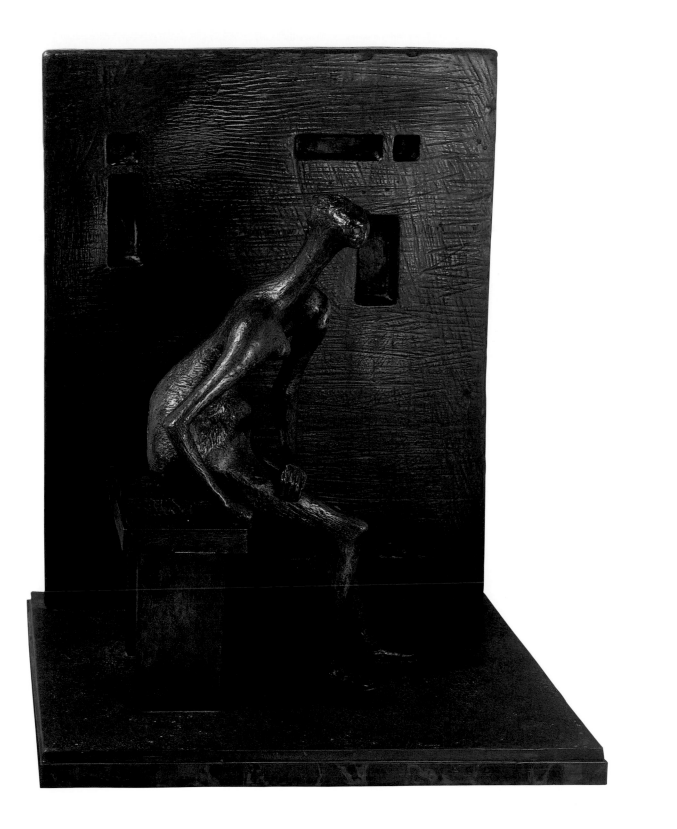

Joel Morrison

American, born 1976

Untitled, 2001
Vinyl over mixed media on wood pedestal
128 x 78 x 60 in.

Untitled, 2001
Gaffer's tape on mixed media
86 x 38 x 42 in.

Los Angeles–based artist Joel Morrison takes an unusual approach to traditional sculpture. He often quotes the formal properties, display formats, and themes of classical sculpture and then upsets and challenges the expectations they arouse. In place of timelessness and idealism, he offers chance, improvisation, and change—values and approaches linked with such movements as Surrealism, Abstract Expressionism, and California Funk art. Morrison's work can in fact be described as an attempt to unite the spontaneity, expressive freedom, and sense of play celebrated by these modern styles with the three-dimensional plastic world of classical sculpture. The result is a quintessentially Californian hybrid art.

Morrison's pedestaled white sculpture exemplifies the playful blend of innovation and tradition characteristic of his works: a pedestal, traditionally meant to simply support and display, skewers and pierces the soft sculpture above it. Instead of serving a secondary role, the pedestal actively enters the object it supports, thus becoming part of that object. Upsetting the balance expected of traditional sculpture, Morrison's work creates a dynamic tension through the contrast between the soft, organic shape above and the sharp obelisk form that impales it. Both the base and the bulging white form are asymmetrical and do not conform to a single, ideal point of view, adding to a sense of formal tension while energetically engaging the space around the work.

Further, Morrison's skewed "figure" presents a drastic reformulation of the traditional image of the human body. Evoking the work of modernist sculptors such as Jean Arp, Morrison's lumpy, protoplasmic shape fragments, disassembles, and explodes the stable outlines of the figure. Covered by a diaphanous membrane suggesting skin, the form, like a living cell, seems to be in a state of metamorphosis. In other figural works, such as the second untitled work pictured here, Morrison has actually exploded the skin so that the insides of the sculpture spill out in a tangle of recycled objects such as tape, fabric, wire, and twine. In this work the skin remains intact, while instead a bright red splash of paint suggestive of an open wound bursts open the fragile barrier between inside and outside.

Playing with various dichotomies—between object and frame, active and passive, inside and outside—Morrison's sculptural practice creates an open and evolving interrogation of the nature of the sculpted object and what it means to display it as art. *R. B.*

Ed
Moses
American, born 1926

Cubist Painting, 1975
Acrylic on canvas
78 x 66 in.

Untitled, 1985
Watercolor on paper
59½ x 40 in.

Although he has been a fixture of the Los Angeles art scene since his first solo shows in the 1960s and has been identified with several major Los Angeles art movements, Ed Moses has maintained a relatively independent artistic identity as a nonobjective painter. He is especially well known for "grid" paintings that juxtapose a severe geometric structure with fragmented brush strokes and densely painted surfaces. This format was first discovered somewhat accidentally in 1966, at an exhibition of his work at the Riko Mizuno Gallery in Los Angeles. Moses had removed parts of the roof and ceiling for the show, with the result that intense light poured through the room, forming a crosshatch pattern on the floor. Clearly linked to the work of a number of modernist artists, including Piet Mondrian and Ad Reinhardt, the grid became Moses's primary structure to investigate.

Much of Moses's work creates a dialectical contrast between permanence and change. He typically combines the fixed structure of the grid with an amorphous and changing background, as in his untitled watercolor from 1985. The grids seem to float on a sea of fluid, watery color, combining the geometric structure of Constructivism with the looseness of Abstract Expressionism.

Cubist Painting belongs to a series of monochrome paintings from the 1970s in which Moses explicitly addressed the heritage of Cubism. Here his signature diagonal grid is not sharply differentiated from its background but merged with it through color so that it becomes almost impossible to tell foreground and background apart. The flickering and unstable spatial relationships between the flat painted forms echo the fragmented perspectival viewpoints of Cubism. Color helps build a sense of change. Depending on the viewer's angle of vision, a different area of the painting's monochromatic surface shifts from reflecting light to absorbing it. Although his subtle use of light and color and the perceptual issues he raises suggest an affinity for the contemporaneous visual experiments of the Los Angeles Light and Space artists, Moses's interests are more explicitly allied with those of the earlier modern artists. *R. B.*

Robert Motherwell
American, 1915–1991

Summer Seaside Doorway, 1971
Oil on canvas
60 x 40 in.

One of the principal Abstract Expressionists, Robert Motherwell was also a prolific writer and art theorist who became one of the leading literary exponents of the New York School. Like Arshile Gorky, William Baziotes, Jackson Pollock, Willem de Kooning, and others who would be associated with the New York School, Motherwell was greatly inspired by Surrealism. The Surrealist exploration of the inner mind—dreams, the unconscious, or some fundamental, underlying reality—took hold of these New York artists, who sought to create art that was about emotional truth, authenticity, and the direct connection between one's inner world and its media of expression. Motherwell was especially interested in the Surrealist methods of automatism, or the free channeling of the subconscious and spontaneous thought into poetry and art.

Calling his own approach "plastic automatism," Motherwell created collages of paint, paper, and found elements through "free association" and then integrated these collages into more formal compositions, some of them on a very large scale. The emotive facets of these collages—facets found in gestural areas and saturated splashes of color in both pigment and collage—were countered by more cerebral components, including identifiable collage elements and schematic, geometric structures. This formal opposition between the emotional and structural characterized most of Motherwell's collages, paintings, and prints throughout his career.

In the painting *Seaside Summer Doorway,* acutely vertical, rectangular strips, including a particularly keen edge of black along the right, are tempered by gestural, painterly imperfections in the lower third of the work, which betray the artist's hand. Viewers' own free associations may be guided by the artist's title to discern a slightly opened door revealing a crack of blue sky dividing the darkness and spilling inside, while lines of green on blue draw sea from sky.

The theme of open doorways, sills, or thresholds of some kind is one that Motherwell occasionally explored from the late 1960s through the 1980s. This body of work, which includes *Summer Seaside Doorway,* is often referred to as the "Open" paintings. According to the artist, the first Open painting came into being when he once noticed a small canvas leaning against a larger one. He contemplated the outline, which appeared as if there was a door in the painting that could be pushed ajar. Lifting that "door" to the top of the canvas, he reversed its outline, transforming the door into a window and freeing the space above.[1] In *Seaside Summer Doorway,* as in other Open paintings, Motherwell may have invoked his childhood summers by the sea in Aberdeen, Washington, or later visits to East Hampton, New York, which had become the summer haven of the New York School. The painting remains a testament to what is at once personal and universal in Motherwell's art—the human soul, the experience of life, and how the inner life expresses itself. *K. M. S.*

Notes
1. Mary Ann Caws, *Robert Motherwell: What Art Holds* (New York: Columbia University Press, 1996), 90.

Matt
Mullican

American, born 1951

Anatomy & Evolutionary Chart, 1987
Oil stick and acrylic on canvas
Four panels, 96 x 192 in. overall

Drawing on ancient and contemporary sign systems, Matt Mullican's condensed visual language serves as a diagrammatic map to guide viewers through various meanings in his work. Best known for his banners, charts, stained glass, and etched granite slabs, Mullican addresses expansive themes such as social, cultural, religious, biological, and technological systems. Upholding his expressed mission of "charting systems," the artist forges his unique lexicon of symbolic configurations to represent his own personal cosmology.

The codified emblems that make up Mullican's diagrams often include motifs for such absolutes as heaven, hell, life, or fate. Multiple sigils are sometimes fused into what he calls an overview symbol, such as the one at the top of the second panel from the left in *Anatomy & Evolutionary Chart.* The artist's explicit distinction between the two left and two right panels parallels the nature/culture dichotomy he symbolically references through the "anatomy" and "evolution" of biological and social systems.

The dominant symbol in *Anatomy & Evolutionary Chart* appears to represent human anatomy. A red circle extending from a yellow "head" is filled with sigils suggesting the contents of the mind, thought processes, or brain functioning. Green circles within and just below the "abdomen" of the figure may refer to other, possibly reproductive bodily processes, while linking to the nature panels on the right. Mullican connects the "anatomy" of this biological system to an attendant social system, signified by a red, yellow, and blue symbol. This color-coded configuration recalls a traffic light, a symbol of the social realm, in which people are taught to read signs and obey certain rules to support established order.

As demonstrated in *Anatomy & Evolutionary Chart,* Mullican's work presents a system of signification that attempts to order the world. At the same time, however, the emblems forming his cosmology convey greater abstractions—birth, death, life, heaven, earth—which reinforce the infinite and unfixed nature of reality. Given the cosmic, if not spiritual, denotations in his work, he is often questioned about the influence of religion on his practice. According to Mullican, his exposure to indigenous African and Oceanic art has had a much greater impact on him than religion itself. He was deeply impressed by what was believed to be the symbolic concentration of cosmic power in these traditional art forms in their original contexts. He has also been inspired by the condensed meaning, authority, and sheer ubiquity of graphic signs in contemporary life. Mullican has merged these diverse worlds, coalescing form, time, and space through his own cosmological paradigm. *K. M. S.*

Barnett
Newman
American, 1905–1970

Death of Euclid, 1947
Oil on canvas
16 x 20 in.

Untitled (Study for Vir Heroicus Sublimis),
1950
Oil on canvas
11⅛ x 17⅛ in.

Combining the Romantic and mythic aspirations of the Abstract Expressionist generation with a severely reduced visual structure, Barnett Newman's sparse canvases were the result of a very long and studied meditation on the personal and social function of painting. Most often associated with the Color Field branch of Abstract Expressionism, Newman did not regularly save or exhibit his work until 1948, when he was forty-three years old. Throughout the 1940s, while the other major Abstract Expressionist artists were beginning to gain wide recognition, Newman wrote art criticism and helped curate several shows at the Betty Parsons Gallery, occasionally painting works that he would eventually destroy. During this time he was developing an aesthetic philosophy based upon a close study of modern European, Native American, and contemporary American art.

In 1948 Newman produced *Onement,* a painting that represented the fulfillment of his studies, and declared his own identity as a painter (he always claimed, dramatically, that it was conceived on his birthday). Consisting of a single red field bisected by a pale line that Newman called a "zip," *Onement* abstractly symbolized the act of creation as the artistic division of a neutral space into two parts that are both separated and conjoined. This primary "cut" was the fulfillment of Newman's search to find the "essence" of what painting is: the act of separating an undifferentiated void, an empty field of color, and thus beginning the possibility of form. Newman's *Untitled (Study for Vir Heroicus Sublimis),* also in the Weisman Art Foundation collection, is an early version of one of his "zip" paintings.

The titles of his paintings, which after this period uniformly followed this "zip" format, evidence the immense meaning he gave to this act of division and separation. *Abraham, Stations of the Cross,* and *Cathedra,* for example, emphasize a religious context; others recall epic poetry, Greek myths, and Jewish mysticism. At the same time—by emphasizing completely nonrepresentational, flat geometric forms—he was attempting to connect his canvases to a simple abstraction evocative of "primitive" art. The ancient, mythic, spiritual, and mystic met in an art style he intended as purely American, for a "New World."

Death of Euclid is one of Newman's rare surviving works from before 1948. In this painting a heavy yellow vertical line—a prototypical "zip"—is placed next to a bending yellow line and a black circle surrounded by a nebulous cloud. The circle has been interpreted as an early symbol used by Newman to designate a primitive void or an abyss. The bending line is an abstract sprout or tendril signifying growth and life. While prevalent in his early work, it too would disappear in the final Newman canvas. Containing several schematic references to life and death, this work has a primitive quality similar to some of Joan Miró's canvases of prehistoric symbols.

Newman's strong belief that abstract art should manifest mythic content and "spiritual" significance is emphasized by the title *Death of Euclid,* which refers to the Greek founder of geometry. It suggests that a purely mathematical attitude toward geometric forms must cede, in the modern era, to the recognition that form is emotional, spiritual, and psychological. *R. B.*

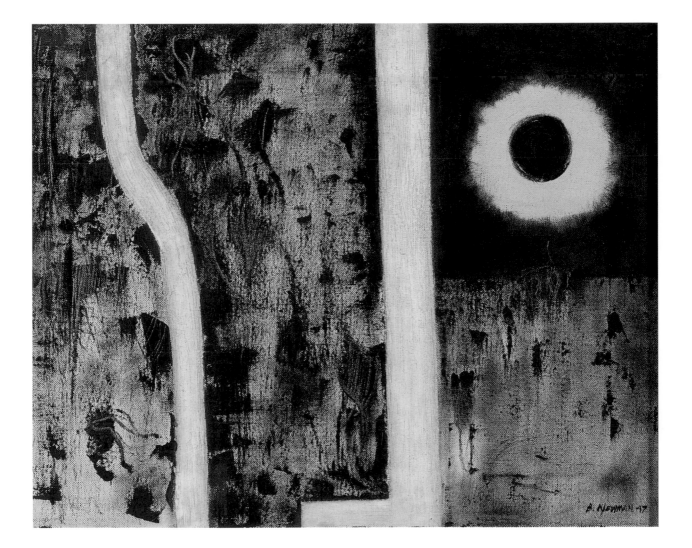

Isamu
Noguchi
American, 1904–1988

The Uncertain Sea, 1968
Black granite and wood base
26 x 42 x 29 in.

Curves of fluid, organic grace define the lines of Isamu Noguchi's stone sculptures. With an extraordinary empathy for the medium, Noguchi invoked the natural qualities of stone through pure forms of smooth, elegant simplicity. He believed that natural materials like stone—along with clay and wood, in which he also worked—were infused with the raw energy of nature. His affinities for natural forces, forms, and materials have connections to his heritage in Japan, where religious sentiments have traditionally been linked to notions of the essence and divinity of natural phenomena, including rocks and stones. The contemplative art that emerges from the Eastern tradition coalesces with facets of Western abstraction in Noguchi's work.

Noguchi was born in Los Angeles to an American mother and Japanese father, spent his earliest years in Japan, was sent alone to live in the United States at the age of thirteen, and for the last several years of his life held residences in both countries. This simultaneous divide and bridge between East and West, between two distinct approaches to art and thought, engaged him for his entire life. He began carving in stone in the 1920s while working in Paris on a Guggenheim Fellowship. During the 1930s he created portrait heads from stone, and in the 1940s he carved attenuated sheets of slate and marble into sculptures of interlocking biomorphic forms. By 1968 he had established a studio on the Japanese island of Shikoku, where he created the large granite and basalt sculptures that constitute his late work.

The Uncertain Sea is one of four wavelike sculptures Noguchi created in that last major period. The wave sculptures are among the artist's Landscape Tables, a group of horizontal granite "landscape" sculptures, begun in 1968, which are placed directly on the ground or on elevated bases (as in *The Uncertain Sea*). From the center of the solid black granite plane of this work, the wave's bulbous dome swells and pushes outward, its surface burnished to a deep luminosity. This primordial "seascape" appears as a miniature floating world, collapsing time and space like a Zen meditation garden.

Noguchi's interest in landscape generated not only individual sculptures but also sculpture gardens, water sculptures, and playgrounds, and he is also celebrated for inventing Akari light sculptures and set designs. His work has transformed entire spaces and engaged the character and natural beauty of materials, to become, in his words, the extension of our existence.[1] *K. M. S.*

Notes
1. Isamu Noguchi, *Noguchi: A Sculptor's World* (New York: Harper and Row, 1968), 39.

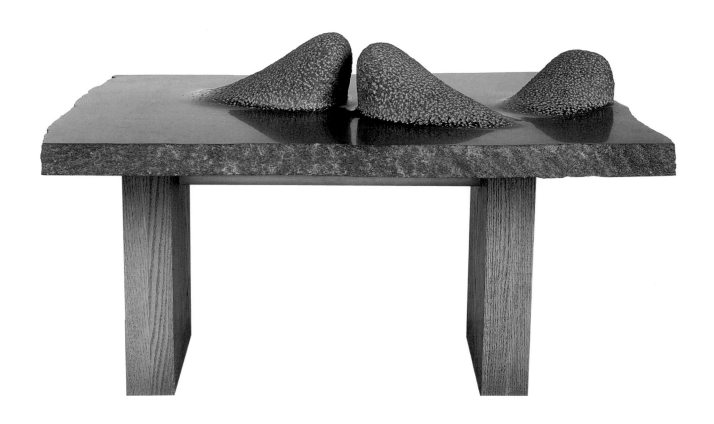

Kenneth
Noland
American, born 1924

Autumn Spirit, 1965
Acrylic on canvas
84¾ x 84¾ in.

Prime Course, 1964
Acrylic resin on canvas
93½ x 95¼ in.

In the 1960s Kenneth Noland, along with friends Morris Louis and Jules Olitski, was heralded for taking the next logical step beyond the innovations of Abstract Expressionism. Countering the thickly painted canvases and gestural style of 1950s abstract painting, Noland and his peers enhanced the flatness of their pictures by introducing texture-free surfaces that showed none of the heavy brush strokes of Abstract Expressionism. They stained raw canvas by pouring paint directly from the can rather than applying it with a small brush. The artist Helen Frankenthaler first introduced the process of staining, originally used by Jackson Pollock, to Noland and Louis in the early 1950s. A decade later, it became essential to Noland's practice and signature style.

Noland's attraction to abstract art developed through his studies at the avant-garde Black Mountain College in North Carolina, where he studied under the abstract painter Ilya Bolotowsky. In the late 1940s he also took courses in Paris and became enamored with the art of pioneering abstract artists Henri Matisse, Pablo Picasso, and Joan Miró. Noland began experimenting with stained painting around 1953, after he and Louis visited the Frankenthaler studio.

In the 1960s both Noland and Louis adopted a then-popular procedure of working in series. For Noland, this involved painting series based on motifs, including circles, ovals, chevrons, and later horizontal stripes. His concentric circle paintings of the late 1950s are derived in part from the concentric square paintings of Josef Albers, who had headed the art department at Black Mountain College. Yet unlike Albers, who was a color theorist, Noland was concerned with the impact of scale, shape, and even the positioning of the canvas, in addition to color.

Autumn Spirit is one of several large, diamond-shaped canvases with chevron motifs turned sideways. The dynamic leftward movement of overlapping diamonds is effectively countered by the color shifts of the chevrons, which become darker in the opposite direction. These are further countered by the stark contrast between the painted chevrons and the areas of raw canvas, which carry the same compositional weight and also read as a chevron and diamond. *D. S. R.*

John
Okulick
American, born 1947

Rainbow's End, 1997
Painted wood and gold leaf
32 x 60 x 11½ in.

Stick Up, 1977
Wood and sticks
26 x 13 x 2¼ in.

John Okulick found his artistic direction in the early 1970s, when he developed a distinct hybrid of painting and sculpture. He began exhibiting carefully crafted wall-mounted containers or boxes filled with earthen materials and bound by rope. These works seem to have considerable depth—an illusion reinforced by the presence of natural forms such as twigs, straw, and rocks—yet they are actually quite shallow. In a single work the artist merged the illusionistic flatness of painting with the real three-dimensionality of sculpture.

By the mid-1970s Okulick had replaced found natural objects with painted elements. Over the years he has alternatively simplified his vocabulary and made it more complex, but he has generally retained the element of the container (for example, the wooden box in *Stick Up* of 1977), which he has come to view as a metaphor for the human body. According to the artist: "The boxes are generally about the space we occupy. They are not only boxes as containers but represent the containment of ourselves in other spaces such as rooms, cities, even our physical bodies and mental states, and the tensions and pressures associated with each other. They are also about the pleasure one might surround oneself with."[1]

In *Rainbow's End,* one of his more playful and eccentric wall reliefs, Okulick has deconstructed the box, leaving only nominal references to its structure and placing greater emphasis on the objects contained within it. The impression is that a box has been opened and flattened from above, then compressed against the wall, with its parts spilling out in a controlled and precisely arranged manner. Elements of the game of tic-tac-toe are thus mixed up with architectural elements, creating the impression that fixed structures have been fluidly moved about and rearranged. The title might refer to the mythical pot of gold, an association echoed by the gold ball at the structure's lower right. This allusion adds a note of fancy and delight to Okulick's opened box, suggesting the discovery of something wonderful and magical. *D. S. R.*

Notes
1. John Okulick, in *Late Twentieth-Century Art* (Richmond: Virginia Commonwealth University, 1978), cited in Michele D. DeAngelus, "Real Illusions," in *Transformation in Perspective: The Sculpture of John Okulick* (Palm Springs, Calif.: Palm Springs Desert Museum, 1991), 27–29.

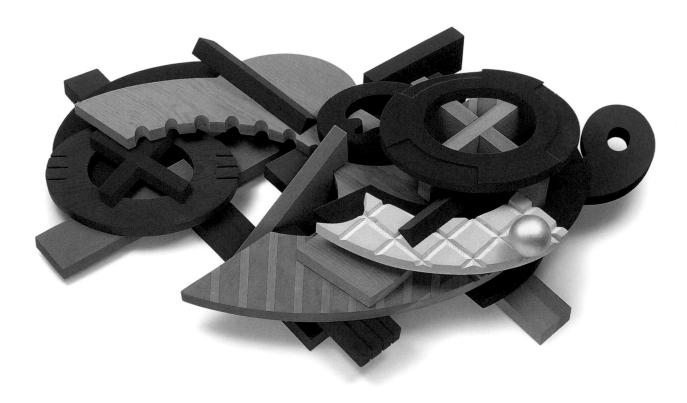

Claes
Oldenburg

American, born Sweden 1929

Typewriter Eraser, 1975
Fiberglass, aluminum, steel, and rope
94 x 47½ x 52 in.

Typewriter Eraser, 1968
Painted cardboard and canvas
31 x 13 x 3 in.

While other Pop artists implicitly engaged the consumer object in its mass-mediated identity, Claes Oldenburg identified with it and anthropomorphized it, transforming the ubiquitous and mundane into the extraordinary. Creating works of varying scales and media, ranging from appealing "soft sculptures" to giant public installations, Oldenburg has displayed wit and a willingness to abandon conventional representational assumptions.

A relentless collector of pop culture ephemera and random sidewalk treasures, Oldenburg imbued what he discovered in his everyday experiences with dimensions of the extraordinary. According to the artist, he could "stretch" his subject matter through metaphoric renderings—resulting, for example, in a soft stuffed toilet or hamburger, a giant water bottle, or a monumental clothespin—yet the subject matter would always emerge from a personal or biographical source.

This generative space often derived from his childhood—which is when he first encountered a typewriter eraser in his father's office, and it became one of his favorite objects of play. Oldenburg incorporated the motif of the typewriter eraser into his art in the 1960s, and throughout his career it served as a subject for drawings, prints, and collages, including the painted cardboard and canvas *Typewriter Eraser* (1968), and sculptures such as *Typewriter Eraser* (1975), made of fiberglass, aluminum, steel, and rope.

Although the *Typewriter Eraser* collage is less of a monumental entity than its sculptural counterpart, each work depicts a remarkably larger-than-life eraser. The sculptural version stands independently, seemingly infused with an internal energy that holds it erect, bristles sweeping upward dynamically. This anthropomorphic quality recalls the imagination of a child, which can animate the most mundane of objects, turning reality into a looking-glass world where large and small shift places and things are just not as they seem.

These two typewriter erasers are among the earliest examples of Oldenburg's use of the theme. Later he would create sculptural renditions on an even larger monumental scale, such as the astonishingly enormous eraser currently in the National Gallery of Art in Washington, D.C. Challenging traditional notions of the public monument as a means to commemorate historical figures, political institutions, and events, Oldenburg has instead brought art and the common object to "new heights" while confounding viewers' perceptions of normal scale. Not simply altering the conventional shape and meaning of actual objects, Oldenburg's sculptures transform the environments in which they are presented, implicating viewers themselves in a world that has strangely shifted proportion and form.
K. M. S.

Nam June
Paik
South Korean, born 1932

Michelin Man Laser Robot, 1996
Video with 13 television screens
84 x 64 x 27 in.

Nam June Paik is widely regarded as the first artist to explore the possibilities of television and video as an art medium. His work spans several disciplines and takes many forms—from musical composition to performance art, from television and video art to laser sculpture and installation, from circuitry to satellite art. Paik has helped redefine artistic practice through his varied and often complex experiments.

Paik pioneered the formal artistic use of television and video in the early 1960s, presenting his daring works in his first solo exhibition, *Exposition of Music—Electronic Television,* in Wuppertal, Germany, in 1963. The title and components of this seminal show—which included viewer-interactive video and scattered televisions turned on their sides, emitting distorted broadcast transmissions—revealed the influence of Paik's earlier training and pursuits. He studied musical composition in Korea and Japan and then traveled to Europe in 1956 to pursue his interest in avant-garde music and performance.

In 1958 Paik met John Cage, whose innovative compositional and performative ideas had an immense impact on him. Since the 1960s Paik has collaborated on video and television projects with Cage, as well as with other artists and musicians, including Laurie Anderson, Joseph Beuys, David Bowie, Merce Cunningham, and Allan Kaprow. George Maciunas and Fluxus, the group Maciunas founded, also influenced Paik. A radical 1960s multimedia movement in which Paik participated, Fluxus involved fine art and collaborative performance, including guerrilla theater, electronic music concerts, mail and rubber-stamp art, street spectacles, and spoken-word events.

At the forefront of the emerging medium in the 1960s, Paik has continued his exploration of technology through the 1990s, producing works such as *Michelin Man Laser Robot,* an automaton composed of televisions in wood casings that project magnetically distorted video imagery. Paik made his first robot around 1964 from pieces of wire and metal. He soon began building robots from vintage television sets and radios, first updating them with current electronic parts. With its reference to popular robotics and a commercialized brand of automobile tires, *Michelin Man Laser Robot* presents a striking metaphor of the late twentieth century. The work typifies the remarkable inventiveness that Paik has displayed over the course of four decades, fundamentally shifting the terms of artistic practice and perception and playing a key role in expanding our definition and understanding of the arts through technology. *K. M. S.*

Michelangelo
Pistoletto
Italian, born 1933

Hitchhiker, 1969
Silkscreen on polished steel
91 x 47½ in.

The word *reflection* denotes the formation of an image, a mirrored likeness, and contemplation or careful consideration. The coalescence and interplay of these significations are fundamental to the work of Italian multimedia artist Michelangelo Pistoletto, who introduced the tangible and metaphorical element of reflection into his art in the early 1960s. Before replacing the canvas surface of his paintings with reflective materials, Pistoletto pursued the creation of self-portraits, paintings that conveyed a sense of deep introspection, even personal isolation. The artist began to varnish the backgrounds of these portraits, and the formal and symbolic potential of their reflective surfaces inspired him to begin using polished stainless steel.

The first group of Mirror Paintings included works, such as *Hitchhiker,* in which photographic images of men and women were silkscreened onto highly polished stainless-steel plates. The merging of surface image and reflection disrupts the viewer's fixed relationship to the work, as the definitive separation of reality and representation is destabilized. One feels oneself to be encroaching on the figure's "private space," yet not only is one's own image reflected back, but the startling realization is made that self and "other"—reality and representation—share the same space.

Hitchhiker also recalls the experience of passing a roadside hitchhiker; the viewer of the work unwittingly assumes the role of driver, who sees (behind) into the work, which is figured as a rearview mirror in which the hitchhiker is seen from behind. Like much of Pistoletto's art, *Hitchhiker* assumes a thoughtful quality—literally and figuratively reflective—for it both mirrors and embodies the meaning of looking back, or reflection.

For Pistoletto, the mirror aesthetic was an artistic and personal "liberation," as it engaged artist, viewer, and the creation of art itself in a complex interrelationship. This interest in the interplay of art and life characterized aspects of the 1960s and 1970s Italian movement Arte Povera, in which Pistoletto was an important participant. Emphasizing the use of unconventional art materials and everyday objects, the movement was informed by the notion that aesthetic experience is grounded in the experience of everyday life. Initially, however, Pistoletto's work was aligned with Pop Art because of its engagement with the poetic dimension of ordinary objects, but his oeuvre was anticonsumerist. While a mirror might signify surface vanity in a Pop context, it imbues Pistoletto's art with a depth and complexity that encourage meditation on the nature of representation and reflection. *K. M. S.*

Sigmar
Polke

German, born 1941

Untitled, 1984
Oil, watercolor, and gouache on paper
39 x 27½ in.

From small drawings to monumental paintings—in media ranging from oil paint to ballpoint pens, rubber stamps, and ink—Sigmar Polke's art engages mass media and culture as much as art historical traditions and techniques. His artistic versatility, pervasive interplay of figuration and abstraction, employment of less than comprehensible techniques, and creation of a completely independent language of images tenaciously defy categorization.

At the age of twelve, Polke emigrated from the former East Germany to West Germany, where he later studied at the Kunstakademie in Düsseldorf. Although his early works were contemporaneous with the American Pop Art movement, his sardonic reflections on consumerism maintained a postwar German perspective and a skeptical distance from consumer culture. In 1967, with fellow German artists Gerhard Richter and Konrad Lueg (later Konrad Fischer), Polke founded Capitalist Realism, a movement that presented an ironic take on Socialist Realism and postwar capitalism. Polke specialized in sketchy, cartoon-like images done in felt-tip pen and spray paint that parodied modern art and consumer culture.

From that point on, Polke has continued to create art that satirizes social conventions and established artistic values. Painting itself—particularly Abstract Expressionism—has also been subject to his irony. His seminal acrylic on canvas painting from 1969, *Moderne Kunst* (Modern art), quotes certain conventions of "modern" style, as exaggerated shapes and lines of geometric abstraction are playfully accented by a large splash of lavender paint. From that year through 1971 Polke's work also incorporated loose doodles at monumental scale, as well as scrawled, stained, and splattered "gestures." Many of these works refer to theories of modern physics and resemble an attempt at synopsizing, and quite possibly satirizing, chaos theory.

Since the late 1970s and early 1980s Polke has continued to explore random color experiments and expressionistic processes. This untitled painting from 1984, for example, is a frenetic explosion of oil, watercolor, and gouache in vividly dissonant colors. In this painting, as in many of the works Polke has made since the 1980s, he made the dripping and flowing of substance his theme. Recalling his earlier "modern physics" paintings, the controlled and uncontrolled flow of physical phenomena plays an important role for Polke as he takes Abstract Expressionism to its feral extreme. *K. M. S.*

José Luis Quiñones

Puerto Rican, born 1949

Crushed Orange, 1980
Oil on canvas
75 x 88½ in.

The work of Cuban painter Jose Luis Quiñones can be allied with the Photorealist movement, which flourished in the 1970s. As developed in the works of such artists as Chuck Close, Richard Estes, Audrey Flack, and Duane Hanson, Photorealism stressed illusionism in sculpture and painting—a kind of ultra trompe l'oeil realism so precise that it mimicked the look of a photograph. Paradoxically, the extreme illusion of Photorealism—rendering people, objects, and places so accurately that it looked as if a camera had just taken a picture—was accomplished through time-consuming, handcrafted painting and sculpting techniques. Although they emulated the "look" of a mechanical device and often used technologically advanced materials, Photorealist paintings and sculptures celebrated the artistic working process and the perfection of a craft while opening up a new realm of questions about the nature of the real and reality.

Like Pop Art, Photorealism also took as its primary subjects ordinary people and things, but through the development of such extreme illusionistic techniques, these subjects started to take on strange and uncanny effects. The hyperreal art object began to function as a "simulacra," something that confused and blurred any sort of clear boundary between representation and reality.

Quiñones's work differs slightly from most of the earlier Photorealist paintings in technique and construction. He chose to use traditional brushes and oil on canvas to achieve his illusionistic style, in contrast to many artists who worked with airbrush techniques. More noticeably, in some of his works Quiñones cut the canvas to assume the shape of the actual thing depicted in order to further solidify the merging of fiction and reality, painting and object. The painting became somewhat like a sculpture projecting from the wall, with the two-dimensional surface taking on a three-dimensional feeling.

Crushed Orange is part of a series of shaped canvas works based upon objects taken from Quiñones's father's store, including bananas, cigarettes, and paper bags. Quiñones wrote, "I found that objects were taken for granted and very much in need of a closer look."[1] It is precisely this interest in slowing down time and focusing intently on objects—and how exactly they are represented—that distinguished Photorealism from Pop Art. To emphasize the fictional or unreal aspect of the hyperreal representation, Quiñones depicted the can at several times its actual size, creating a very large shaped canvas that becomes more and more abstract the closer one gets to it. Through the attention and labor focused on exactly re-creating it in facsimile, an ordinary can of "Orange Crush" is thus made compelling as an art object hovering somewhere between fiction and reality. *R. B.*

Notes
1. Letter from José Luis Quiñones, 1978, Frederick R. Weisman Art Foundation files.

Larry Rivers

American, 1923–2002

Last Civil War Veteran: Indigo Blue, 1987
Oil on canvas mounted on sculpted foam core
75¼ x 57½ x 5 in.

In the early 1950s, during the height of Abstract Expressionism's popularity, Larry Rivers was one of the first young artists to reintroduce representational imagery into the vocabulary of painting. In his landmark _Washington Crossing the Delaware_ of 1953 (Museum of Modern Art, New York), Rivers reconfigured imagery that he appropriated from Emanuel Leutze's 1851 painting of the same title (Metropolitan Museum of Art, New York) and rendered it using the characteristic Abstract Expressionist brushwork of the day. Motivated by an interest in American themes and filled with a desire to shake up the art world, Rivers became one of the pioneering artists who paved the way for the eventual acceptance of Pop Art, a movement with which he is sometimes identified, even though his subjects extend beyond popular culture and include many historical references.

Rivers's interest in Americana was strongly evident even in his youth. He did not set out to become a visual artist but pursued a career as a practitioner of an indigenous American art form—jazz music. To gain acceptance in that milieu, he changed his name in 1940 from Yitzroch Loiza Grossberg to Larry Rivers and began working as a saxophonist. In 1945, however, after serving briefly in the United States Army and studying music theory and composition at the Juilliard School, Rivers decided to take up painting. By the late 1940s he was studying with New York School luminaries Hans Hofmann and William Baziotes.

Following the success (and notoriety) of _Washington Crossing the Delaware,_ Rivers continued to develop his interest in American subjects, and in 1959 he found an image in the May 11 issue of _Life_ magazine that he would render over and over again. The periodical contained a photograph of a dying man, believed to be 115 years old, whose story had attracted a great deal of media coverage because he claimed to be the last living veteran of the Civil War. In a subsequent issue, following his death, it was discovered that his claim was a lie. Fascinated by the manner in which the media had sensationalized the event, Rivers made numerous paintings, drawings, and prints of the image of the man shown on his deathbed before a backdrop of a Civil War uniform hanging over the Confederate Flag, Old Glory, and floral-patterned wallpaper. In one of the earliest versions, dated 1960, Rivers applied oil paint directly over the _Life_ magazine photo, as if envisaging the Abstract Expressionist brushwork that he would apply in large-scale painted versions. Between 1959 and the mid-1960s he rendered the image repeatedly and varied the style to fit the format. While large paintings were thickly painted, for example, smaller prints and drawings could be rendered in clean and simple lines.

The quirky composition of the dying veteran was clearly one of Rivers's favorites, as he returned to it in later years. In _Last Civil War Veteran: Indigo Blue_ of 1987, his attention seems focused less on the subject than on the formal consistency of a particular shade of blue, which he noted in the title. At a time when younger artists of the 1980s were championed for appropriating imagery from the masters—as he had himself done early in his career—Rivers could now simply appropriate from himself. _D. S. R._

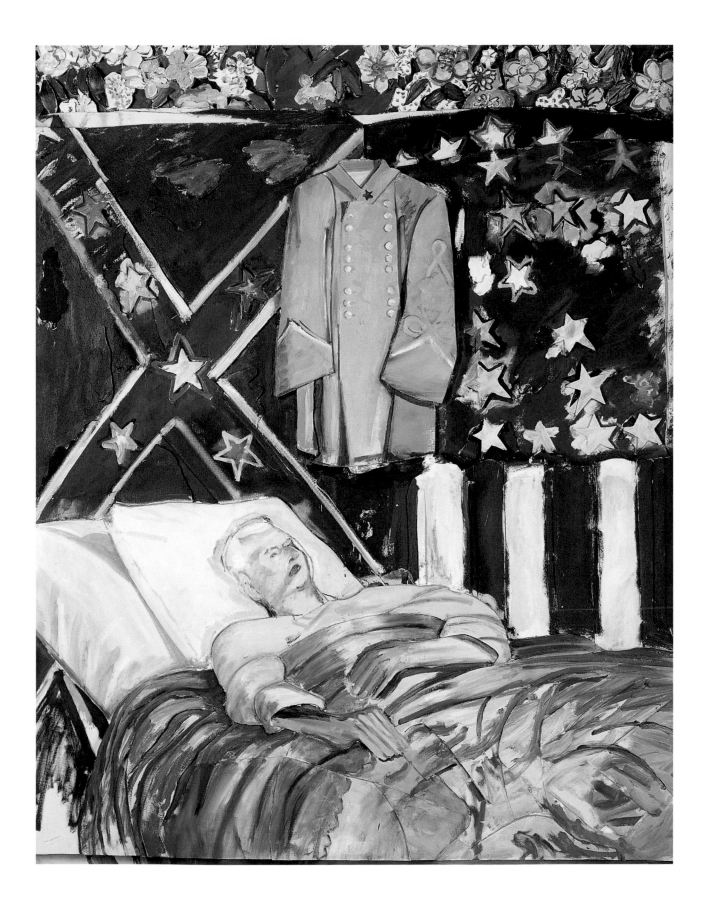

James
Rosenquist
American, born 1933

Bacon, 1980
Oil on canvas with wax
51¾ x 96¼ in.

Toaster, 1963
Mixed-media construction
11¼ x 11 x 12 in.

**Sketch for Fire Pole Expo 67 Mural
Montreal Canada,** 1967
Oil on canvas
48 x 24 in.

James Rosenquist's early work as a professional billboard painter laid the technical foundation for his subsequent Pop Art style. The huge billboard scenes that he would paint high above the New York streets appeared to him at close range as simple, abstract forms in disjointed perspective. He would consequently decide, in his words, "to make pictures of fragments, images that would spill off the canvas instead of recede into it."[1] Rosenquist would "slice" the individual depictions into large, sharply angled shapes and then fit them—incongruent yet interlocked—into a visually complex whole.

Since 1960 Rosenquist has juxtaposed these fractured images to form a single perceptual screen of associations. As demonstrated in *Bacon,* the separate images within his paintings are often marked by radical shifts in scale and sharp transitions from color to black and white, effects that integrate the images along a two-dimensional plane. Constructed of barbed wire, metal, plastic, and wood, *Toaster* translates Rosenquist's method of uniting jagged forms into a sculptural work while creating jarring associations between the parts and the title. Although comparable to Surrealist effects, the associations are not dreamlike or intuitive but are, in the artist's words, "thrust at us."

In 1967 Rosenquist was commissioned to paint one of his large-scale works for the United States Pavilion at Expo '67 in Montreal. The pavilion, itself a giant geodesic dome designed by Buckminster Fuller, was given the theme "Creative America" and housed the exhibition *American Painting Now.* As one of the most celebrated American artists of the 1960s, Rosenquist was selected to show work in the exhibition, along with Jim Dine, Jasper Johns, Ellsworth Kelly, Roy Lichtenstein, Barnett Newman, Claes Oldenburg, Robert Rauschenberg, and Andy Warhol. *Sketch for Fire Pole Expo 67 Mural Montreal Canada* is a small oil-on-canvas version of the thirty-three-foot-high mural Rosenquist painted for the pavilion.

Using traditional formats like easel painting and murals, Rosenquist has attempted to convey the psychological experience of the artificial realm of advertising, consumerism, and mass culture—the fragmentation, objectification, perception, and desire that constitute the contemporary visual field. *K. M. S.*

Notes
1. James Rosenquist, in Judith Goldman, *James Rosenquist* (New York: Penguin, 1985), 27–28.

Ed
Ruscha
American, born 1937

Please . . . , 1985
Oil on canvas
59¼ x 149⅝ in.

End, 1983
Oil on canvas
36 x 40 in.

Known for his Conceptual and West Coast Pop Art sensibilities, Los Angeles–based artist Ed Ruscha has remained an important figure in American art since the start of his career. In the early 1960s, after completing art school and while working for an advertising agency, Ruscha began painting works that incorporated language and images derived from advertising and popular culture. Large, isolated words and phrases floating on an atmospheric background quickly became his signature style. By setting commercial-art motifs and methods in a high-art context, Ruscha diffused artistic hierarchies while exploring the symbolic power of words.

In 1956, at age eighteen, Ruscha left Oklahoma City for California by driving along Route 66. The highway he traveled and the landscapes he passed profoundly influenced his work. In 1963 he published his famous book *Twentysix Gasoline Stations,* which featured black-and-white photographs of filling stations along Route 66 between Los Angeles and Oklahoma City. Like his word and sign paintings, the book reveals the parallel between the uniformity and interchangeability of urban signs—the gas stations—and the endless repetition of the road itself. The long stretch of his drive likewise inspired his paintings, especially their sparse, elongated, and panoramic qualities.

In *Please . . . ,* the horizontal extension of the canvas is literally marked out by a long bamboo stick with a carrot at the end of it, stretching diagonally from one corner of the canvas to another. This stick not only fulfills the formal function of designating the horizontal expanse, but it signifies desire through the proverbial "carrot on the end of a stick." Like the longing implied in the title *Please . . . ,* it conveys temptation, yearning, and a search for fulfillment symbolized by a highway trailing off into the horizon. Ruscha offers a tantalizing image of desire but ultimately leaves the viewer dangling.

Although the canvas of the painting *End* is virtually a square, an elongation similar to that of *Please . . .* is evoked through the perspectival illusionism of the work's lettering. Seeming to expand and recede into space, the letters of the word *end* play on the meaning of the word itself, as they literalize distance as the horizontal extension of the canvas. In the two paintings, the sign of the carrot and stick, in conjunction with the "end" that is always in sight but never comes, can be seen as signifying the allure of the horizon and the desire that perpetually fuels the journey. *K. M. S.*

George
Segal
American, 1924–2000

Woman in White Wicker Rocker, 1984–89
Bronze with white patina
42 x 33 x 50 in.

George Segal's passion for the experience of ordinary life determined his decision to "enter" literal space by creating sculptural works. His trademark life-size plaster casts evolved from nascent sculptural inquiry in 1958, when he experimented with plaster, burlap, and wire mesh in the chicken coops of his New Jersey farm. By 1961 he had discovered the technique of using medical bandages in his art. He used his own body as a model for *Man at a Table,* his first plaster and bandage cast. Subsequently recruiting his friends and family as models for his works, he would wrap their bodies, set in everyday poses, with plaster-soaked bandages. When the plaster was dry, he would incise and remove these casts in segments to create molds for their life-size sculptural analogues.

Just as Segal aimed to project his art into the full dimension of lived experience through sculpture, he likewise sought to portray the daily experience of life, particularly its most ordinary events. "I think a minute of existence is miraculous and extraordinary," he once famously explained.[1] In Segal's art, seemingly mundane moments—a lone man nursing his coffee in a diner, a young woman staring ahead in a subway car, someone waiting for the bus or listening to the radio—become fleeting instances of the ordinary disconcertingly frozen in time.

Despite the gestural quality of their surfaces, achieved through the unfinished accretion of plaster or paint on cast-bronze works, Segal's figures often exert a static quality. The relaxed, almost airy impression of *Woman in White Wicker Rocker,* however, belies its rough surface. The diaphanous quality of the woman's dress, the openness of her gaze, and the curving relaxation of her limbs all blend with supple repose to produce a gracefully prosaic moment of simple humanity.

From an edition of five that the artist created between 1984 and 1989, this sculpture belongs to a common Segal genre of figures seated in chairs, diner booths, benches, or bar stools. Like most Segal sculptures, it bears a reflective, ethereal presence. Like white inverted shadows of the living, these ghostly human replicas embody a melancholy silence, lingering in lonely limbo as shells of their former selves. *K. M. S.*

Notes
1. George Segal, interviewed in *George Segal: American Still Life,* a film written, produced, and directed by Amber Edwards (NJN Public Television, 2001).

Al
Souza

American, born 1944

Surprise Inside, 2000
Puzzle parts and glue on wood
84 x 72 in.

Houston-based artist Al Souza has been making elaborate "paintings" out of ordinary jigsaw puzzles for about ten years. He started by combing flea markets and junk stores for discarded puzzles, but as the complexity of the paintings increased, he began to buy puzzles from the Web-based auction company eBay as well. His works range from easel-size to gigantic. *The Peaceable Kingdom,* for example, displayed in the Whitney Biennial of 2000, is an eighteen-foot-long piece composed of approximately one hundred thousand puzzle pieces. For most works, he layers fragments of partially assembled puzzles with loose pieces, so that parts of images peek through a dense visual labyrinth. At first Souza put together the puzzles himself or used already-completed puzzles, but eventually he began to hire others to help with this time-consuming work.

Souza's subversive elevation of puzzle making to the status of an art form is a quintessentially postmodern gesture. To blur the boundaries between fine art and craft and upset conventional aesthetic expectations is a hallmark of postmodernism, as is the idea of returning art to its origins in fun and play. Evoking childhood and the pure pleasure of image making, jigsaw puzzles embody the kitschy element of craft shunned by high modernism but embraced by later artists. Souza often picks particularly gaudy and colorful subjects reminiscent of Pop Art: cartoons, junk food, candy, and balloons. A plethora of American consumer culture flows through the puzzles and becomes incorporated into an improvised formal rhythm that is itself reminiscent of some strains of abstract modern art. Souza has referred to his work as a mixture of Pop, Abstract Expressionism, Arte Povera, and Fluxus.

Surprise Inside makes a dazzling visual experience out of hundreds of assembled puzzles of the Muppets. In this work Souza skillfully combines the most childlike and innocent of subject matter with a very sophisticated and complex grasp of space and structure. The formal placement of the puzzle pieces and images creates an exploding sense of infinite color and space, as complex and intricate as Jackson Pollock's layers of flung paint, but offered in a spirit of fun and humor. *R. B.*

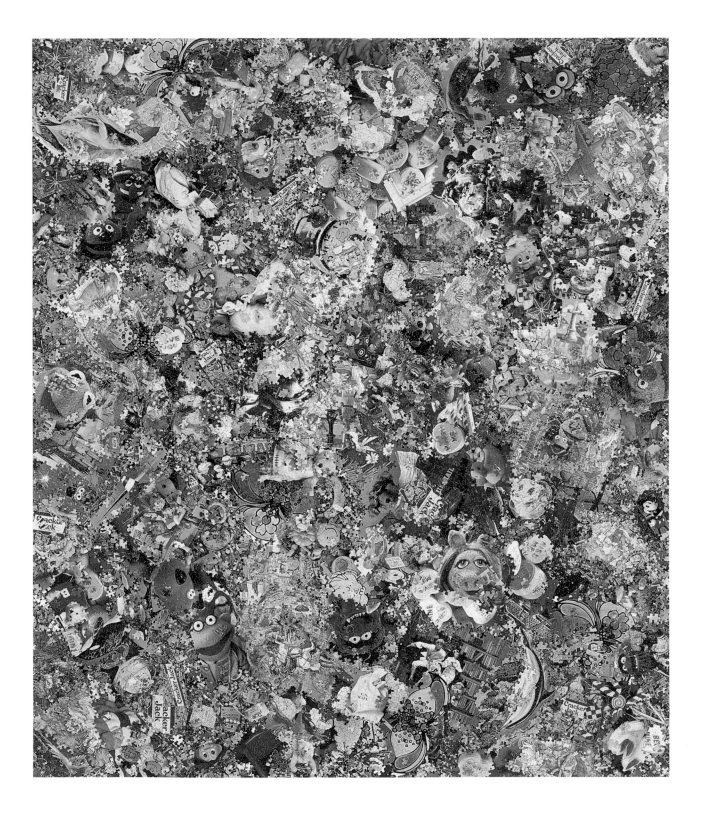

Frank
Stella

American, born 1936

Bonin Night Heron, 1979
Hand-painted screenprint
60⅞ x 84 in.

Sinjerli Variations Squared with Colored Grounds, 1981
Offset lithograph and screenprint
Six prints: 32½ x 32½ in. each

Frank Stella has tested the extremes of pure abstraction since arriving on the New York art scene in 1959. Just one year after graduating from college, he achieved professional recognition with his monochromatic Black Paintings of 1959–60. These pivotal works, viewed as precursors of Minimalism, led to his hard-edge geometric paintings of the 1960s. Prototypically Minimalist in their emphasis on the two-dimensionality of the canvas, they included his Protractor series of large-scale shaped canvases painted with flat geometric designs. Known for his exceptional level of productivity and versatility, Stella has been a major figure not only in abstract painting but in sculpture and printmaking as well.

Stella's prints have frequently rivaled his paintings in scale and vibrancy of color. His earliest prints, which he began in 1964, were initially monochromatic and modestly scaled. He then began making prints based on his paintings, following their vivid colors and hard-edged geometric compositions (as in the print series entitled *Sinjerli Variations*). He would often name a print series after the painting series that inspired it. In the early 1970s he began moving away from flat geometric shapes toward bold-colored illusionism and an experimental approach to theme and technique.

The Exotic Bird series of 1977 to 1979, for example, is marked by a newly gestural, lyrical style and engagement of pictorial space. The prints in the Exotic Bird series are based on gouaches that Stella had executed to use as sketches or working drawings. The series includes the hand-painted print *Bonin Night Heron,* whose subject matter of an exotic bird yields to the relationship of the forms themselves and to the colors that enliven them.

Some prints in the Exotic Bird series, and others Stella was creating at the time, were executed as mixed-media works in relief. Although it is not a mixed-media work, *Bonin Night Heron* bears some dimensionality, as it is printed on paper with a honeycomb backing approximately half an inch thick. The three-dimensionality of Stella's art became increasingly more pronounced over the following years, eventually leading to bright wall constructions that often extended several feet off their supports. By the early 1990s his work had become fully three-dimensional, taking the form of large, abstract sculptures constructed of various found and selected elements cast in stainless steel and bronze. *K. M. S.*

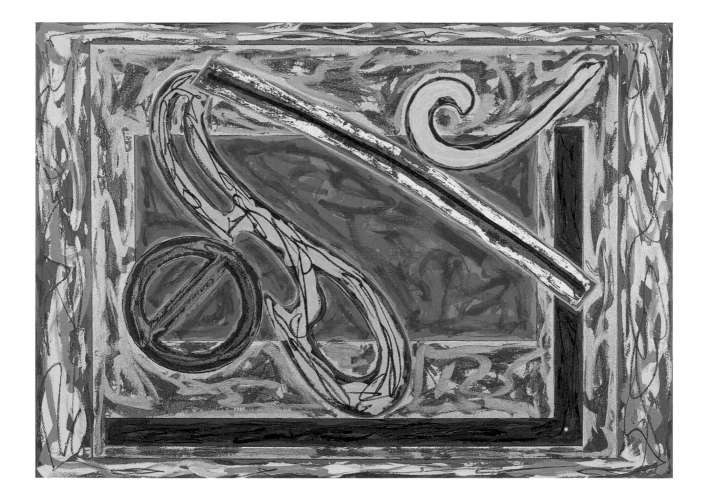

Christopher
Taggart
American, born 1973

SPR(O)ING(!), 1999
Aluminum and glass
96 x 48 x 48 in.

(Virtual) Hand, 2000
Color photographs and transparent tape
48 x 36 x 12 in.

Christopher Taggart draws upon his varied background in art and science to create one-of-a-kind sculptural installations that are as intriguing for the conceptual issues they raise as for their technical construction. Revolving around numerous concerns—including the study of optics, perspective, movement, and virtual reality—Taggart's installations typically show images, texts, or some sort of body being constructed through highly unusual, often mechanical, means. He frequently juxtaposes a precisely controlled mechanical process with an unpredictable, fragile aesthetic result, creating a fascinating synthesis of the disparate realms of science and art.

Taggart's *(Virtual) Hand* is part of a series of objects made from photographs cut and pasted together. In this case, he first divided his own hand into about three hundred triangles, photographed each triangle, and then recombined the processed photos into a new, "virtual" hand. Differences in the color and shading of the triangulated sections of the hand are due to the uneven quality of the photo processing, the result of Taggart's intentional use of low-budget labs. This complicated process of construction demonstrates how machines and technology intervene in our most personal experiences, including that of our own body. The final product is a reconstructed Frankenstein hand far removed from the real hand Taggart began with. Ironically, however, we are never far from the artist's own hand, for it controls the whole process.

Taggart thus proposes that, by working with and understanding mechanical procedures, the artist can avoid becoming a passive victim of technological manipulation. To this end, in works such as *SPR(O)ING(!),* he investigates optical mechanics and how they help shape illusions and the realm of the image. Here he created another "virtual" object—a gorilla—that is half sculpture and half reflected image. The virtual creature is partly cast aluminum and partly an optical illusion created with a mirror. Through such experiments, Taggart raises intriguing questions about the nature of the real while optimistically celebrating the artist's participation in making that reality. *R. B.*

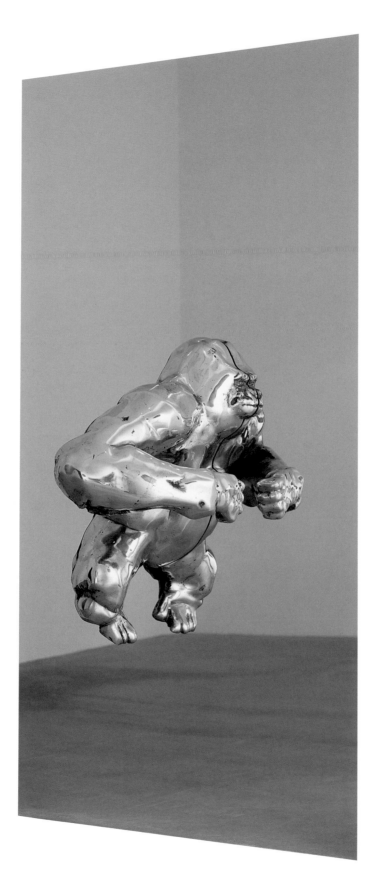

Tony
Tasset

American, born 1960

Big Eye, 2001
Acrylic and polystyrene
60 in. (diam.)

Tony Tasset first gained attention in the 1980s as a Conceptual artist. His work since then has been diverse, incorporating a variety of media, such as photography, video, sculpture, and painting. Tasset deliberately eludes strict categories of style, preferring to make works that cannot be easily identified as part of a single artist's oeuvre. As he has noted, "It puts more pressure on the idea and on viewers to look at the piece individually and not come to it with notions of what they think my artwork is."[1]

Although varied in terms of materials and forms, Tasset's works are united by their ideas and questions about the institutional display of art, the private and public identity of the artist, and the relationship of the contemporary artist to the history of art. In recent years he has turned toward an exploration of what he calls the "plastic representation of the ego" through works that focus both on his family and home life in the suburbs of Chicago and on his public persona as an artist. His sometimes theatrical staging of identity involves an objective, exterior representation of himself being subject to a series of questions, provocations, and distortions that concern the place and function of the self in the art world.

Big Eye is an especially comic and ironic exploration of the artist's identity. Through this gigantic trompe l'oeil sculpture of his own eyeball, Tasset ponders how the inner self is externalized as an object. His eye, or "I," is presented as a strangely distant thing completely severed and separated from his body, yet it is an exact copy of a part of himself. Both inside and outside, self and other, Tasset's "I" is both intimately personal and disturbingly alien. By displaying and ultimately selling his own eyeball in the art museum and market, he comments on the uneasy relationship between the intimate self and the commodified artistic identity. At the same time, however, Tasset seizes control of this relationship. The eye/I stares back at the viewer, reversing the usual relationship between consumer and consumed. *R. B.*

Notes
1. Lucinda Barnes, "Dialogue with Tony Tasset" (interview conducted July 21 and August 16, 1995); cited in *Robert Smithson Tony Tasset: Site/Nonsite* (Chicago: Museum of Contemporary Art, 1995), 21.

Robert
Therrien
American, born 1947

No Title (Black Steeple), 1980
Oil and wax on wood
96 x 35 x 3¼ in.

Robert Therrien's sculptures reveal his longtime interest in simplified objectivity. Bridging affinities with Minimal and Pop Art, his abstract forms are derived from common subjects that are in some way meaningful to the artist, such as clouds, keyholes, snowmen, and, in this case, church steeples. Through allusions to everyday reality, Therrien's sculptural work transcends the self-referential nature of Minimalism while remaining true to the subtle iconographies the artist has traced through his own personal history.

With remarkable structural clarity and classical emphasis on formal articulation, Therrien hones his source images into abstract entities and dramatically alters their scale. Through this process, he transforms the ordinary so that the object seems vaguely familiar but cannot exactly be placed. Narrative correlations are frequently offered in the descriptive portions of his titles—for example, "Black Steeple"—even if the works remain "untitled."

Having worked with photography early in his career, Therrien once again assimilated the medium into his artistic process in the early 1990s, when he began to take black-and-white Polaroids of his work. These photographs provided him with an ontological distance from his sculptures, enabling him to see them more objectively in order to foster their evolution. By visually reducing his sculptures to two-dimensional shapes, the photographs also made it easier for Therrien to work on them in terms of positive and negative space.

The interplay of form and space is integral to his art, which is why Therrien actively participates in the design of his exhibitions when possible. His giant, eloquent sculptures are best viewed when surrounded by ample space, free from the distraction of other works and their possibly dissonant colors and forms. In their structural simplicity, Therrien's sculptures become charged by the surrounding void, and their archetypal resonance and associative reverberations can unfold. *K. M. S.*

Alison
Van Pelt

American, born 1963

Agnes Martin, 2001
Oil on canvas
108 x 84 in.

Alison Van Pelt describes her paintings as "my way of merging the ancient tradition of portraiture with contemporary abstraction."[1] Poised halfway between recognizable images and indecipherable blurs, her enigmatic faces and figures have been likened to holograms because of the way they seem to float in a mysterious depth of space and to the work of Mark Rothko because of the way they evoke a realm of transcendence, a metaphysical state.

Van Pelt has said that she is most interested in ambiguity and in exploring "the edge between annihilation and a clear reality."[2] In addition to Rothko, one of her most important inspirations in this respect is the figural paintings of Francis Bacon, whose work she encountered during a stay in Paris in 1988. Van Pelt was "taken with the way he smeared paint on the face"[3] and how he was able to "transform images into fluid mutating visions that dissolve, melt and erupt into ambiguity."[4] Like Bacon, Van Pelt also bases much of her preliminary work on photographs; she selects a photograph, from which she paints a realistic portrait, and then, while the paint is still wet, she obscures the image by dragging a dry brush across the surface of the canvas. She has a very controlled, delicate approach to what she calls the "destruction" of the image. Her evenly applied vertical and horizontal brush strokes seem to lift the image into and onto a kind of floating veil or screen as it wavers in and out of visibility. The image can appear sharp and distinct from some angles, while up close it can melt away into nothingness.

Van Pelt has applied her distinctive smeared or blurred style to a number of different subjects, including boxers, birds in flight, and female nudes. In each case, she subtly plays upon the relation between motion and stasis, time and timelessness, reality and abstraction. *Agnes Martin* is from her most recent body of work, The Women, a series of portraits of women artists, including Georgia O'Keeffe, Frida Kahlo, Alice Neel, and Louise Bourgeois. Born in 1912, Agnes Martin is known for her monochromatic abstract paintings. Her canvases are often composed of grids or other geometric structures that are barely perceptible. Van Pelt's especially vague and delicate rendering of Martin's face in this work clearly evokes and pays homage to the older artist's distinctive and influential minimal style. At times clouding over into an indistinct blur and at times standing out in sharp chiaroscuro, Martin's face hovers, resembling a religious icon or ancestral portrait. *R. B.*

Notes
1. Quoted in George Melrod, "Femme Noir," *World Art,* no. 12 (December 1997): 52.
2. Quoted in Robert Scheer, "Local L.A.," *Los Angeles Times,* 6 August 1998.
3. Melrod, "Femme Noir," 54.
4. Quoted in Dr. Jonas Wright, "Flight and the Figure: The Paintings of Alison Van Pelt," in *Flight and the Figure: The Paintings of Alison Van Pelt* (Los Angeles: Rusconi, 1999), 5.

Andy
Warhol

American, 1928–1987

Frederick R. Weisman, 1974
Acrylic on canvas
Four panels, 80 x 80 in. overall

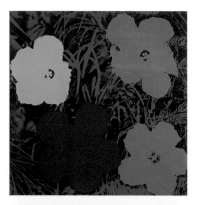

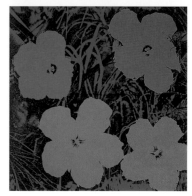

Flowers (Red), 1980
Flowers (Blue), 1980
Glass and polymer on canvas
72 x 72 in. each

Andy Warhol is considered to be one of the most influential American artists of the twentieth century. His name is synonymous with Pop Art, and his significance is undeniable as an innovator whose radical impulses infused virtually every field of visual culture. Warhol manifested his signature style with the use of commercial silkscreen techniques to create multiple images on canvas distinguished only by color variations. He laid the groundwork for his Pop Art prototypes by hand-painting soup cans and newspaper headlines, and by late 1962, using a method of photographically transferring images onto silkscreen, he had created works such as *Coca-Cola Bottles* (1962) and *Brillo Boxes* (1964), which brought him immediate acclaim.

Warhol's silkscreen techniques successfully fulfilled his aim to eliminate all vestiges of the "artist's hand" to achieve a remote, mechanically constructed aesthetic. He is legendary for wanting his art to look "programmed or impersonal" in order to reflect the impersonality and consumerism of American mass culture, and he made a revolutionary style of such detachment. He documented suicides, car crashes, and the electric chair with the same objectivity that he brought to his name-brand commodities. In 1964 he also began making paintings of flowers, taking the initial image from a magazine and creating a flatly decorative motif that recalled his early work in commercial art. By 1980 he was using "diamond dust," or ground glass from crushed Coke bottles, in works such as *Flowers (Red)* and *Flowers (Blue)*. By literally incorporating the consumer object (Coke-bottle glass) into these paintings to produce glittering effects, Warhol achieved both the irony and the "gratuitous beauty" that he so esteemed.

Warhol's business of making commissioned portraits in the 1970s not only revitalized the traditional genre of portraiture but made it fashionably avant-garde. Among his clients were political figures, artists, actors, socialites, and art collectors, including the entrepreneur and philanthropist Frederick R. Weisman. Weisman had purchased a 1967 Marilyn Monroe suite in 1968, and over the course of a few years, he became a top client of Warhol commissions. Warhol created portraits of Weisman and his family throughout the 1970s and early 1980s. In addition to the numerous personal commissions, the Marilyn suite, and the flower paintings, Weisman acquired Warhol's *Dollar Sign,* which epitomized the artist's renowned philosophy that "the best art is good business." *K. M. S.*

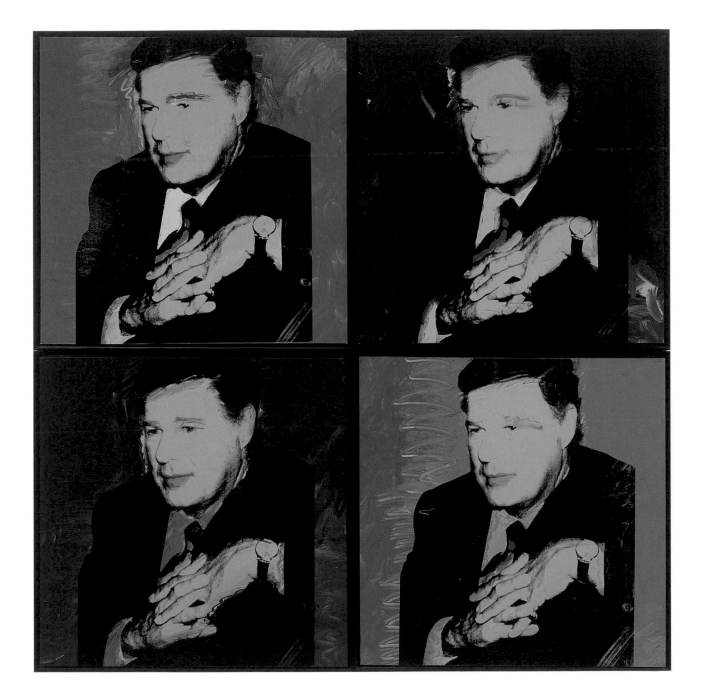

Marijke van Warmerdam

Dutch, born 1959

There You Are, 1999
Color photograph
70¾ x 106½ in.

Marijke van Warmerdam works in a variety of media, including film, video, silkscreen, and photography. Her absorbing, intriguing images of everyday objects and places hover between an intense and focused realism and a delicate, dreamlike sense of fantasy and otherworldliness. Placing her work on the fragile border between the real and the make-believe, she notes: "Art can give a twist to life and vice versa. I really enjoy it when a work comes very close to life and almost merges with it but stops just short."[1] Perhaps reflecting her Dutch background, her photographs and films have the appearance of paintings by Jan Vermeer or of seventeeth-century still-life paintings in which time has stopped and objects are preserved in an intense clarity of light.

Warmerdam typically combines a straightforward shot of an object with a subtle manipulation of the photographic process in order to introduce an odd and magical dimension into the image. In one of her best-known works, entitled *Pancake,* a half-cooked pancake is depicted frozen in midair, caught in what seems like an impossible weightless moment. In the film loop *Weather Forecast,* a single bathtub is filmed slowly overflowing in an empty room, while mysterious clouds drift into and out of the frame. Questions of time and aesthetics, realism and the gaze are interwoven in a mesmerizing, hypnotic mood.

There You Are presents the unique combination of dream and reality found in Warmerdam's works. It is simultaneously an exquisitely shot photograph of a crystalline turquoise sea, and a fantastic world where graceful swans can swim in and out of clouds. Through the low horizon—which cuts a stable, balancing line through the image—Warmerdam seems to be overtly quoting seventeenth-century Dutch landscape painting, which frequently depicts enormous skies full of billowing clouds over a low, straight horizon. The artist thus connects her work to the tradition of Dutch painting but at the same time subverts the realism of this tradition by introducing weightless swans into an otherwise perfectly normal world. *R. B.*

Notes
1. *Single, Double, Crosswise: Marijke van Warmerdam,* Artmag.com: Museums, 6 July 2003 <http://www.artmag.com/museums/a_payba/anleiva/anleiva5.html>.

Tom
Wesselmann

American, born 1931

Still Life #31, 1963
Mixed-media construction with television
Two parts, 48 x 60 x 11 in. overall

Study for Mouth #4, 1966
Charcoal on paper
48 x 56 in.

Tom Wesselmann is viewed as one of the leading figures of Pop Art. As an art student in the mid-1950s, he intended to become an abstract painter, and his early work betrayed an expressionistic impulse. By 1959, however, he had begun creating bright, Matisse-like collages of female figures in interior spaces—a theme he would invoke throughout his career. In 1960 he appropriated this flat, "cutout" style for his Great American Nude paintings. A year later his first one-person exhibition took place at the downtown Tanager Gallery in New York, and in 1962 the Green Gallery had its own major solo Wesselmann exhibition. Roy Lichtenstein, James Rosenquist, and Andy Warhol—working in a similarly flat, detached aesthetic inspired by consumer society and popular culture—also had one-person shows that year. Pop Art had arrived.

Taking his earlier collages a step further, by 1962 Wesselmann was creating paintings containing actual functioning objects, including turned-on television sets, ringing telephones, and workable window blinds. This facet of his work might best be described as a performative Pop subversion of the conventional still life, which provided a satirical celebration of mainstream American culture. *Still Life #31* includes a television set, the focal point of the postwar American home, and an image of the ubiquitous Gilbert Stuart portrait of George Washington. These powerful emblems of American identity are placed among painted elements alluding to the European modernist still-life tradition.

Wesselmann's exploration of the popular lifestyle and imagination has been characterized by an analytical detachment, a stylistic objectification that is best exemplified by his Great American Nude series. By isolating elements of the female body and rendering them in large scale, Wesselmann has explored and exploited the sexual content of Western art and mass media. These paintings evoke an anonymous—literally faceless—mass-consumer eroticism. Occasionally skimming the line between aesthetics and pornography, these works provide glimpses of the most sexually charged features of the female nude. In other works, such as *Study for Mouth #4,* these parts are presented in isolation, without a bodily context, further magnifying the sexualization of a woman's body. *K. M. S.*

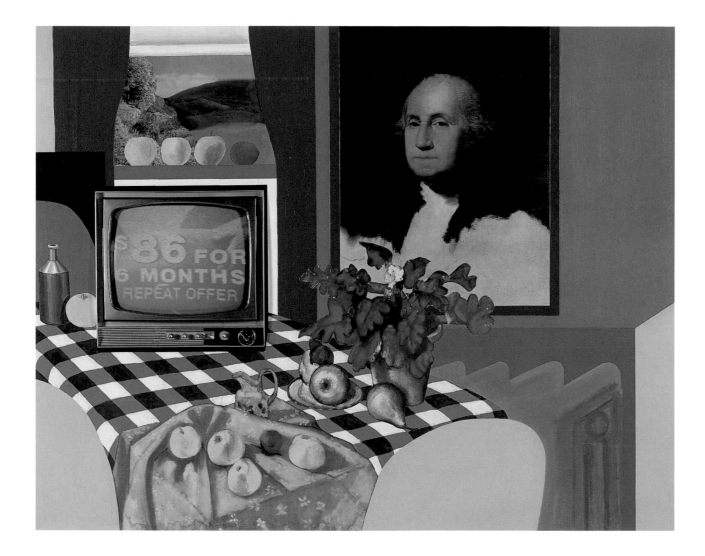

Tom
Wudl
American, born Bolivia 1948

Untitled, 1973
Acrylic on paper
70 x 90 in.

Tom Wudl first came to prominence in the early 1970s through a series of abstract paintings made from perforated rice paper. His nontraditional materials and colorful, flat surface patterns were typical of Los Angeles art of the time. Preoccupied with the dynamics of surfaces, many Southern California artists created taut geometric structures employing new materials. Wudl's rice-paper constructions combine mathematical precision and cosmological symbolism, bringing together the disparate realms of science and myth.

This 1973 work is almost six by eight feet. Its majestic size, reminiscent of nineteenth-century landscape or history painting, envelops the viewer in an abstractly rendered skyscape. The turquoise and white background represents the heavens. Two round shapes schematize stars or planets. A yellow bolt recalling lightning zigzags across the canvas. Finally, the rice paper perforations create the impression that a fine rain streams across the surface. These elements culminate in a storm designed to evoke the mythic or religious symbolism of the sky as a place of cosmic creation. The abstract references to nature are one of the aspects of his work that link it to California art.

Wudl balances this dramatic scene—in which the forms are read symbolically—with a purely formal, structural approach to the surface. His creation myth is a simultaneously studied and careful arrangement of geometric shapes related to one another in deliberate ways. For example, the space of the canvas is marked out with a map of interlocking equilateral triangles of similar proportions. The light and dark areas are cut out of this underlying triangular grid. Similarly, the "stars" and "planets" are perfectly symmetrical spheres placed in a balanced relation to one another, and a bolt of "lightning" composed of more symmetrical triangles connects the exact center of each spherical planetary form. Combining symbolism, a looseness of technique, and measured precision, Wudl's skyscape shows that the seeming randomness of nature has an underlying mathematical structure. *R. B.*

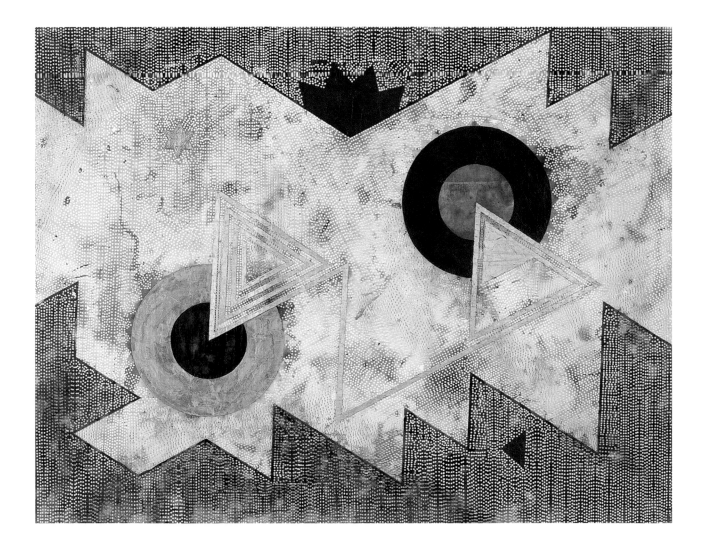

Reproduction
Credits